ALL OF WHICH I SAW

Photographs by **LUCIAN READ**

ALL OF WHICH I SAW

With the US Marine Corps in Iraq

Preface by Congressman **SETH MOULTON** (Captain, USMC) Introduction by **DAN RATHER**

SCHIFFER MILITARY

4880 Lower Valley Road Atglen, PA 19310

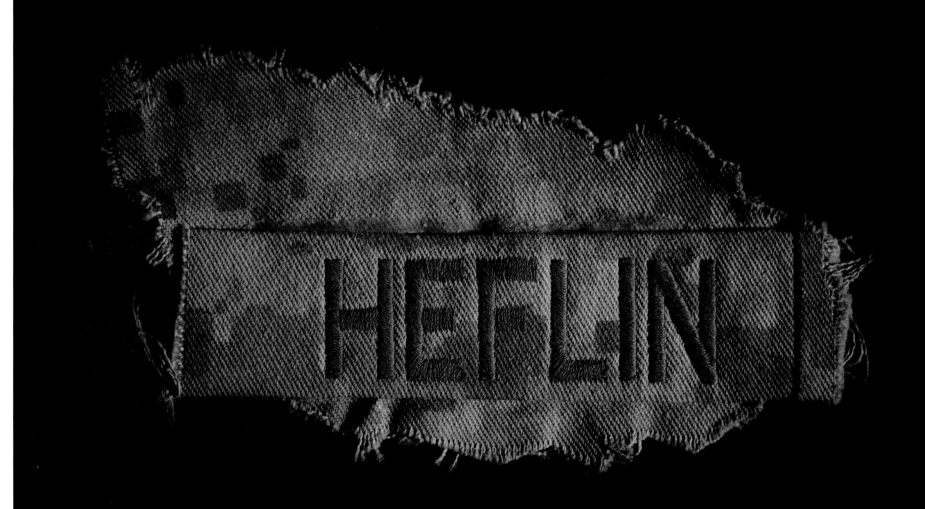

"Great queen, what you command me to relate
Renews the sad remembrance of our fate:
An empire from its old foundations rent,
And ev'ry woe the Trojans underwent;
A peopled city made a desert place;
All of which I saw and part of which I was:
Not ev'n the hardest of our foes could hear,
Nor stern Ulysses tell without a tear. . .
But, since you take such int'rest in our woe,
And Troy's disastrous end desire to know,
I will restrain my tears, and briefly tell
What in our last and fatal night befell."

The Aeneid of Virgil, Book II, i 2–15

PREFACE by Congressman Seth Moulton (Captain, USMC)

The worst days of my life were in Iraq. But some of the best ones were there, too. We were so young and hopeful when we started. We were so weathered and proud when we came home—those of us who made it. And the years since haven't been easy for any of us. At least not for the guys I know.

But it was worth it, if for no other reason than the fact that nobody had to go in our place. When the nation called, we took on a tough job that few wanted to do. Some of us supported the war, some of us didn't, and some of us weren't sure. But we all supported each other, and that's what got us through.

For us, the war was not about the political fights back home or the policy debates in Washington and Baghdad. It was about serving our country and looking after each other. It was about being a part of something larger than ourselves, no matter where we came from or what we looked like. It was about putting others first—our family and friends back home, our buddies in the "sandbox" with us, and the nation we all love.

Every time I deployed to Iraq, I tried to imagine the most awful things that could happen, the hardest challenges I would face. And every time, the war surprised me with something worse. Yet, how we came together to meet those challenges continues to inspire me. The courage, the values, and the strength of men and women from all over the country are a reminder of the best America has to offer.

Turning the pages of this book brings back those memories, the most powerful of my life. It's an incredible mix of emotions. Like the odd comfort I still find in the smell of burning trash, that repulsive smell that brings me right back to those days I strangely miss. Or the subconscious sense of relief I feel when I hear a helicopter overhead—even back here at home.

To those of us who served, these images represent the best of times and the worst of times, and many in between. Blood on one page and laughter on another; despair in the morning and inspiration at night; abject loneliness in one second and brotherhood in the next; and moments when you'd rather be anywhere else in the world and moments when you're exactly where you want to be. Death and life, sitting right next to each other.

Life in Iraq could switch from one of those extremes to another in an instant, just like turning a page. And when you turn the page, you remember what you'd briefly forgotten—that both extremes were there to begin with. That you can't have one without the other.

That's what you'll see depicted so beautifully in this book. Lucian Read embedded with my company on my second of four deployments to Iraq, and he became a close friend. He was a civilian with a camera—we were Marines with guns—but he never shied away from being at the front—from sharing the same risks we did—to capture our stories with the honesty and breadth that only someone there with us could have known.

I write this today in a different world than the one in which Lucian and I met. I'm now a United States congressman—another job often maligned, rarely appreciated, and particularly lamented in this dark political moment. I didn't plan to go into politics and wouldn't be doing this if I hadn't been a Marine first. Iraq brought me face to face with the consequences of failed leadership in Washington.

But for the first time since being a Marine, I have a job where I can help people every single day. It's another time when being a public servant makes me proud—not because it is easy, but because it is hard. Not everyone will agree with me or with everything I do, but I'm proud to be serving my country again. It's the second-best job I've ever had.

That's the craziest part of looking through these pages. Sitting in the comfort and safety of my home, I'm reminded of all that we shared: the passion, the love, the fellowship, the sense of purpose, of opportunity, of service, and of hope—all that amidst the tragedy of war—and I miss it. I miss it dearly.

What I wouldn't give to be back there with my Marines.

FOREWORD by Dan Rather

While covering wars off and on for over fifty-five years, I have known many of the best war photographers of our times. Lucian Read is among them. His photographs have not been limited to those of war; Lucian has photographed a wide range of subjects all over the world. However, his signature work has been in and out of war zones: deft portrayals not only of warriors, but of all those touched by battle and within harm's reach. Often, the suffering of women, children, and the elderly is little noted, if at all. This is not the case in *All of Which I Saw*.

At its best, photography is a universal language that speaks from and to the heart. So it is with Lucian and what he has recorded for posterity. While he may protest the description, he is a true artist, as well as a superb technician. This praise is not something I give to him; he has earned it. The hard way. He worked for it, poured his heart and soul into it, and put his life on the line many times for it. Blood, sweat, tears, and nights alone far from home in one hellhole after another. He has undoubtedly paid the price to be the photographer he has become.

I first met Lucian in the early 2000s, well before he became one of the most respected artists in his craft. At that time he was scratching around trying to eke out a living as a freelancer. He quickly became a regular for my hard-news program *Dan Rather Reports*. During his tenure Lucian's forte remained the still camera, but he quickly added the ability to do moving pictures for television as well. Most of his work at that time was in Iraq and Afghanistan. He excelled, all while doubling as a producer of news segments for which I was the correspondent and anchor.

We had a sense of camaraderie almost right from the beginning. In the field we sometimes shared rations and often talked of war zones past and present. At base, Lucian is a bit of a loner and tends to be laconic—doesn't say a lot (at least when he is working). Once, in a dangerous piece of Afghanistan, I tried to loosen him up. It was an attempt and effort to get him to say something other than just "Yup," "Nope," or "I dunno." I joked to him that if there had been war photographers in ancient Greece, Homer would have written one—someone like Lucian—into *The Iliad*. Lucian didn't respond, other than to shrug. Now I suspect why: when it comes to the ancients, he prefers Virgil and *The Aeneid*.

Far into the distant future, when historians and poets want to know what war was like in the early twenty-first century—what it was really like—they will do well to look up Lucian Read's work, including this book.

INTRODUCTION by Lucian Read

Fourteen years ago today, in the cold, wet hours before dawn, the Marines of 3rd Battalion 1st Marines awoke—those who had been able to sleep—and began to move from their foxholes. Aboard a motley assortment of vehicles, the battalion, along with six others, assembled and crept forward from their desert staging points into the insurgent-held Iraqi city of Fallujah.

They had trained and waited for years for a morning like this, and though few of them knew what to expect, all were sure that they would be part of something historic in the next hours and days—if they survived. The Second Battle of Fallujah would reach its crescendo in the coming few days and then recede over weeks, taking with it eighty-two Marines, sailors, and soldiers, and countless more insurgents and Iraqi civilians. At twenty-nine years old—a photojournalist with a single camera and no assignment—I rode and then walked into the city alongside them. For me, too, it was the culminating moment of years of patient effort, the very moment and place I had dedicated myself to reach. Now this book brings another long effort to its end.

These images, drawn from more than 30,000, document four years of the war in Iraq; the years I spent with the Marines. The book begins in May 2004, when I was given permission to join the 11th Marine Expeditionary Unit (MEU) for their full deployment just as they were being rushed to Iraq to bolster a US force unprepared for Iraq's growing descent into chaos. I spent those first weeks abroad the USS *Belleau Wood* as she carried the 11th MEU to Kuwait, the gateway to Iraq. With the 11th MEU I was present for the Battle of Najaf, the only journalist on the American side during the hardest days of fighting. Months later, I would find myself in the midst of the bloodiest fighting of the war: Fallujah. It was here that I would take the now-iconic—sometimes still to my surprise—photograph of then-First Sergeant Bradley Kasal being carried from the room-to-room fight in what instantly became known as the Hell House. Even as it captures a moment of bloody desperation, the photo is a portrait of heroism and brotherhood. I would go home with the 11th MEU after nine months in 2005, by plane this time. (No other journalist would cover a Marine unit in Iraq for as long.) I would make the first of many returns to Iraq—just as the Marines did—later that year. There were to be no more true battles, but the war went on. Fall 2005 saw fighting on the Syrian border near Al Qa'im, the daily grind of counterinsurgency, and the most troubling moment and images in this book: the killing of twenty-four Iraqi civilians, including women and children, by Marines in the town of Haditha. My photos of that dark moment on November 19, 2005, went around the world and came almost exactly a year after the Hell House and Sergeant Major Kasal's

photograph. Both incidents involved the same Marine rifle company—a fact that tells you much that you should understand about Iraq. From there, the book carries on to Ramadi—most searingly to Ramadi Surgical—where, in 2006, I saw the entire war in just two rooms—the ER and OR—laid bare in all its horror and sacrifice. We stay in Ramadi through the first moments of the Anbar Awakening in 2007, which began to turn the tide in the American war in Iraq. The book's last images capture the joy and relief, and introspection, of my first homecoming with the 11th MEU in 2005—an experience shared by the more than two million Americans—and still counting—who served in Iraq and Afghanistan.

Even before Fallujah was over, some of us promised that the battle would not define our lives, and for the fortunate that has been true. But Fallujah, Najaf, Ramadi, and Haditha (and Baghdad, Baqubah, and Mosul) are, even fourteen years later, never really that far from those of us—in uniform or without—who were there. This book is the fulfillment of the promise I made as a young man to other young men that what they did then, who they were, and all that I saw would be remembered.

Brooklyn, New York
November 8, 2018

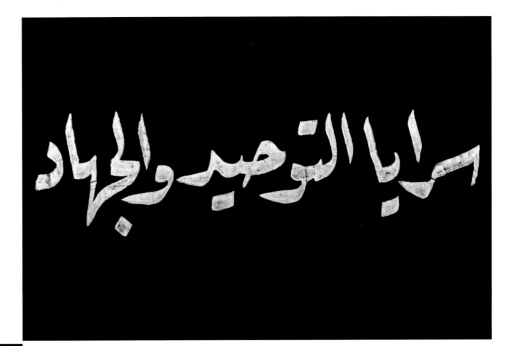

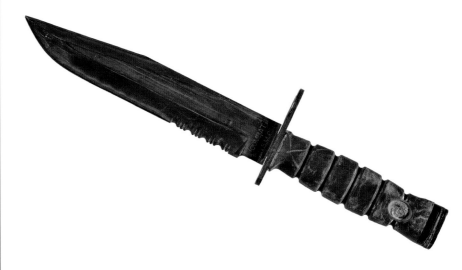

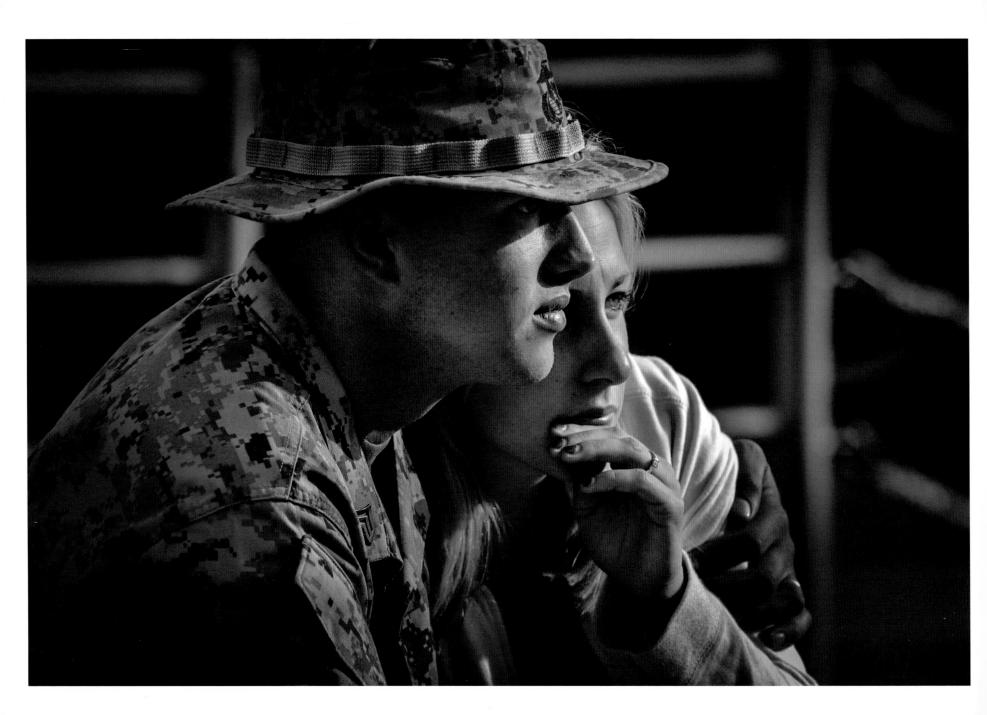

Dear Lt. Batson,

As per your suggestion, I am writing to state my reasons for requesting a place as an embed within the IIth MEU. It is my intention to accomplish two goals. The first, generally, is to cover developments in America's involvement in Iraq should they fall in or near the IIth's area of responsibility. My second, and more crucial, goal is to accompany the IIth throughout their deployment with the aim of documenting completely their experience from departure to return. I hope to create a lengthy record—ultimately in book form—that, going beyond just the news of the moment, captures intimately and comprehensively the experience of one small part of the American military family in this conflict (something that as far as I know no one has yet done). I understand that this is an unusual request and requires a large commitment of time and energy on both sides' parts. I also think I understand the discomfort and danger inherent in this course of action. Still, I think the goal worthwhile and hope this request will be granted. Again, many thanks for your help in this.

Best, Lucian
Brooklyn, New York
May 19, 2004

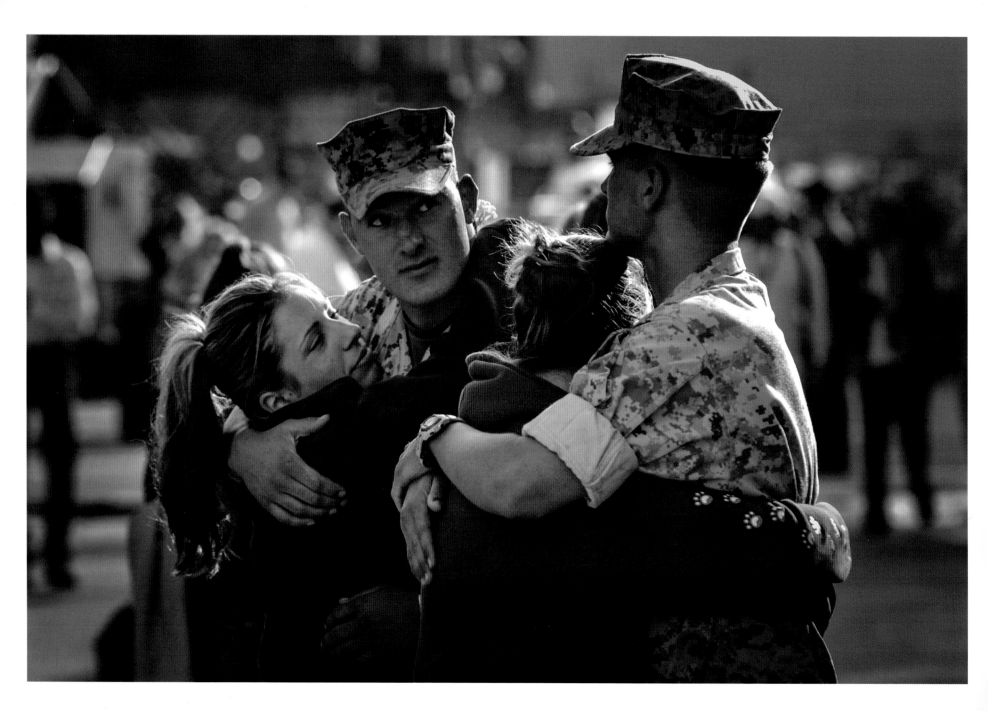

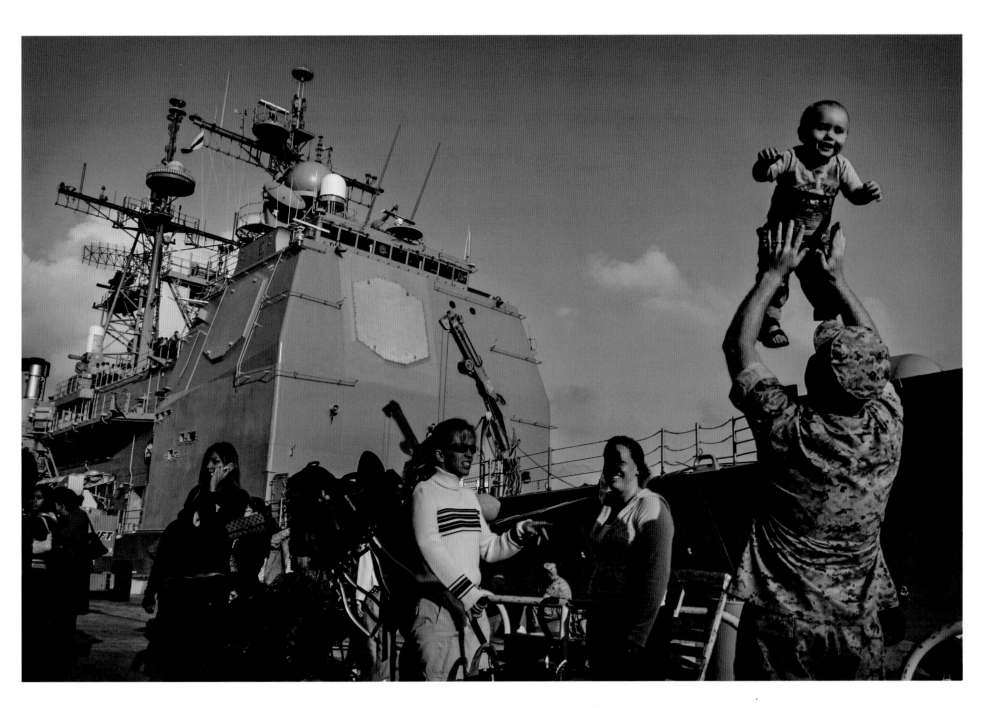

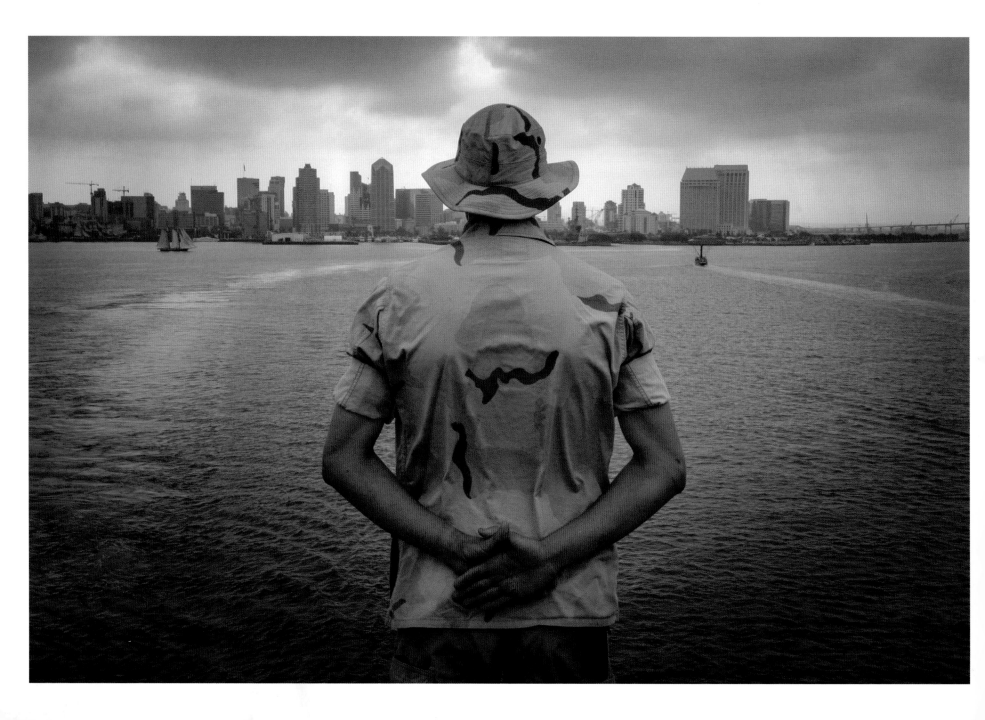

"This is a drill. This is a drill. General quarters. General quarters. All hands to battle stations." A couple of times a week the Navy runs drills to train for the unlikely event of a fire or enemy attack. For those of us just along for the ride, it means stop, drop, and roll wherever you are. The last time around I got caught on the way to the shower and had to wait in my sweat for two hours. This time I was smart and beat them to it, and now at least I can be clean while I sit in my cell. For my part I'm happy to have the morning locked in my room to work and catch up on things—mostly sleep.

Before I forget them, these are some of the topics that I should make an effort to address, a to-do list of sorts. What did I expect the Marines would be like? What are my days like? How do I think I've changed since coming along? The Marines' unending fascination with the fact that I'm not going to carry a gun. The differences between the civilian and Marine world. Thoughts on why Marines join the Corps. Thoughts on what they expect to find in Iraq. Thoughts on what I expect to find in Iraq. What are the Marines like, the enlisted men, the officers, the women? Notes on living on this ship. What else?

I'll try the first one. What did I expect to find here? That's a funny one, because I didn't have much time to form expectations. From the time I first called Capt. McSweeney to the day we sailed was how many days? Let's see. I met

Kevin Hugye, who convinced me this was possible, on a Monday night. So I called McSweeney on a Tuesday. Elizabeth's birthday party in Glencoe was on a Friday. Tuesday to Tuesday to Tuesday is fourteen days. Plus Wednesday. Thursday we sailed. Just sixteen days. In those sixteen days I thought about money, always money. I thought about how I hoped I would have time enough see my family and my friends. I thought about how to make this happen, what it would cost, and what it would cost me.

In my thinking, this time on the ship was a blankness that I thought would be filled with grudging exercise (that's true). I thought it would be a time for me to learn and integrate (that's also true). If pushed hard, I might say that I expected the Marines to be older and younger, and somehow less and more serious. I expected to find a much more stratified world of crisp salutes and crisp boundaries. I didn't expect to hear "This fucking sucks" and "ma'am" in the same sentence. I didn't expect to find infantry lieutenants putting up their own tents or lieutenant colonels bear-hugging lance corporals. I didn't expect that in twenty-four hours I would be officially adopted and folded into their Corps as if I had been there all along.

USS Belleau Wood, *somewhere near Guam*
June 14, 2004

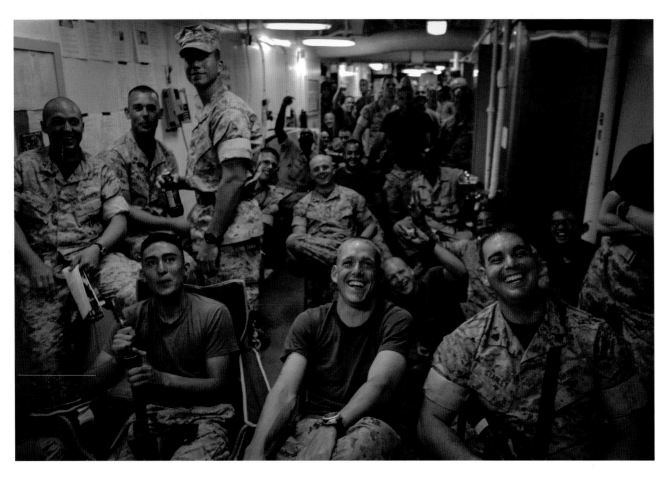

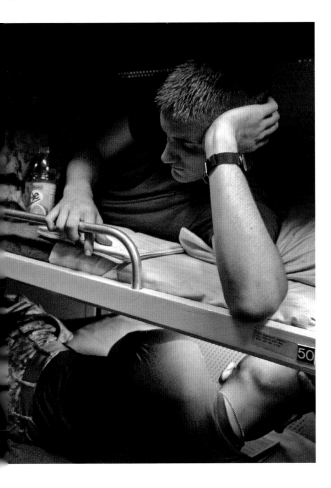
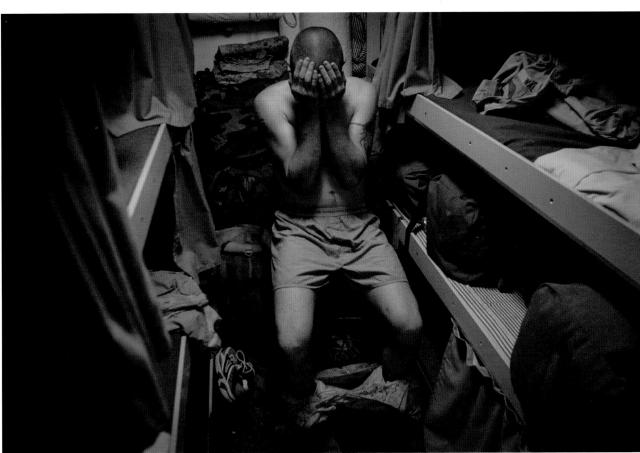

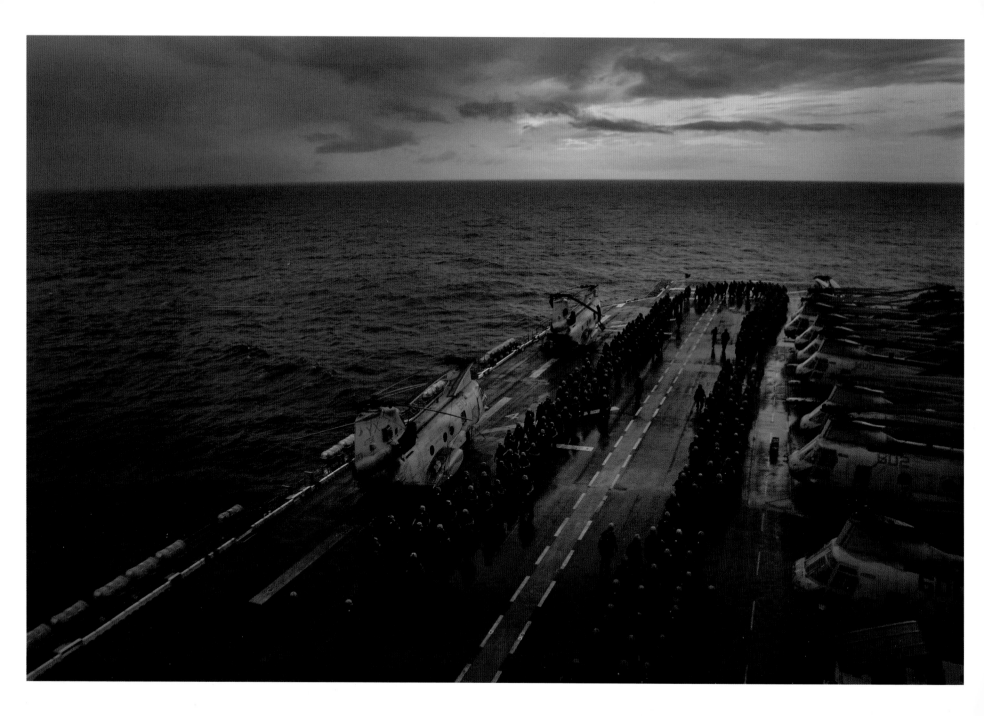

Been away for a few days trapped in the land that time forgot—the USS *Denver*. Already renowned for its genteel pace of life, activity aboard ship—including my return flight to the *Belleau Wood*—came to a halt as we slipped past the super typhoon Dianmu. Personally, I didn't think it was so super to be stuck over there for four days, and I'm pretty sure all the green-tinted, Dramamine patch-loaded sailors and Marines weren't having a super time either. I have to admit that there was a small amount of pleasure to be had in doing nothing – reading, no PT, no training, waking up at (can this be right?) 6:30 am.

It was interesting to see Marine life at a bit slower pace. The more I spend time with the Marines the more normal they seem to me. Like the rest of the world, when the boss is away the mice will smoke cigarettes, sit around in their PT shorts, and watch movies endlessly while playing spades. I must have watched portions of twenty different DVDs in the three and half days I was there – an omen, I fear, of days to come.

I left just as I was beginning to make friends. It was tiring to go through the twenty questions bit again. Where are you from? Do you have a wife or girlfriend? Whom do you work for? How long will you be with us? Did you volunteer for this? Are you going to be with fill-in-the-blank company the whole time? How much money do you make? How much does your camera cost? Did you go to school for that? Did they give you a weapon? What do you mean you don't want a weapon? What do you think so far? Have you ever been to Iraq before? You know it's going to suck, right?

To tell you the truth, I'm most afraid of being bored. It seems that peace is breaking out all over. With everyone's political future—American and Iraqi alike—on the line, both sides seem to want things to be as quiet as possible. What the terrorists, insurgents, freedom fighters, criminals, and head-severing psychopaths want is anyone's guess. Do they win by forcing us out on our own ridiculous time frame? By forcing us to stay by ratcheting up the level of violence? By doing nothing and then taking the country by civil war when we bail in a year or two? Which brings me back to what do I expect? Well, I expect it to be hot and dirty. I expect to be reduced to a mumbling infantile state by my inability to have decent Mexican food or sex for an indefinite number of months. I expect to go on more patrols, convoys, and goose chases than almost anyone in the province while trying to make this project work. I expect to make almost no money whatsoever and return with an annihilated financial position. I expect to want to leave almost immediately and then long for it when I'm gone. I expect to sweat excessively, to bitch, to complain. I expect to be bored and disappointed and exhilarated and fascinated and disgusted.

USS Belleau Wood, *off Singapore*
June 22, 2004

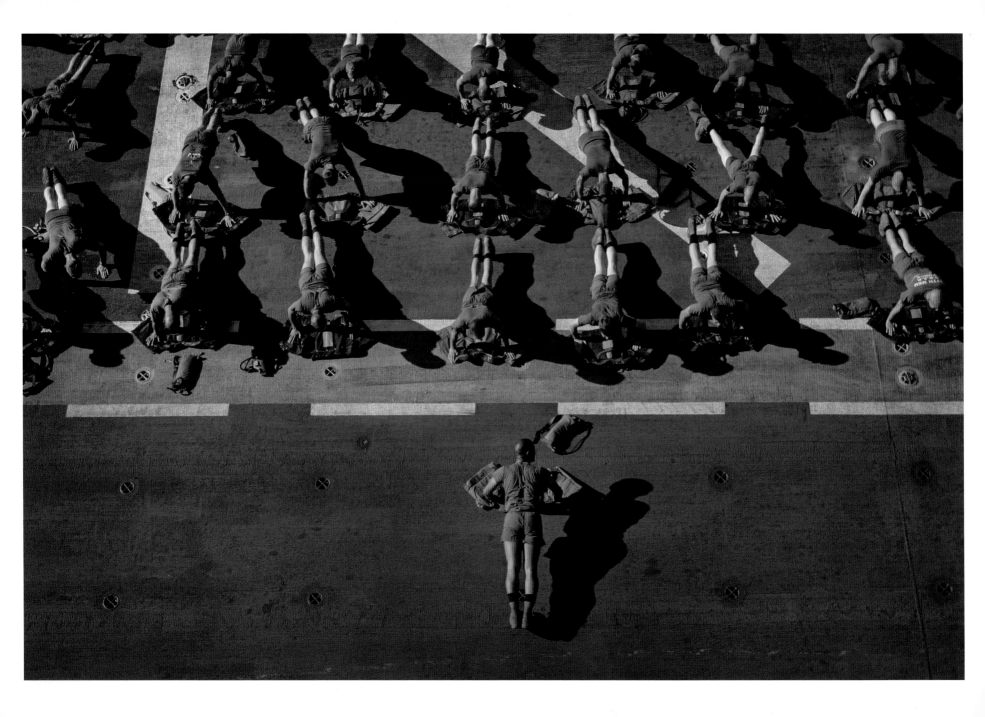

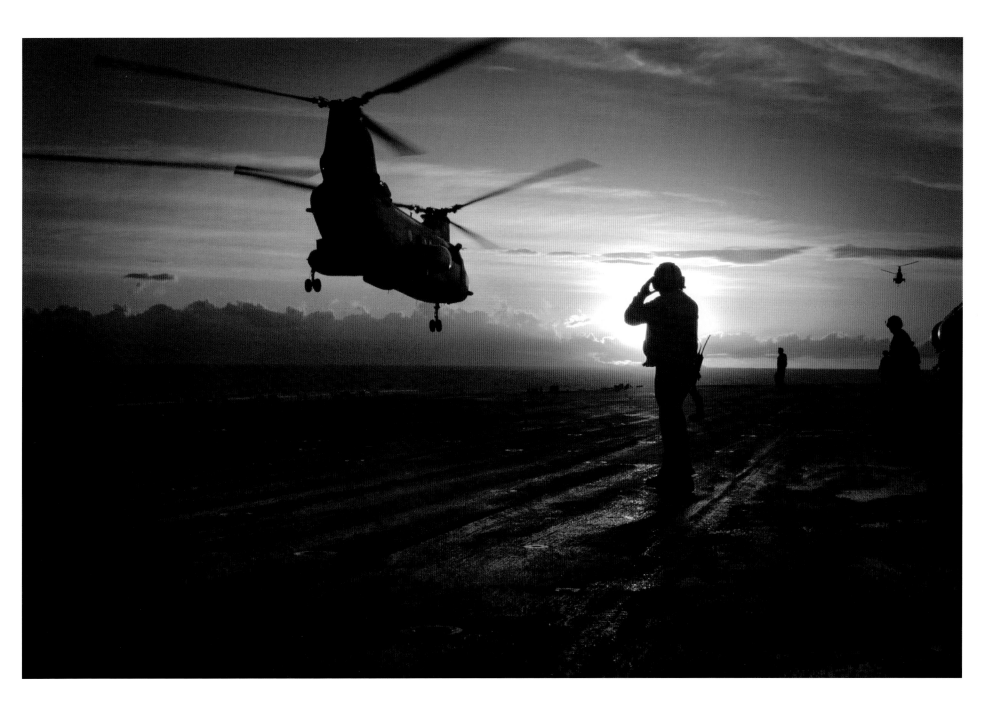

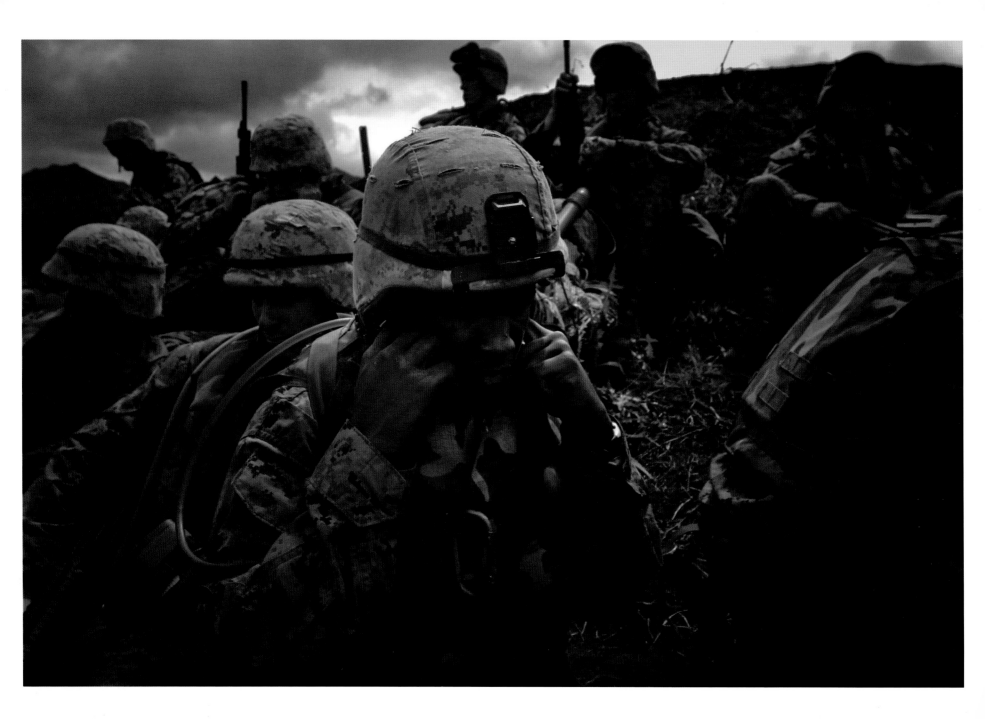

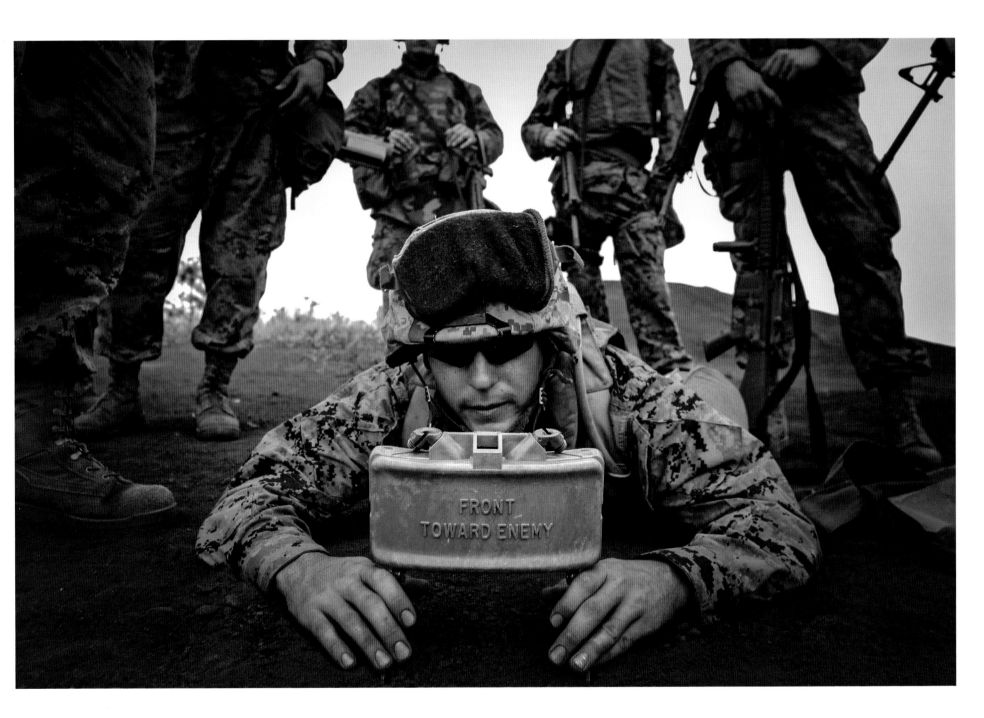

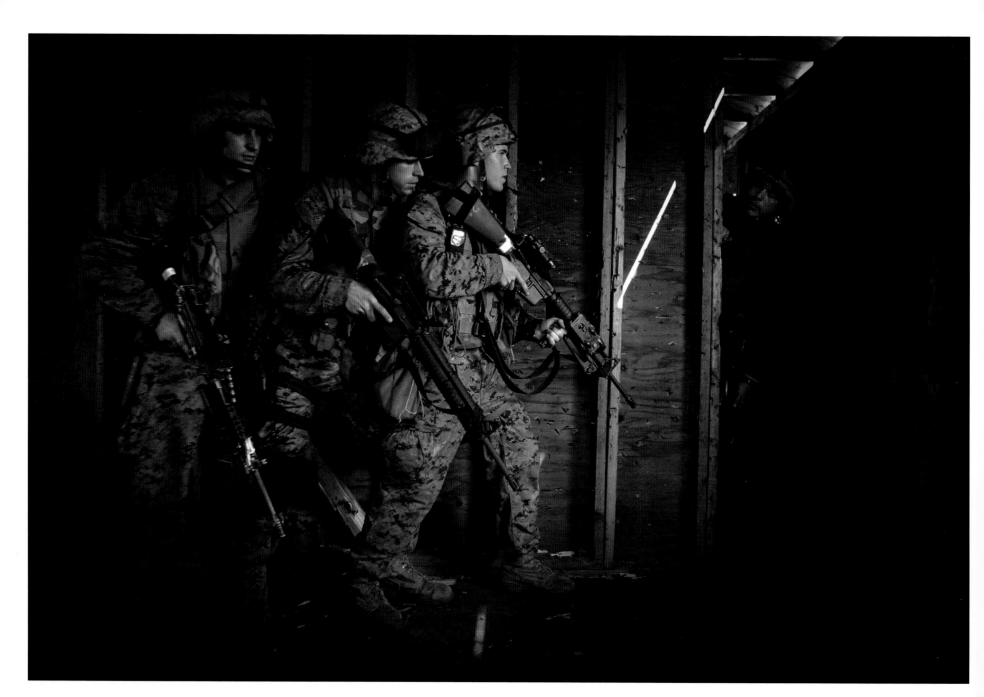

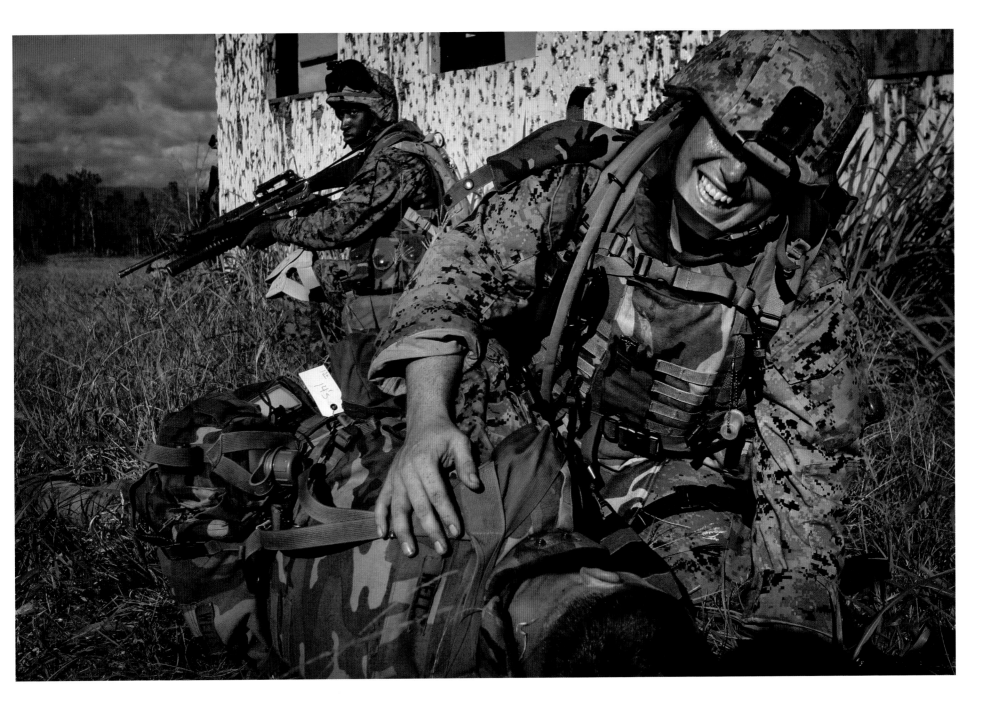

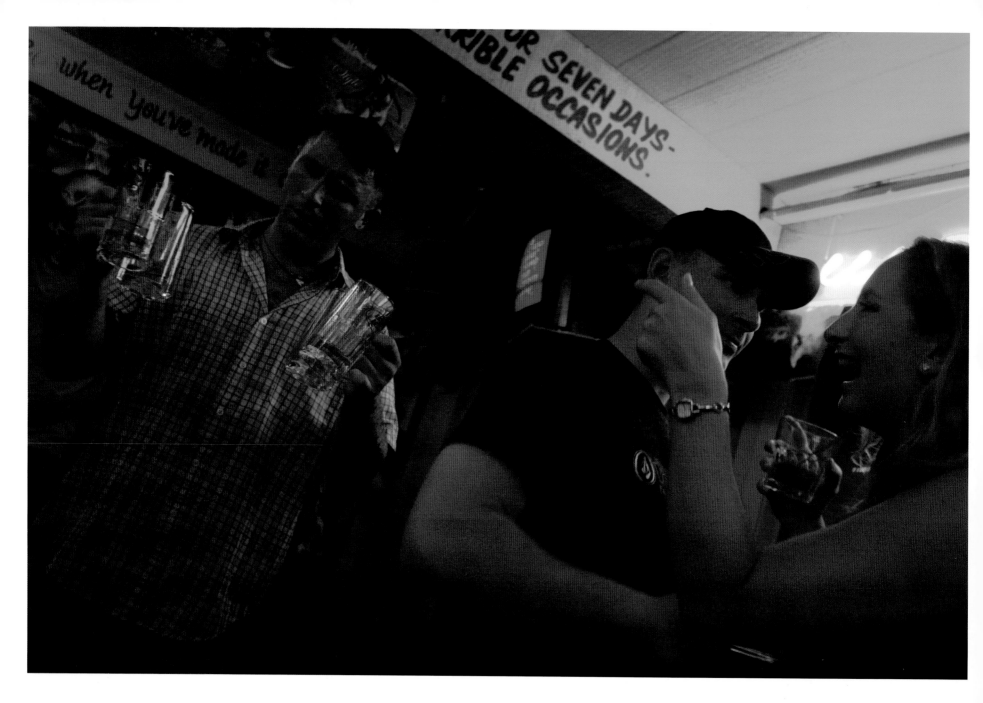

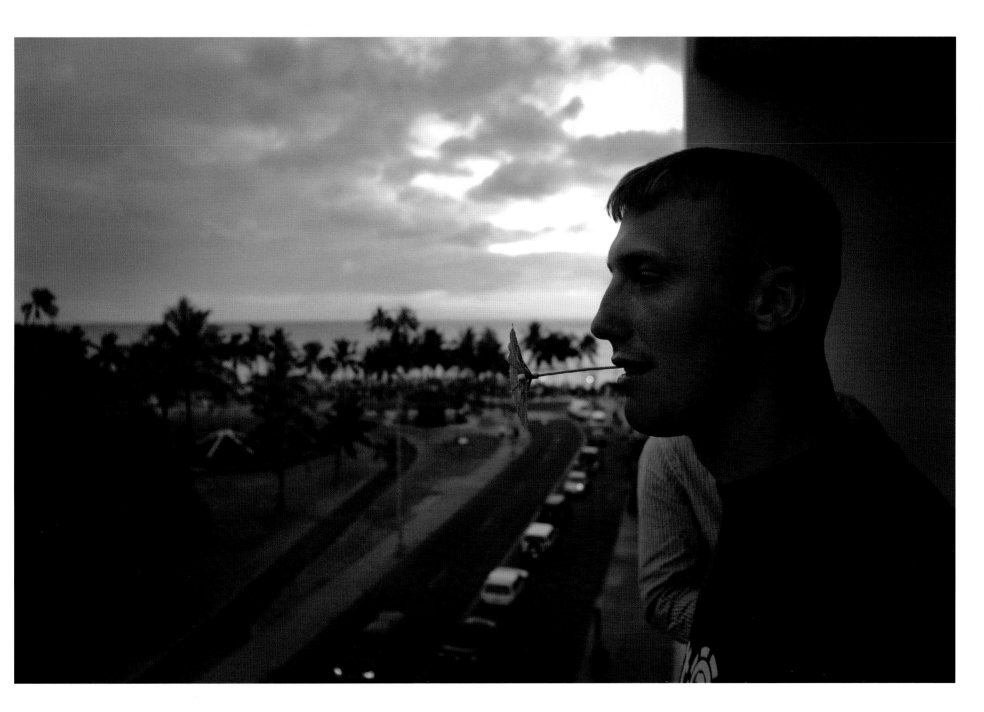

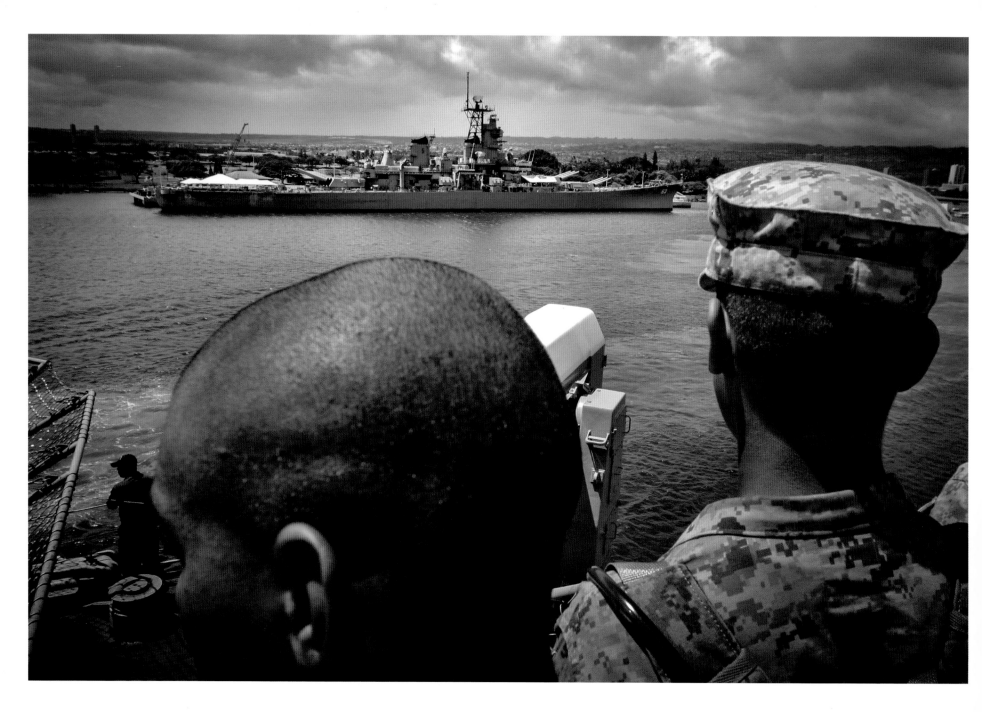

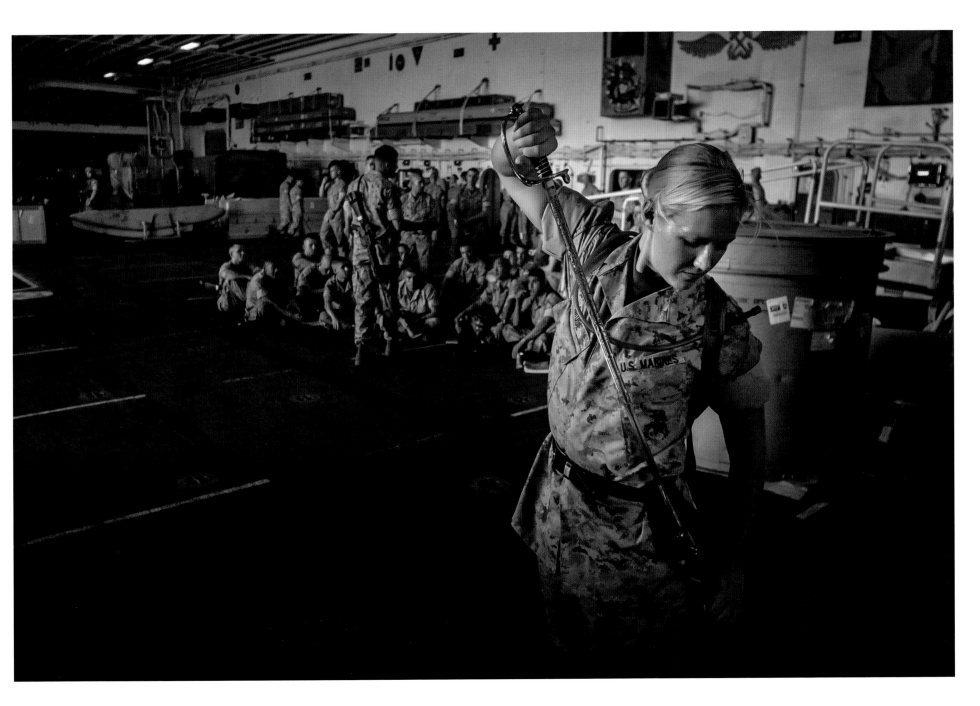

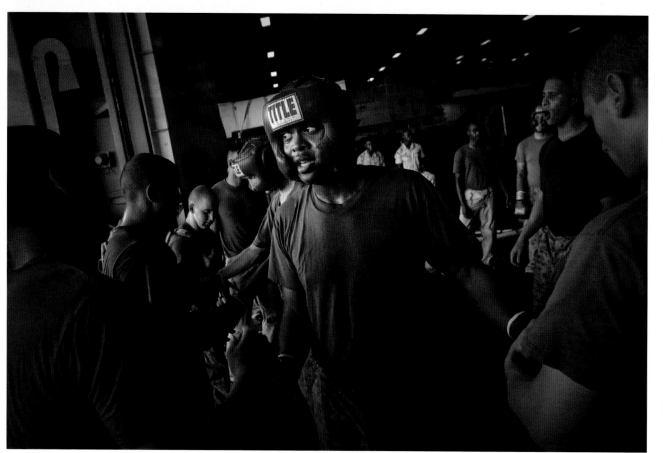

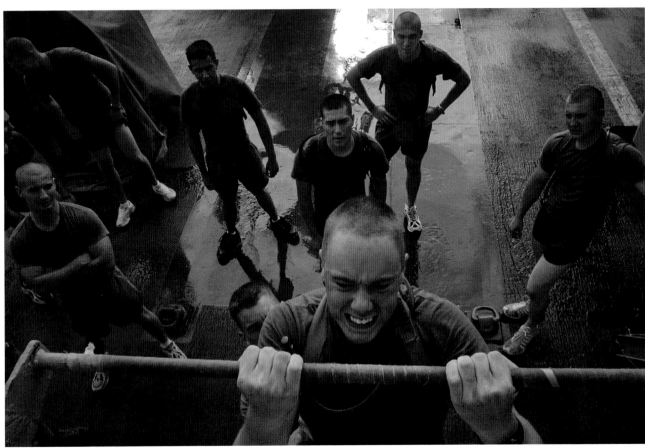

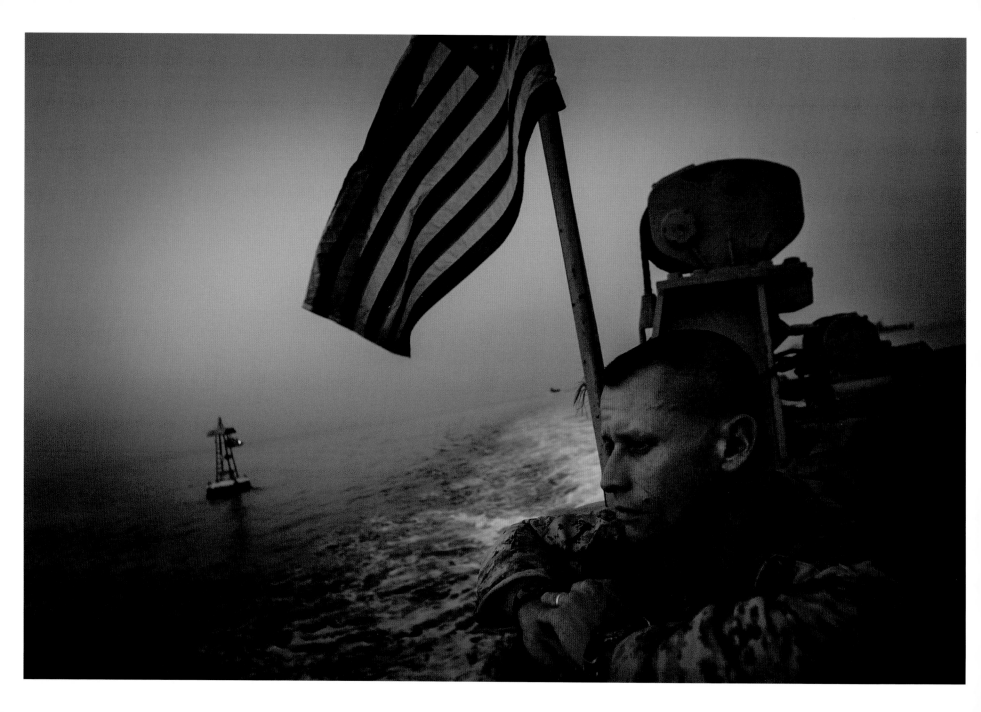

Another rollicking day aboard the *Comstock*—18-to-20-foot swells have been coming across the ship's beam for the last eighteen hours or so, rolling the ship. We dodged 150 miles out of the way to try to outrun them, but it looks as though we couldn't run far or fast enough. I need to get off this ship.

USS Comstock, *near the Strait of Hormuz*
July 2, 2004

The night is ominous as we pass swollen tankers making their way south toward Hormuz and the west. Gas fires burn on the horizon, lighting skies that for weeks have been empty of anything but starlight and the Moon. We arrive tomorrow.

USS Comstock, *off the Kuwaiti coast*
July 5, 2004

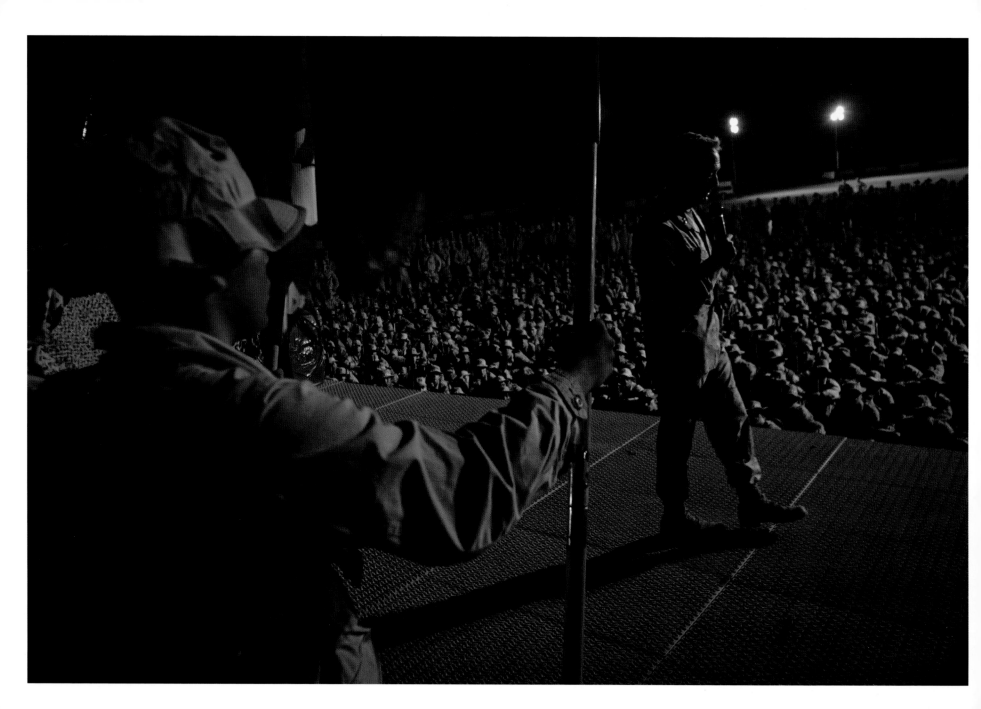

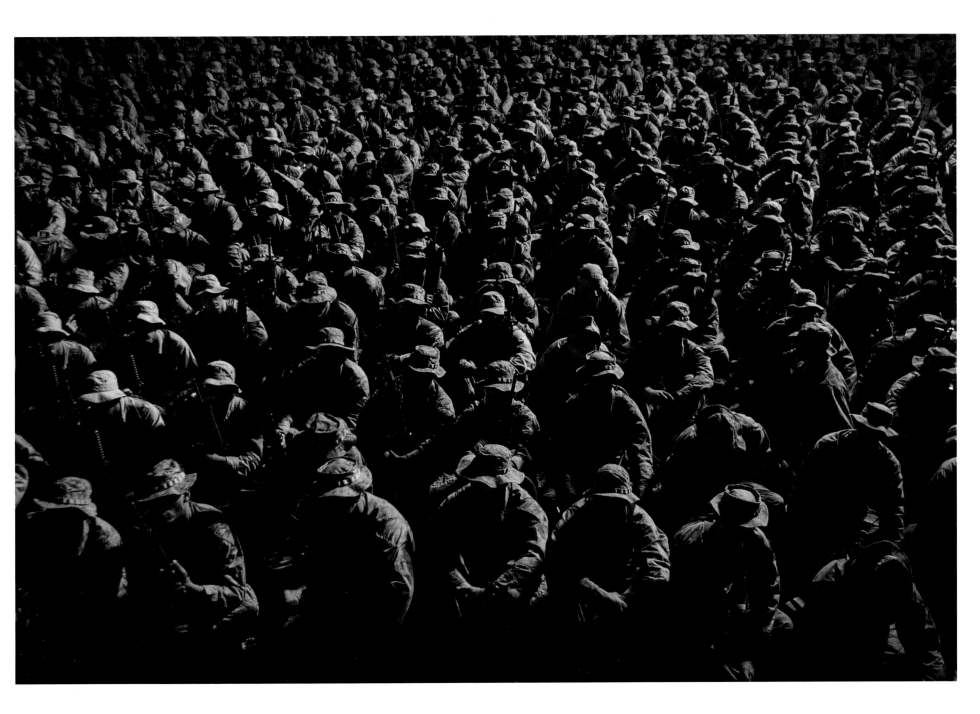

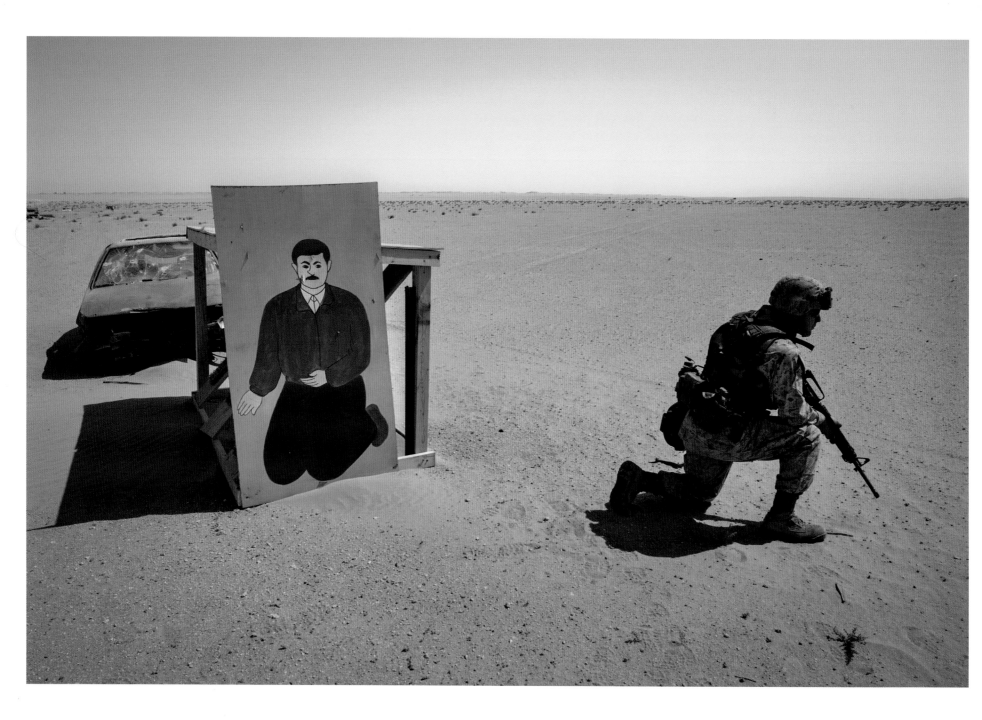

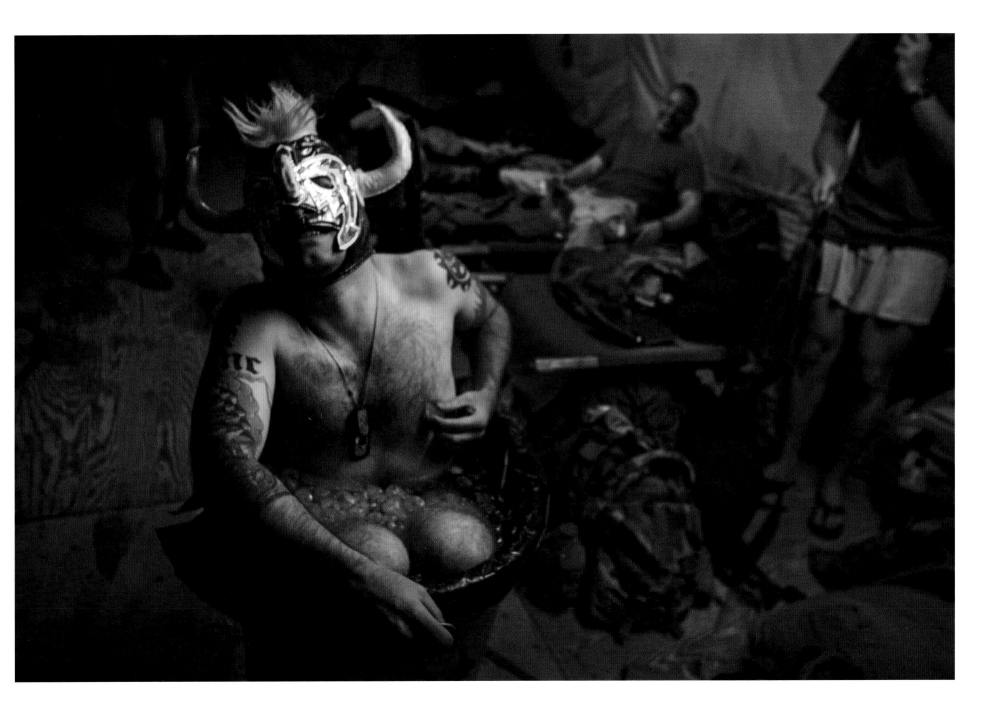

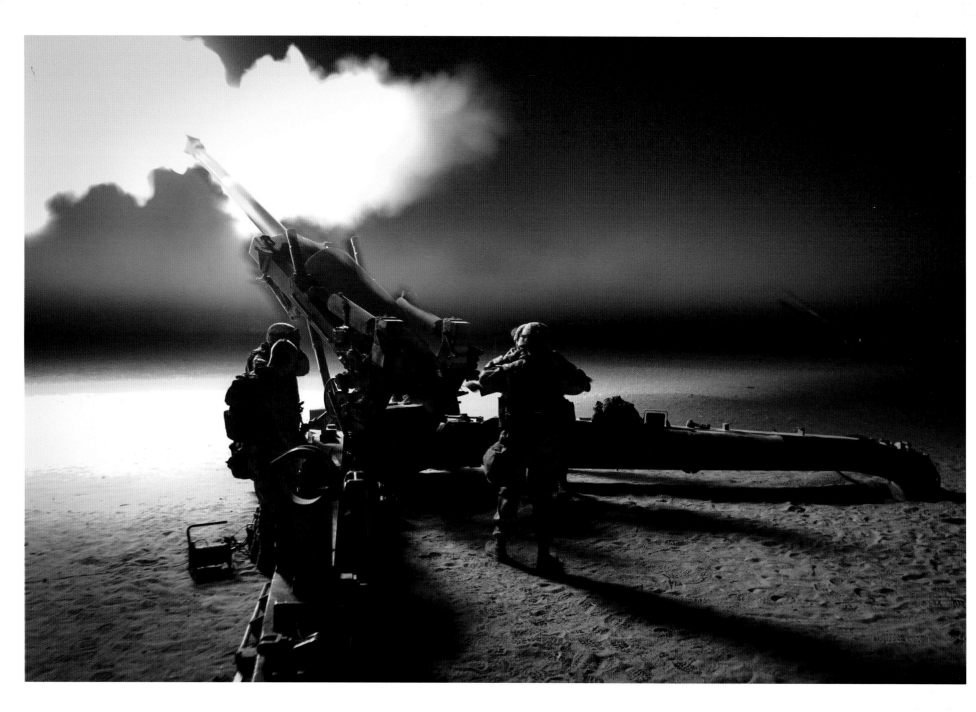

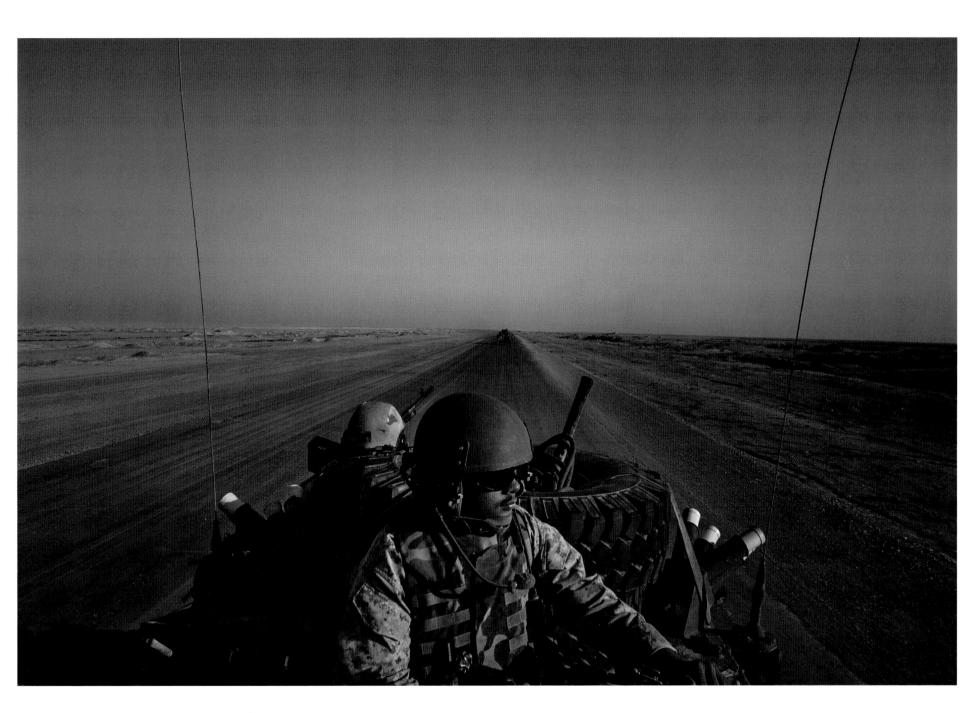

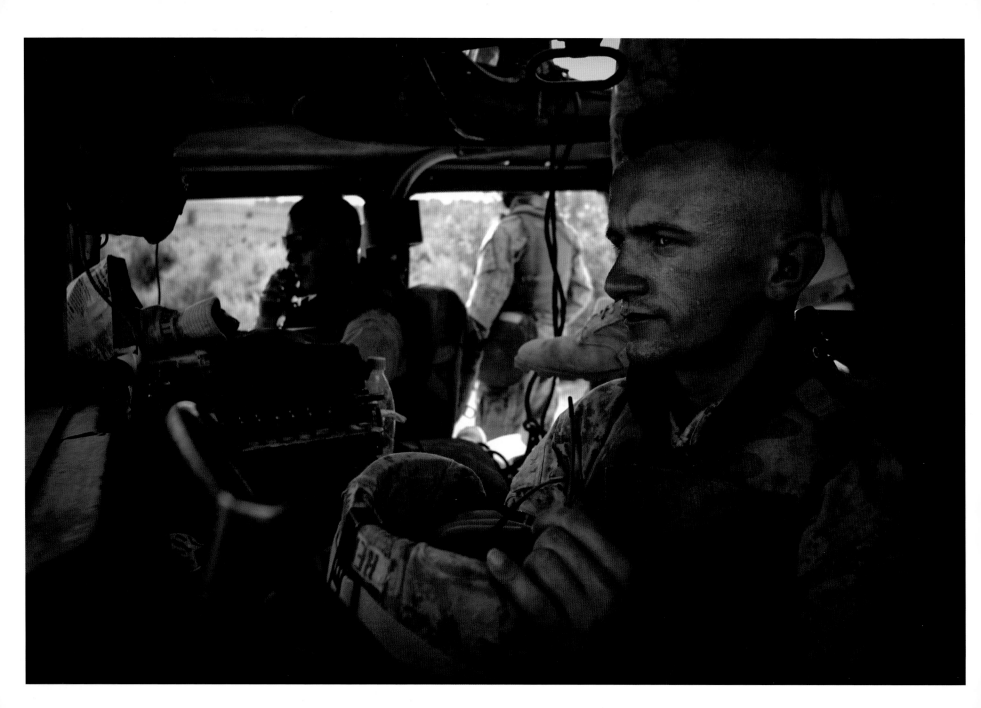

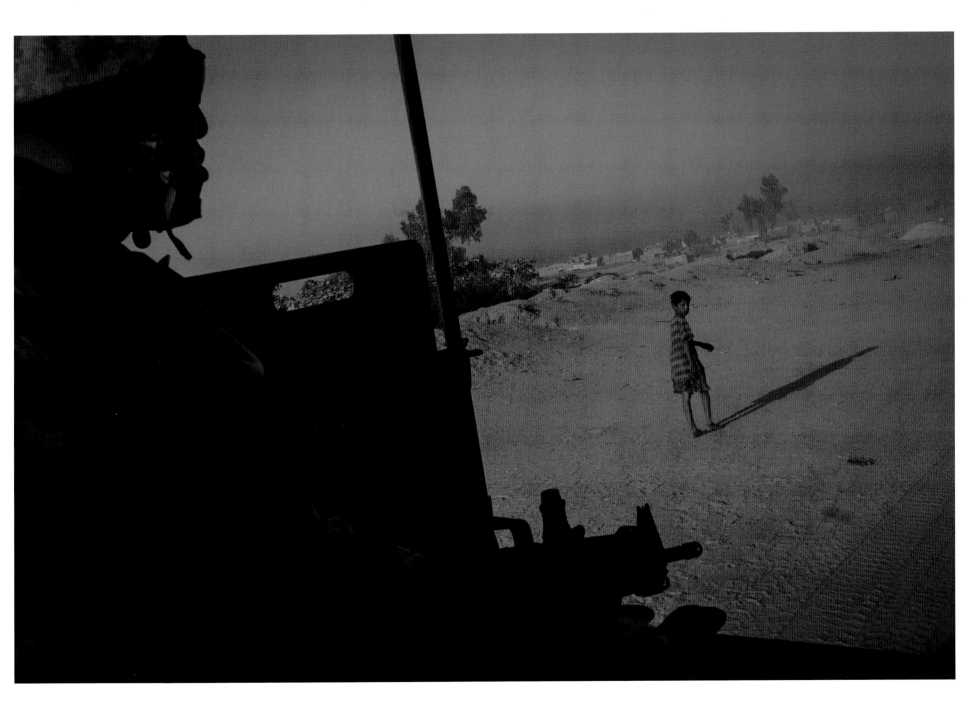

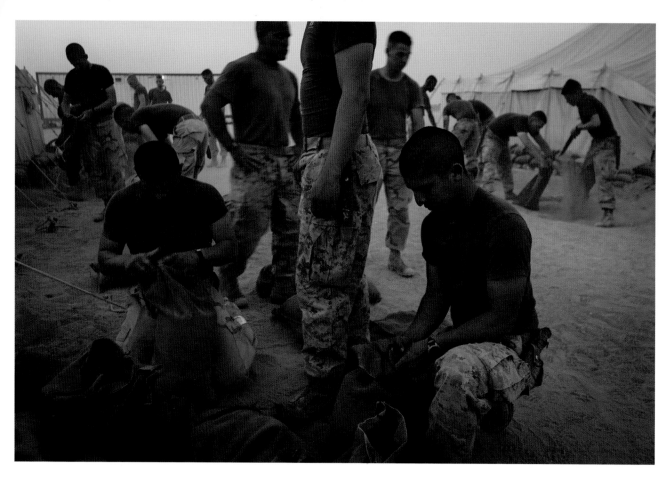

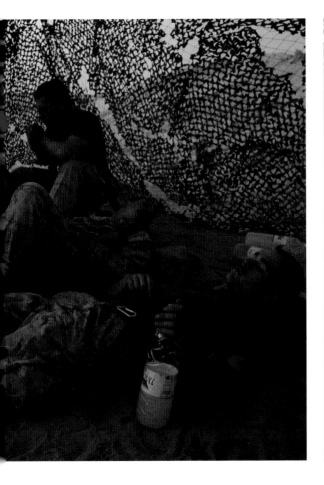
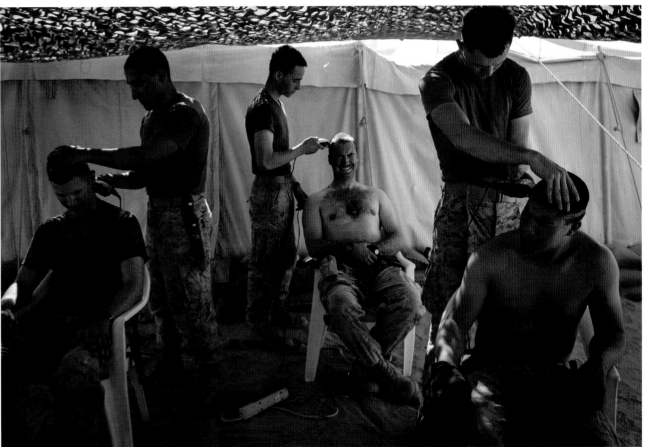

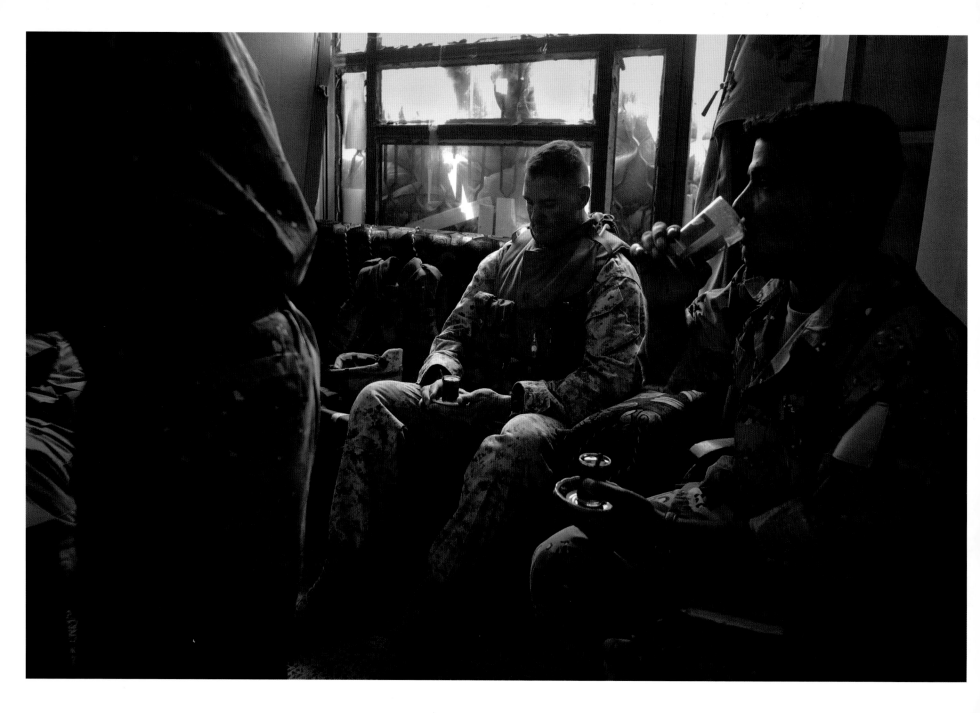

Costa and Moulton are arguing over whether turning down the thermostat on the air conditioner will actually make it any cooler in our tent. I try not to get involved in the arguments, or pass messages, or give orders for that matter, but it gets a little harder each day. I've nearly given up using "you" for "we." They're having a Charlie Co. meeting now— Ssgts. Cisneros, Boydstun, Budd, and Cordsen; Lt. Swihart; Cpl. Brady; Sgt. Bell; Gunnies Askew and Fitzgerald; Capt. Gibbons; Lts. Schickling and Costa; Capt. Morrissey; Lts. Moulton and Sellars; and First Sarn't Lehew. Morrisey is passing the word to expect some sort of upcoming offensive against the militia gang downtown this fall. Whether it's us or the Iraqis—"us" again—remains to be seen, but either way it looks like I'll be there. Everyone wants this—the Marines, the ING, the militia. Sometimes I have to shake my head when I think about these otherwise rational and pleasant people talking about planning to kill other people and when I find myself wishing them on.

We all have more or less decided that the best part about being here is the nights. The camp where most of the Marines live is 5 or 6 miles northwest of the city in the desert. Away from what little city light there is and with most days and nights cloudless, the stars in the night sky are almost bright enough to drive by. Some evenings, I carry a chair out away from the tents, smoke cigarettes, listen to music, look up at the Milky Way for shooting stars, and enjoy the warm breezes and cooled night air. Sometimes the loveliness of the evenings comes in strange ways, such as when two evenings ago we drove away from the city in a high-back truck, leaving behind what looked like on the horizon a mortar bombardment downtown. The cool blue moon and starlight amplified the handsomeness and silence of the young Marines. All day they had been laughing and bullshitting, but now sat quietly, waiting for the word to turn back toward town, which they knew probably wouldn't come, and which made everyone rethink a little for the first time their anxiousness for a fight.

Forward Operating Base Duke, Najaf
July 30, 2004

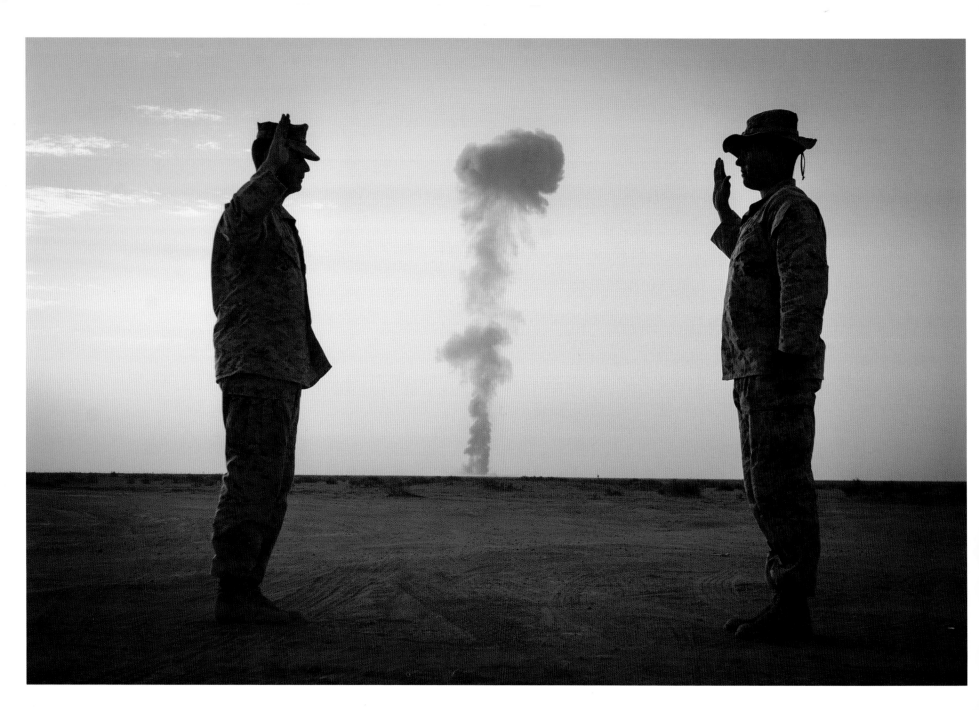

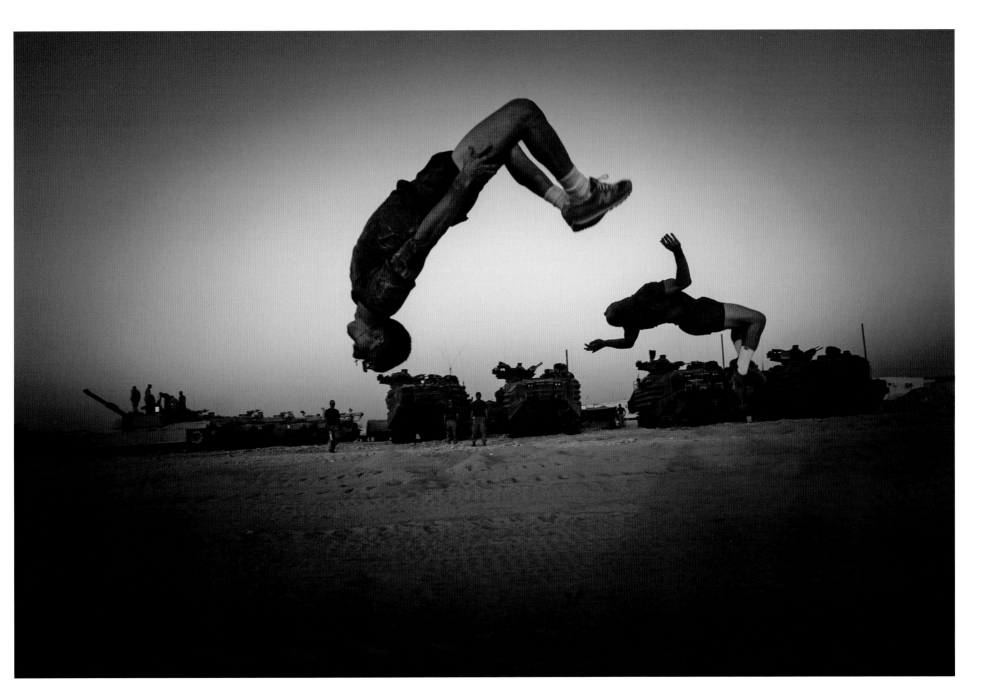

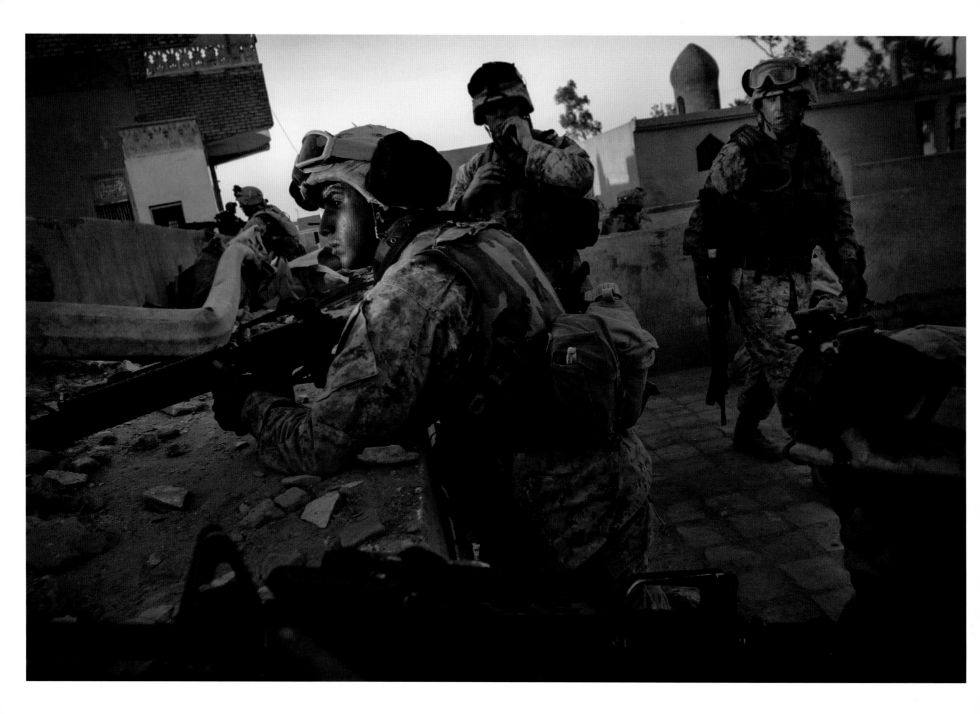

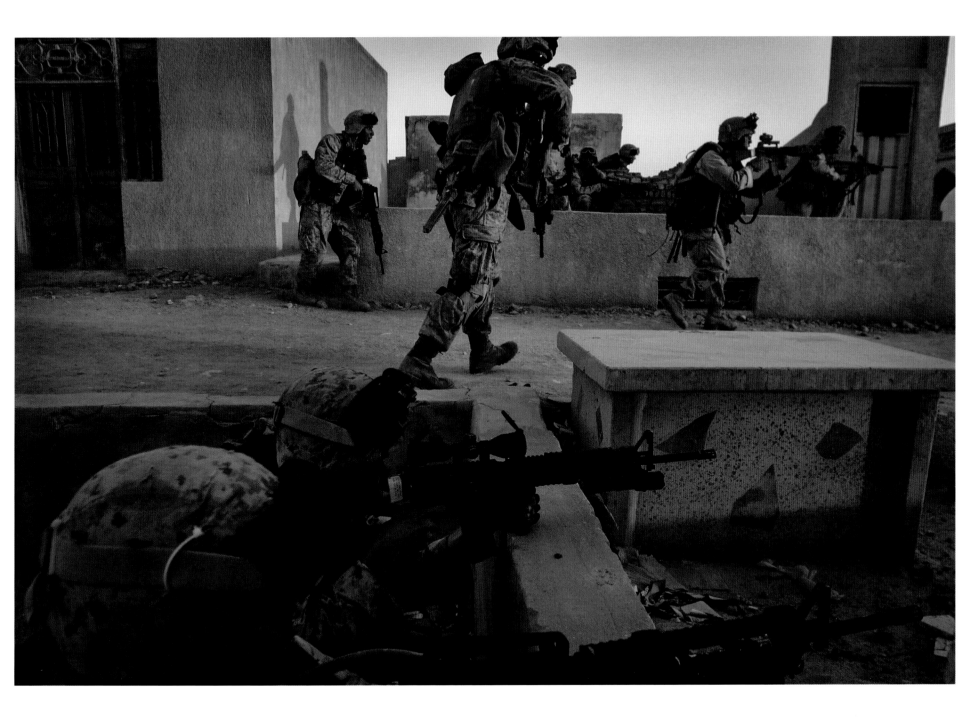

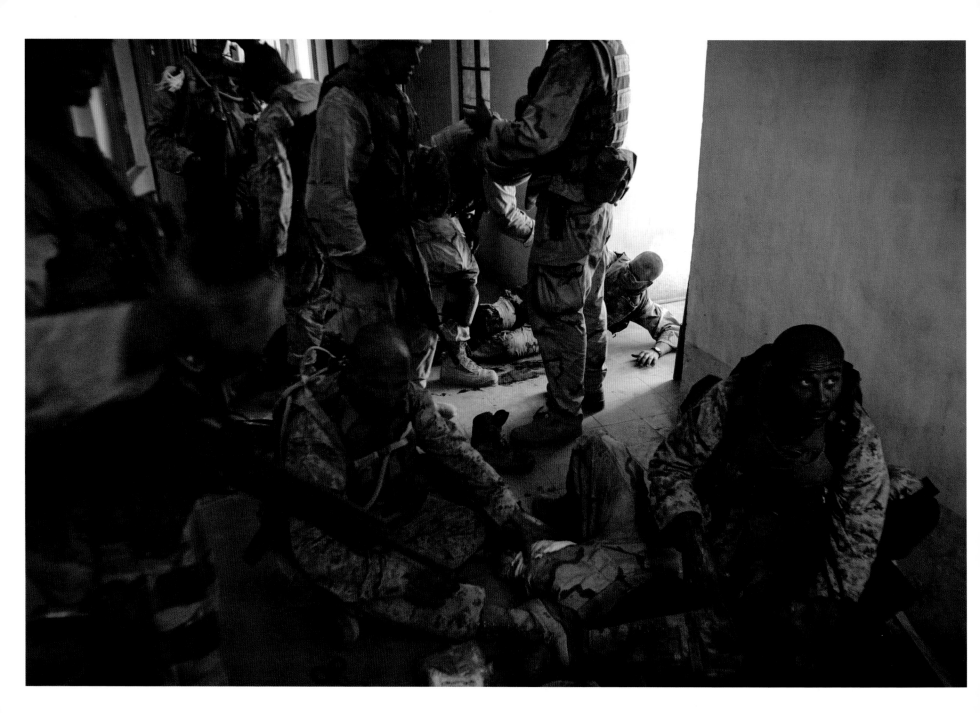

THE CEMETERY

They told us it was supposed to happen in October, maybe November, but it's the beginning of August and that's definitely gun fire, the Iraqi police walking alongside us definitely look scared, and Staff Sgt. Cisneros is yelling at Sgt. Ledesma like he means it and Phil Ledesma's yelling at the team leaders in his squad like he means it. Everyone is tense and nervous, and yeah, the bad guys are down there somewhere, probably in that big fucking cemetery, the one they're not supposed to be in, the one I pointed out during the war gaming on the ships we would probably not ever want to get in a fight in, and that's the direction we're going—toward the place where the bullets chirping over our heads are coming from.

At first it's easy. There's a 6-foot wall around the cemetery. The wall has holes and breaks in it. You get behind the wall so they can't shoot you, but you can shoot them, and go at it. McDonald with his LAVs and Borneo and CAAT tuck in near the wall—25 mm cannons, grenade launchers, and .50 cals banging away. The Mk. 19s erupt in the call-and-response of grenades being fired behind you and exploding thump-thump-thump in front of you. The .50s rattle your teeth and drive the thoughts out of your mind as they fire over our heads.

A RPG sizzles overhead—a red streak of light—and explodes behind us against the steps of the traffic circle that separates the cemetery from the police station. A Marine crouching on the same steps maybe 15 feet from the impact is toppled over by the blast. Is he . . .? Shit. He gets up, whew, and looks himself over. Surprised to find all the parts where they're supposed to be, he sprints away to find better cover. It's funny, because he's fine and the look of surprise and the high-tailing-it-the-fuck-out-of-there are exactly what you would have expected him to do. All the guys around me who see it laugh in relief and go back to blasting at the unseen enemy in the cemetery.

Mortars fall on the police station 300 meters away, erupting in gray geysers of dust and debris that crumple the air, but they never fall on the guys along the wall, so we all go about our tasks in relative safety. Tracks rumble by and then a tank. Then another tank. If they've let Gator and Tiger out—the units' call signs—someone must figure this thing is serious. A helicopter swoops overhead, then another. A Cobra and a Huey. Their guns growl and snarl—rounds fired so fast in succession that the individual explosions that propel them toward their target blur—a guttural and angry sound. There's a sound like a jet landing on top of us, then a deep explosion and a cloud of smoke rises from somewhere across the cemetery. Air strike. Those make the evening news, don't they? Weeks of wondering and worrying whether I'd chosen the right unit to come to Iraq with evaporate.

Some of the guys are headed into one of the half-finished hotels across from the cemetery, so I follow them in looking for photographs. In one room, two snipers are lying on a floor behind a .50 cal sniper rifle. "There he is. Do you see what looks like a little house with the blue metal door that's sort of half open? I think he's in there." The guy out in the cemetery does something stupid: sticks a head, or arms, or leg out. He doesn't know it's stupid because he doesn't see the two guys with the five-foot-long rifle lying in the shadows in that window 500 yards away. Maybe he doesn't even hear the shot, because the round that kills him travels faster than the sound that follows it. The tiny room we occupy explodes when the shot is fired. The pressure knocks the air from my lungs. I wonder for a split second what hit us. Dust in the unfinished room fills the room and it's hard to make out the snipers six feet away. Time to go. If someone shoots back we won't be here.

On a different floor in an interior hallway, I offer the two snipers a cigarette. Sitting, our backs away from open doorways, they gladly accept my offer. One of the guys is sort of giddy. "It's the first time I've ever shot someone," he says. He seems pleased, but then what he's just said sinks in and a look of weariness comes over his face. He closes his eyes and his head lolls back against the wall for a few seconds before this killing thought is replaced by satisfaction again, only to be replaced again itself and then back again. Emotions flickering.

Charlie. I've got to get back to Charlie. Hey Recon, have you guys seen Charlie? I think they left. Shit. I head down toward the tanks and tuck in beside one of them to figure out what to do next. Something about having a tank between you and the bad guys lets you relax and think about the future. Before I can really enjoy this feeling of wellness, though, the Abrams turbine engine whirs to life and it starts to rumble back up the street toward the cemetery. I learn to hate it when they do that. There you are all nice and safe and comfortable one moment, and the next you're standing exposed in the middle of the street. Oh well. I jog along beside it, lacking any other plan, and as it passes the entrance to the station, I see Butson and his beautiful smashed boxer's nose crouching in the guard box by the street. Charlie. What's the plan? We're loading up and heading into the cemetery.

We've been melting in the heat all day. We're heading into a warren of graves, crypts, and meandering pathways at least a mile and a half wide and three miles long where the militia has been operating for months, storing weapons and preparing positions, and doing whatever-the-fuck else it is they do. With a million places to hide we could walk right past these guys and never know they're there. Once we're far enough inside, we'll be stretched too thin to cover our flanks and unable to see each other as we move forward. It will be dark in an hour and a half. Guess the fun part is over.

With a half hour of the thinnest light to go, we pick up and push forward. The guys are supposed to clear every crypt, grave, and hole, but it's a ridiculous idea. It'd take an hour to go a hundred feet, there are so many of them. They try at first—pistols and shotguns at the ready—but it doesn't last. We just move forward. Without contact, we reach the paved road that cuts diagonally northeast to southwest across this part of the cemetery. The Diagonal Road. The road is maybe 15, 20 feet across, with retaining walls on both sides. Hold up here for the night, and if they try to come across, the Marines will be able to cut them down in the open. Good place to stop, I think. We cross the road.

We start to take sporadic fire almost immediately. The Marines with me move forward from grave to grave, wall to wall, and building to building, trying to stay on line. AK fire and a RPG or two pass overhead, but from where? The Marines fire down through the crypts ahead—suppressing fire, trying to keep the bad guys' heads down. The return fire becomes more intense. A Cobra passes overhead. Tracers from every compass point rise up to meet it. The

sun is gone. The bad guys are everywhere. Welcome the night. The order comes—fall back to the road. It's about goddamn time. I stumble back out onto Diagonal Road hearing my agent's angry broken Irish voice in my head. You got to get tha fffff-ucking pictures back, mate. I don't realize then that the world won't care about what's happening here for another two days.

Black and Davis are hunkered down between their high back parked in the street and the retaining wall. Hey, are you guys headed back? Get over here and get down. We've been taking fire here. There's fear in Black's voice. He's not going anywhere but he's afraid. He gives some of that fear to me. It's full dark now. Unable to shoot anything more, I have become a spectator, not a participant. The charm hanging around my neck has lost its power until the morning, and at the base of my skull a small voice is telling me to go. Now. How? The worst way you could imagine.

The mortar men come out onto the street and they're screaming—not yelling, screaming—for us to bring the Humvee. Black jumps in the driver's seat and backs it up. Out of the darkness, when we pull up I can see that they are carrying someone by the legs and arms, a wilted black form. Davis and I frantically start shoving the gear in the bed out of the way to make room. I take one of the wrists with one hand, grab the material around the shoulder of his blouse with the other. Davis helps on the other side, cradling the sagging head, and we raise the Marine into the high back. He's gone. I feel no pulse in his wrist. He still feels alive, still warm and supple, but there's the terrifyingly irrevocable absence of the flicker of blood moving within. For a moment the world closes in on me, and all I am aware

of is that absence. Wrong. All wrong. Black starts to move the high back when more voices call out. It's Bravo. Up there. All the Marines are pouring out onto the roadway now. Disorganized in the darkness. We move through them to where Dave Lewis's Bravo platoon is huddled near the wall. They've taken wounded. Shit, it's Dave. His face is a mask of blood. One of their docs has been injured too, but he's up and walking around. We help them up onto the vehicle and slowly pull away. I can feel Dave going limp against me from blood loss and shock, and put my arm around him, pulling him close, to keep him from slipping off the back of the truck. As Black drives off I look back and see Charlie and the rest moving across the road and back into the cemetery. I hate myself for leaving them there. This is cheating. They'll face the night among the graves while I'll face it from the safeness of hot food, a shower, and—after I realize there's no getting back until first light—bourbon. All my fear is forgotten. Leaving, I only feel regret.

Forward Operating Base Hotel, Najaf
December 10, 2004

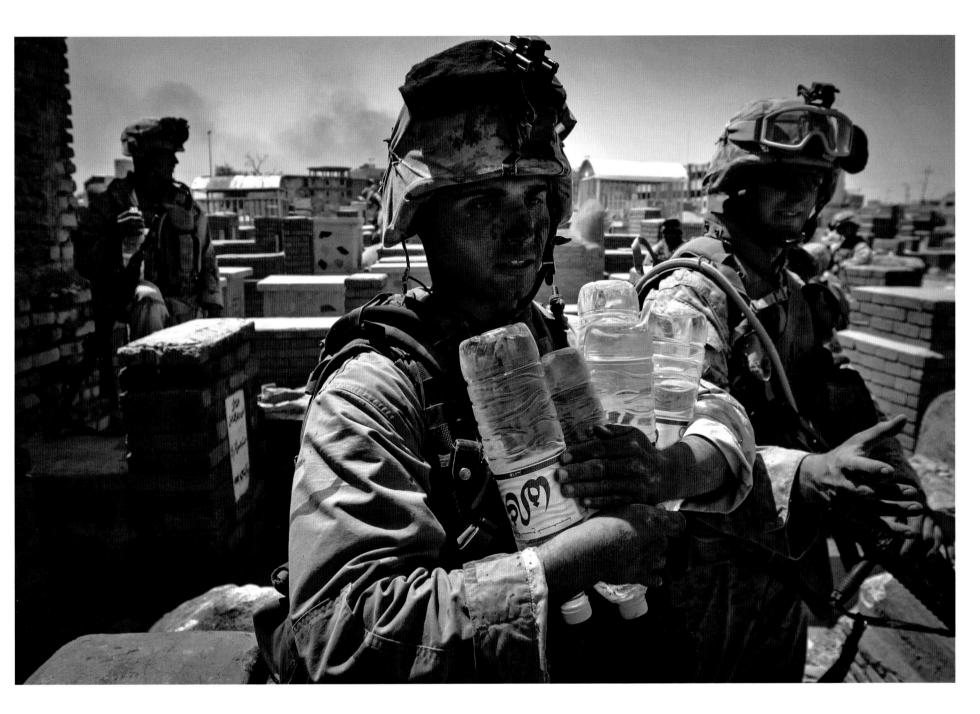

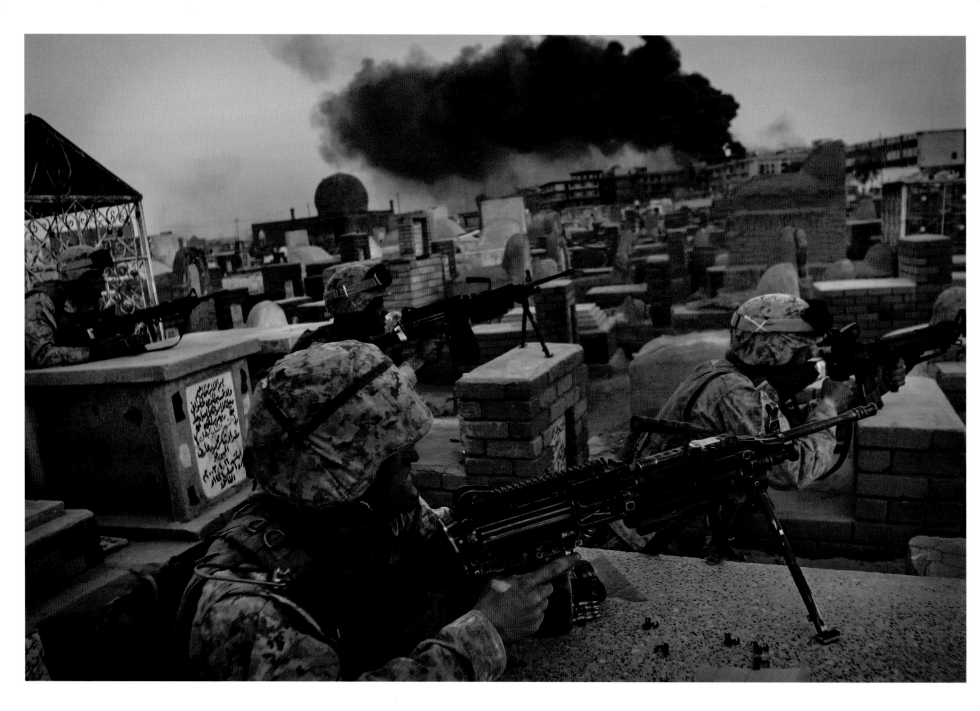

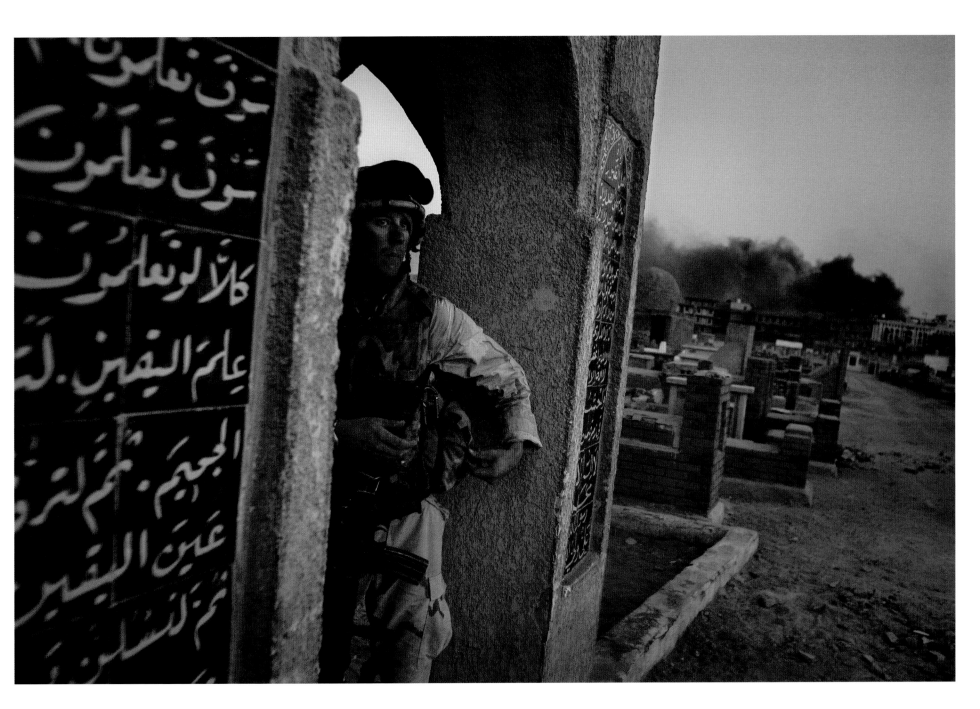

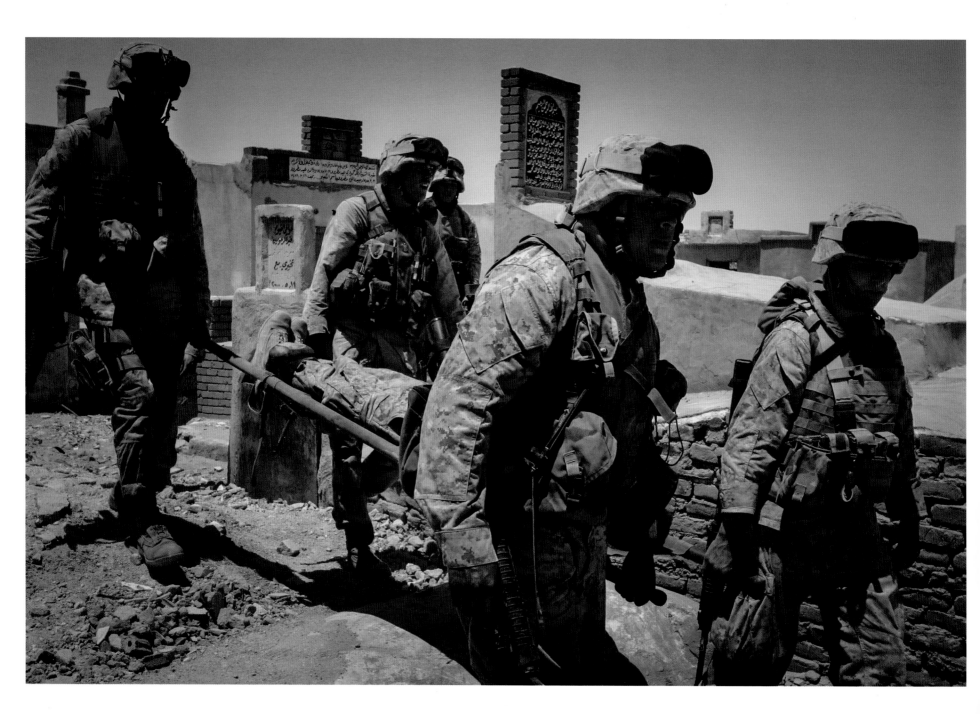

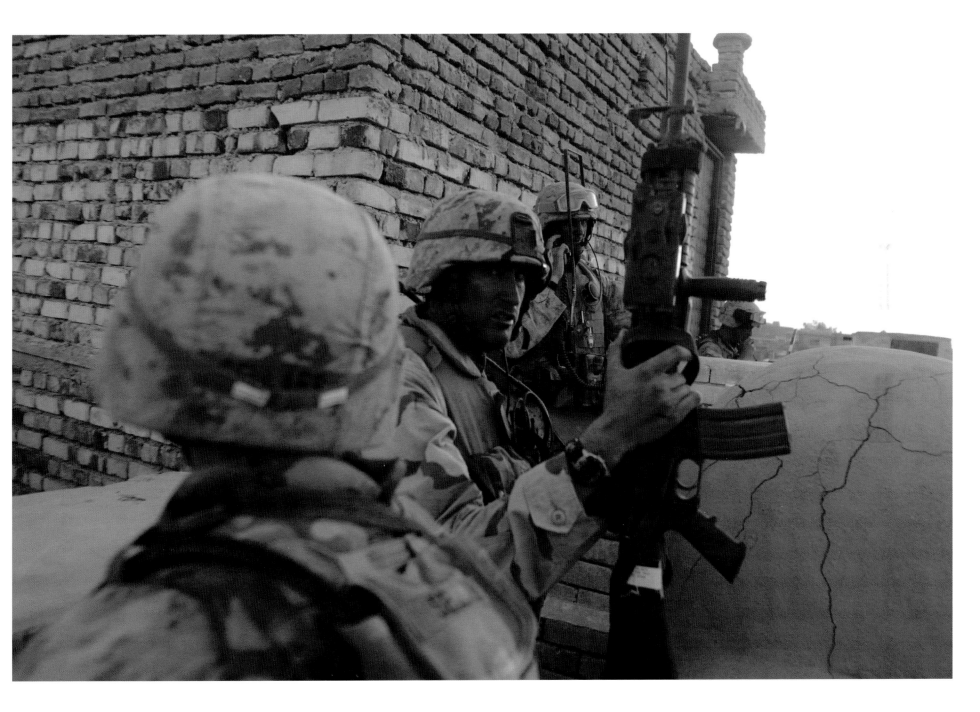

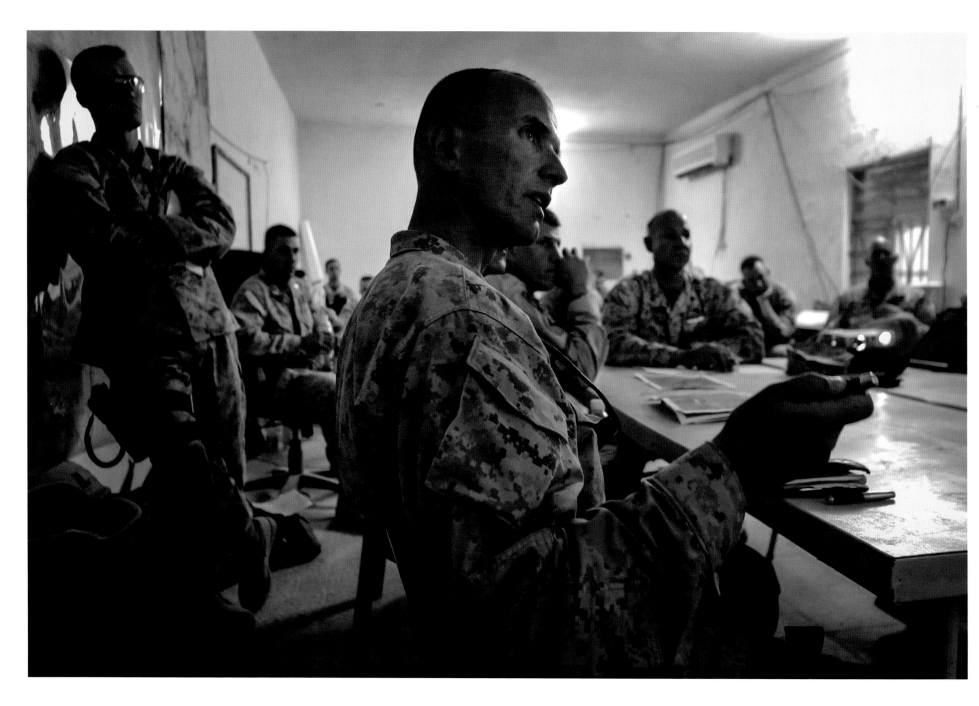

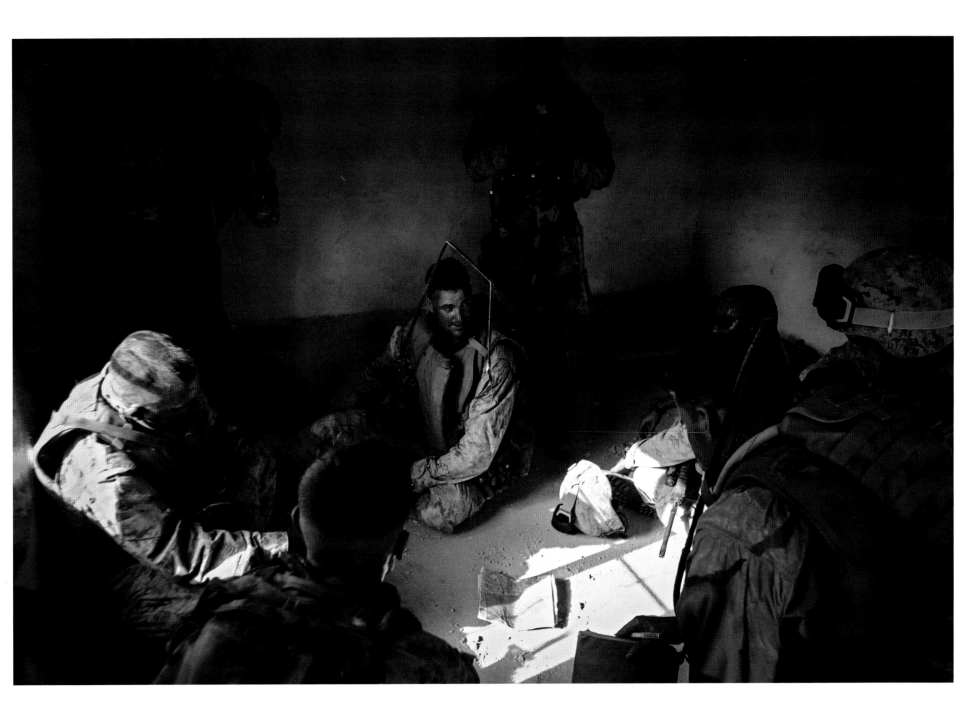

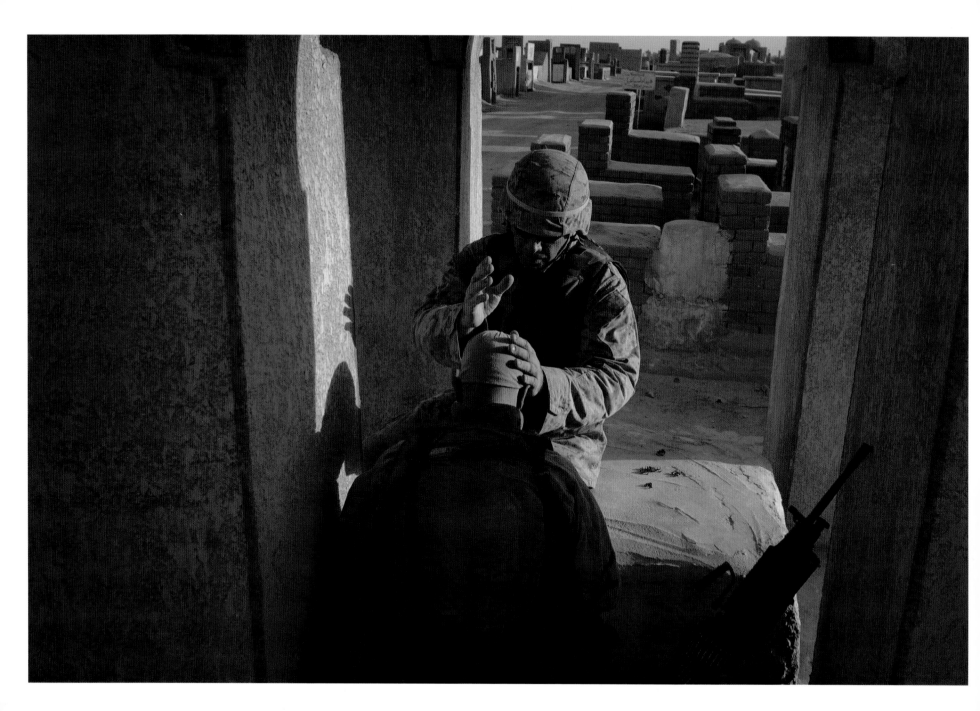

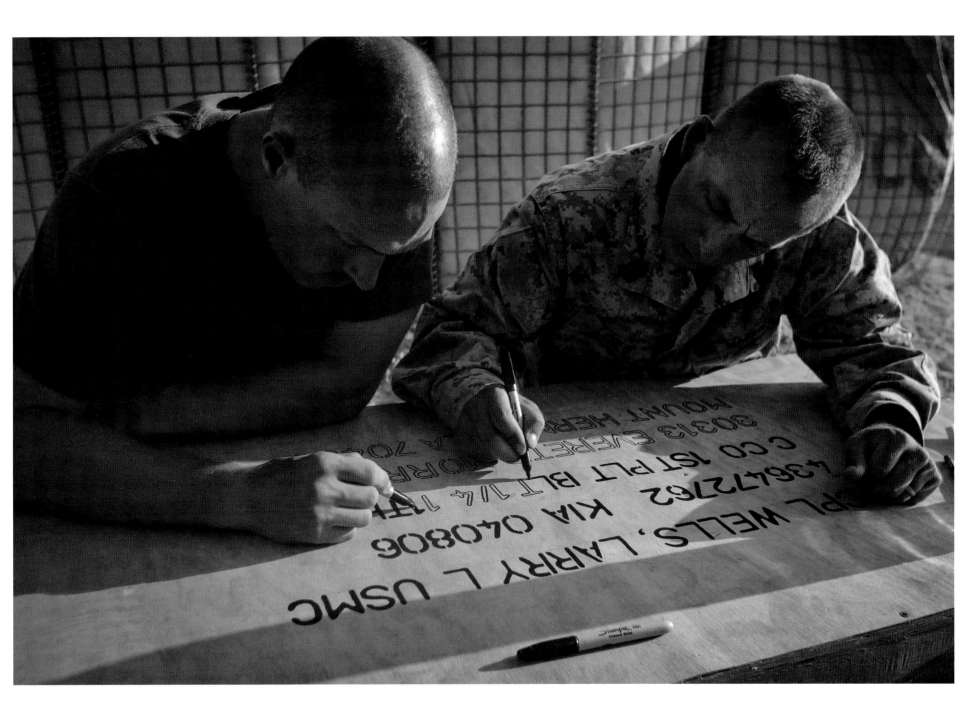

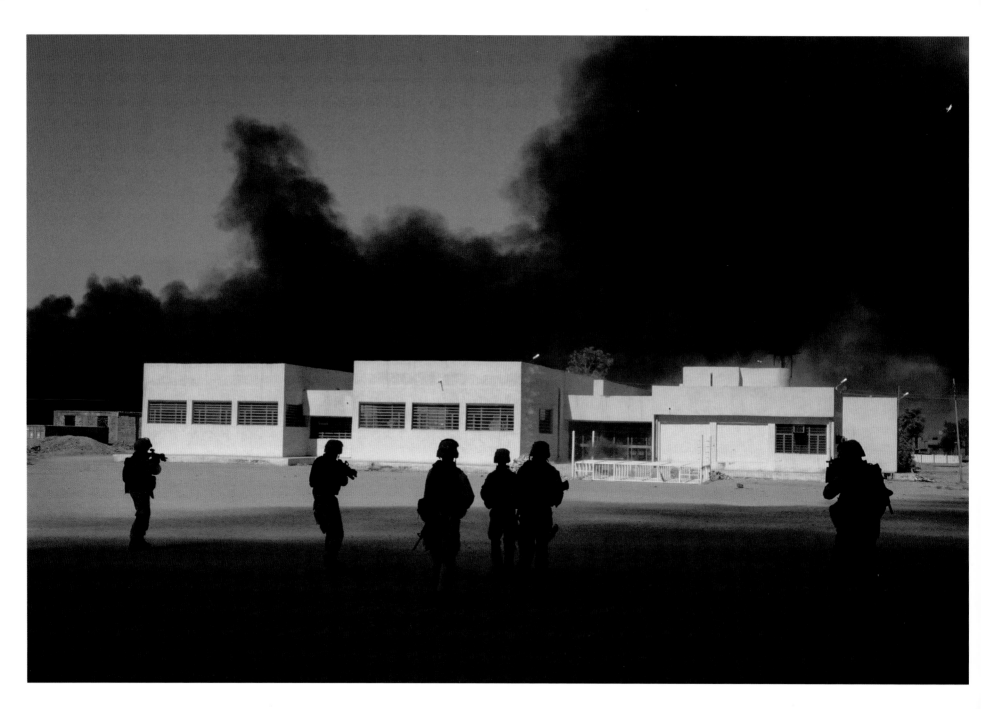

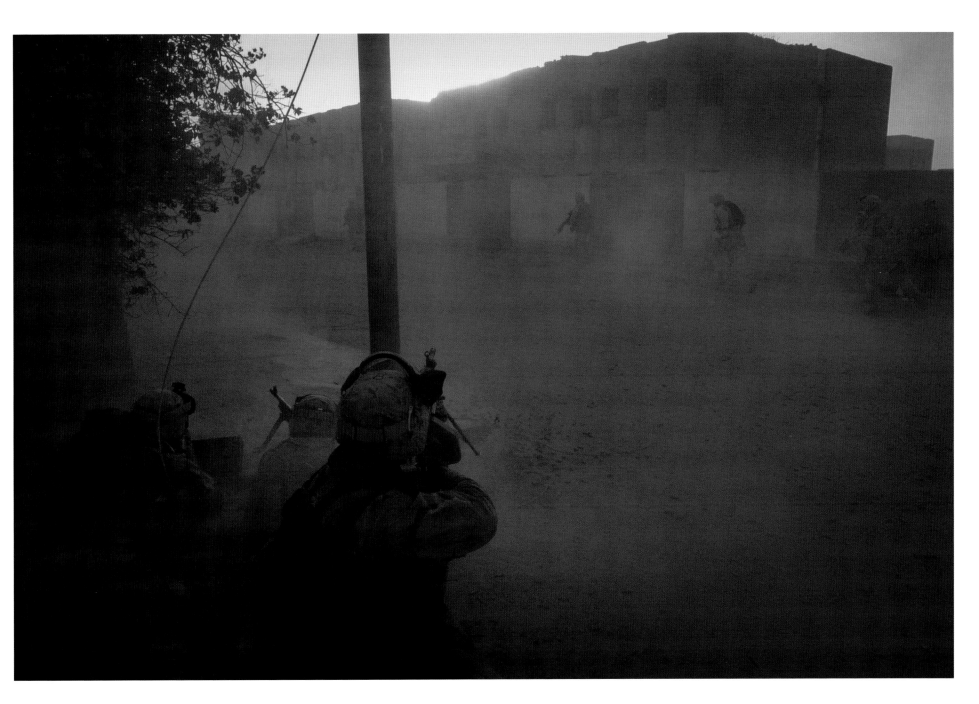

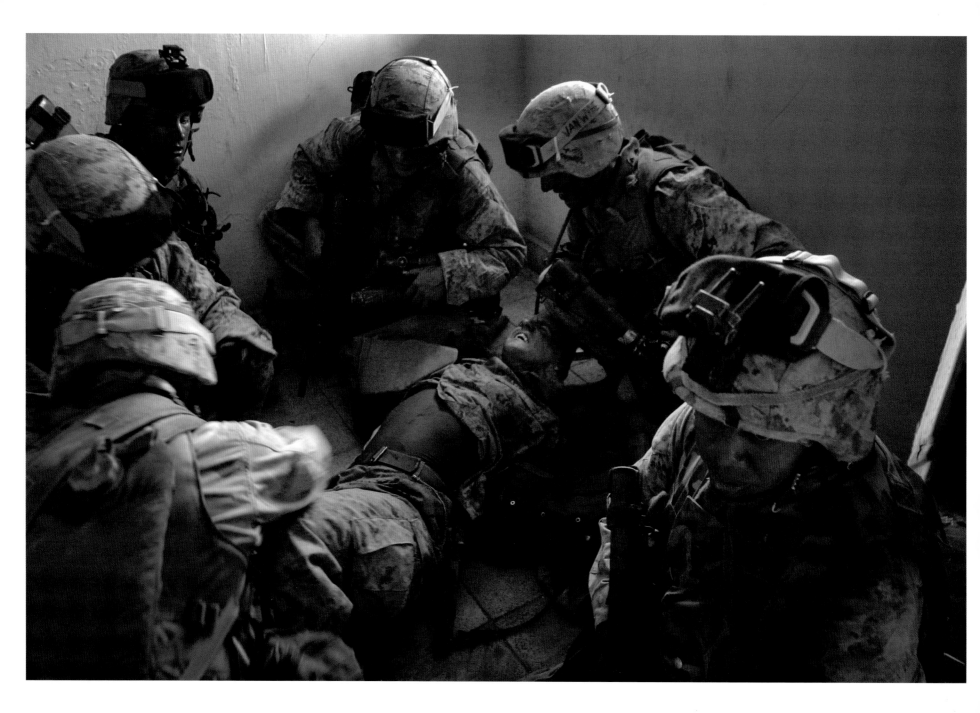

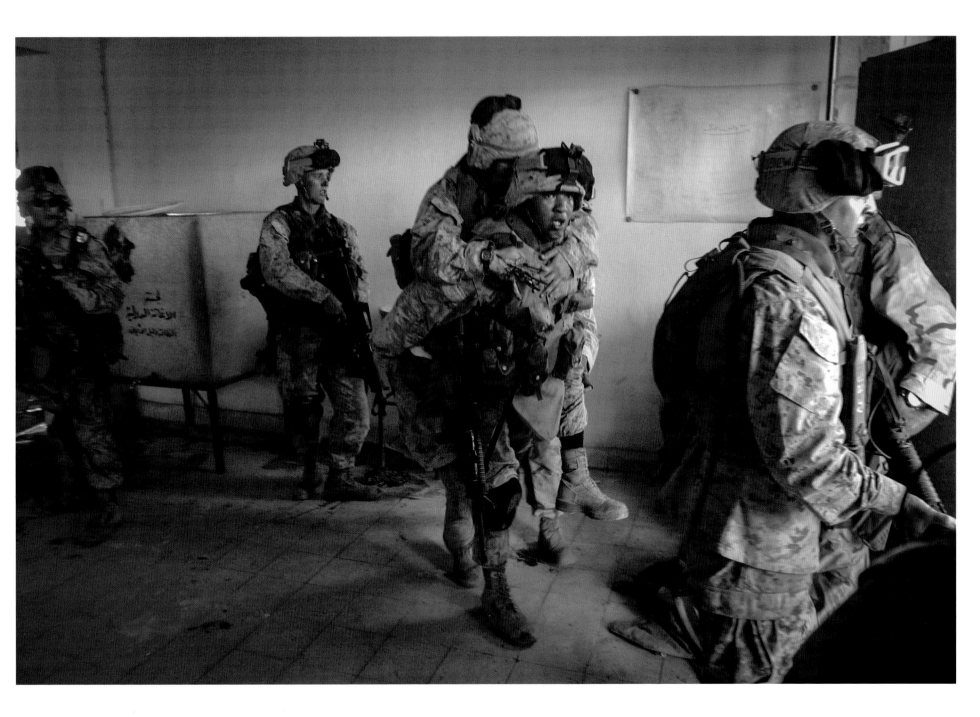

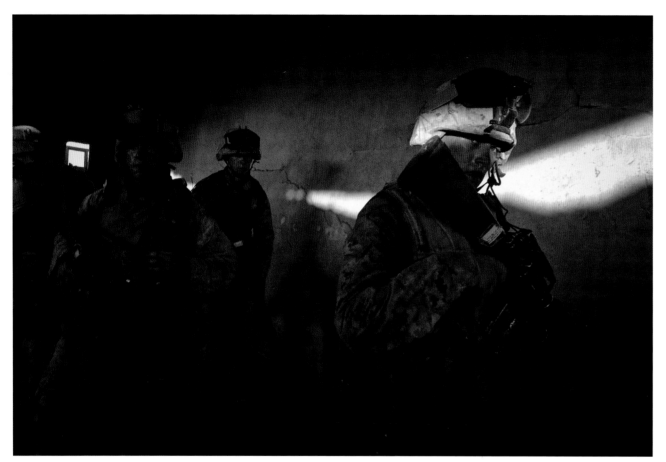
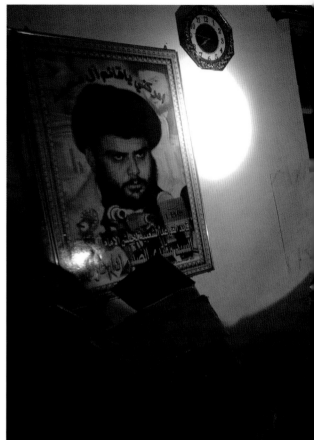

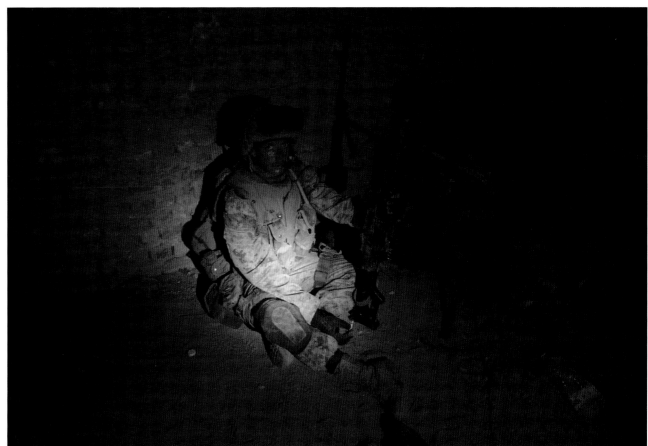

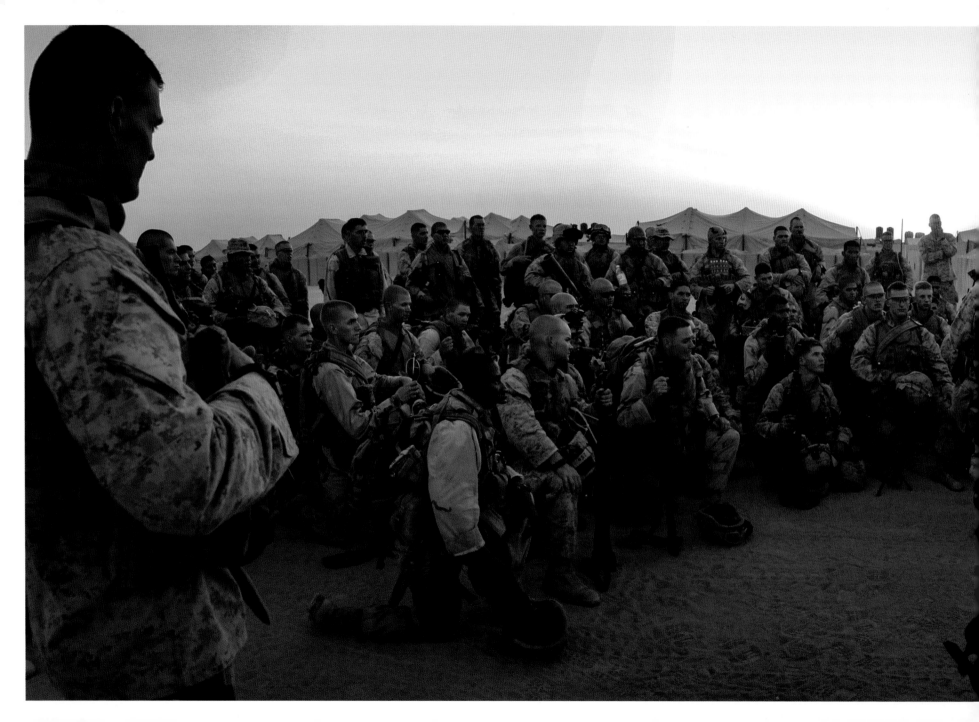

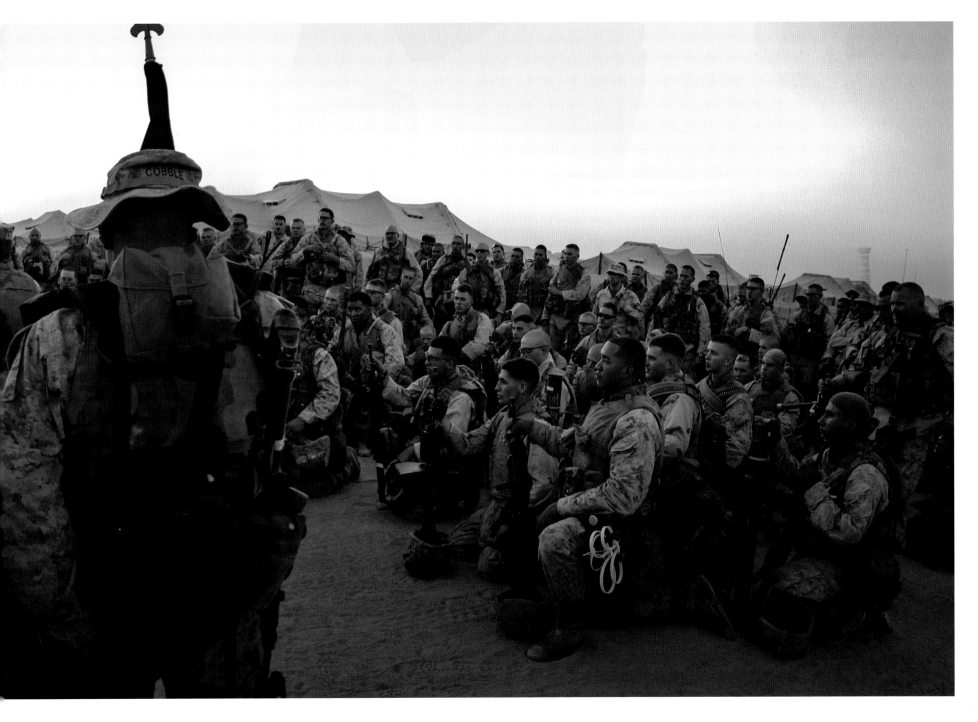

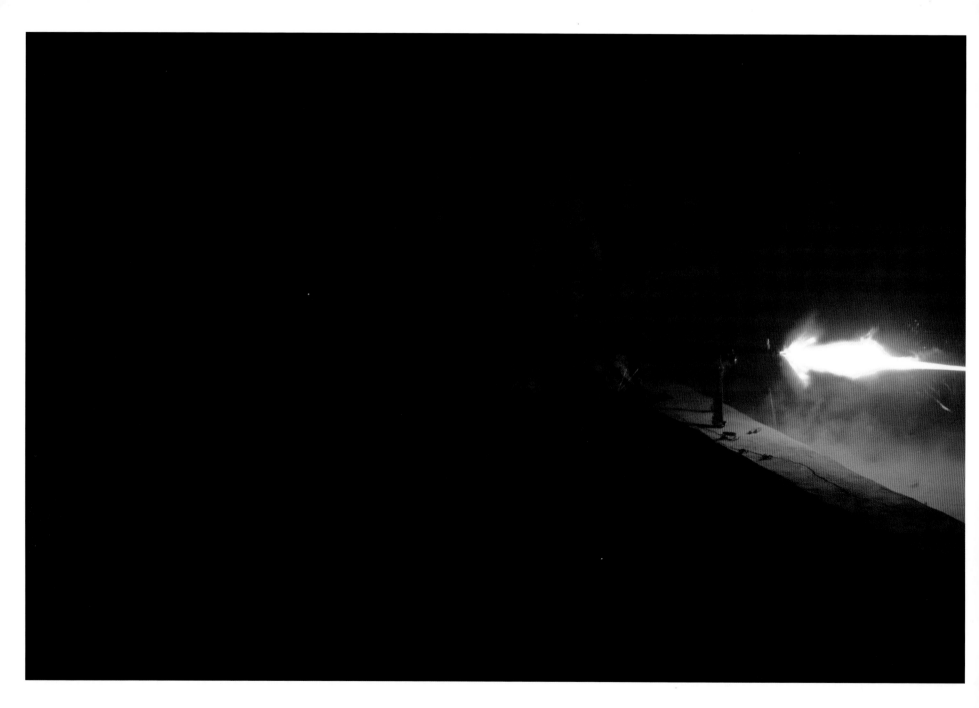

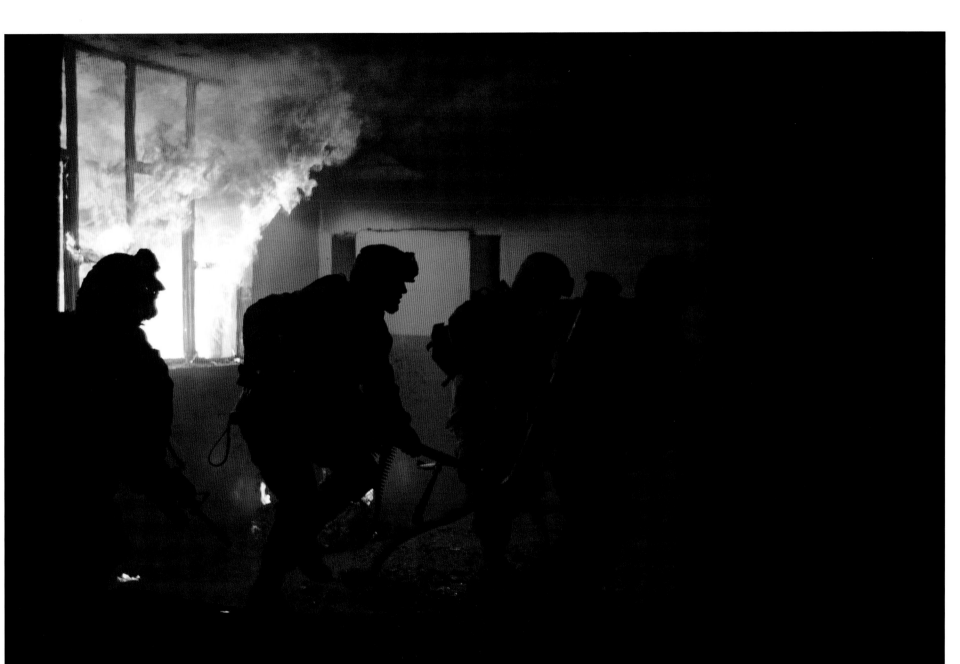

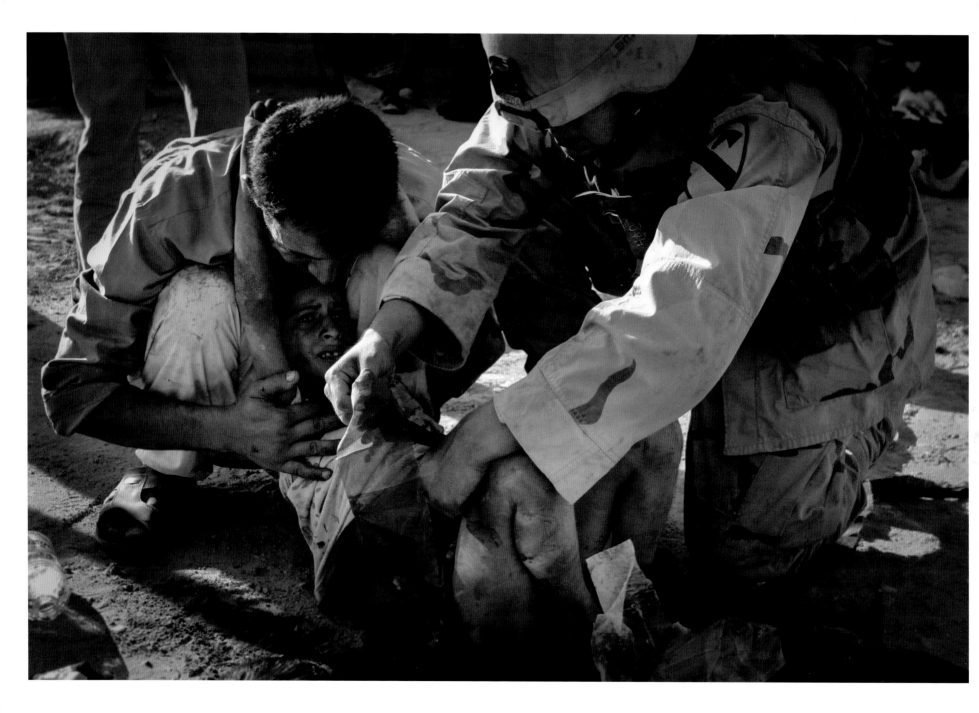

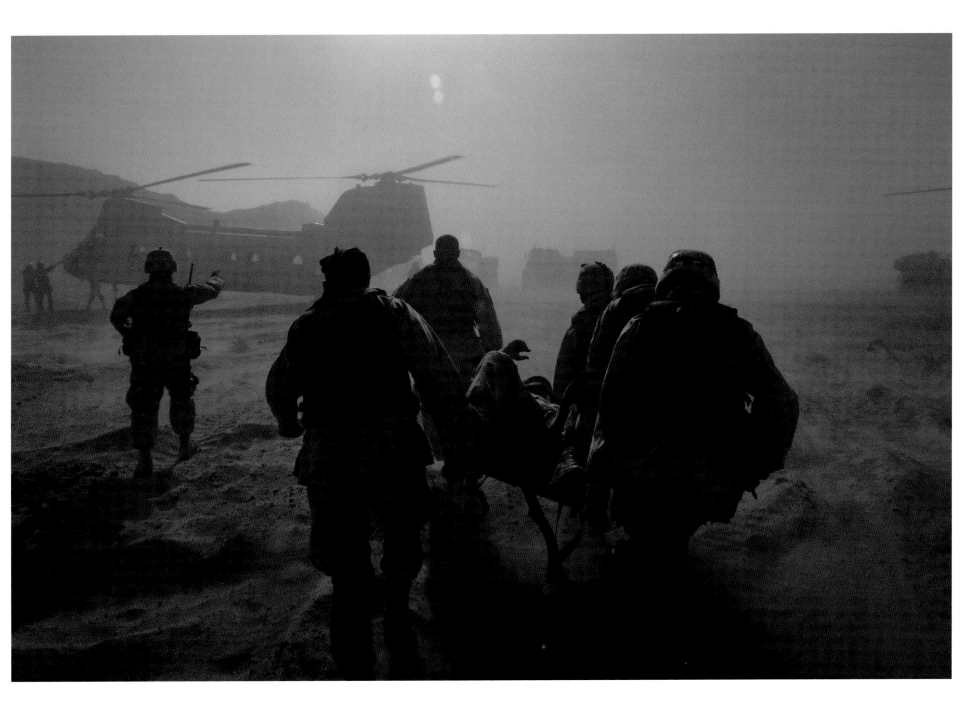

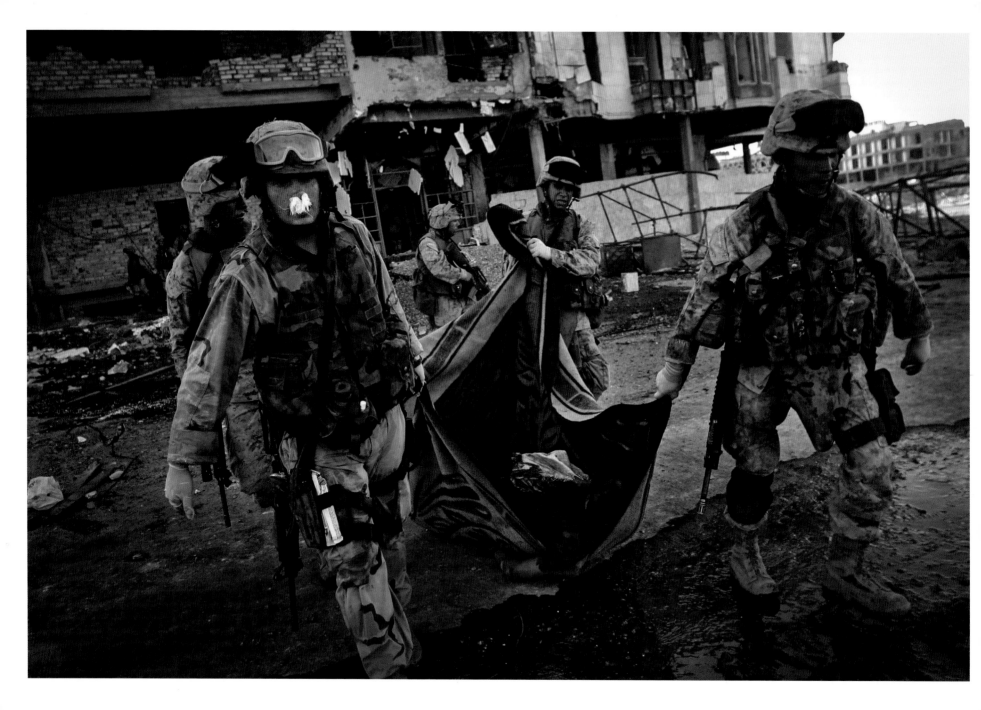

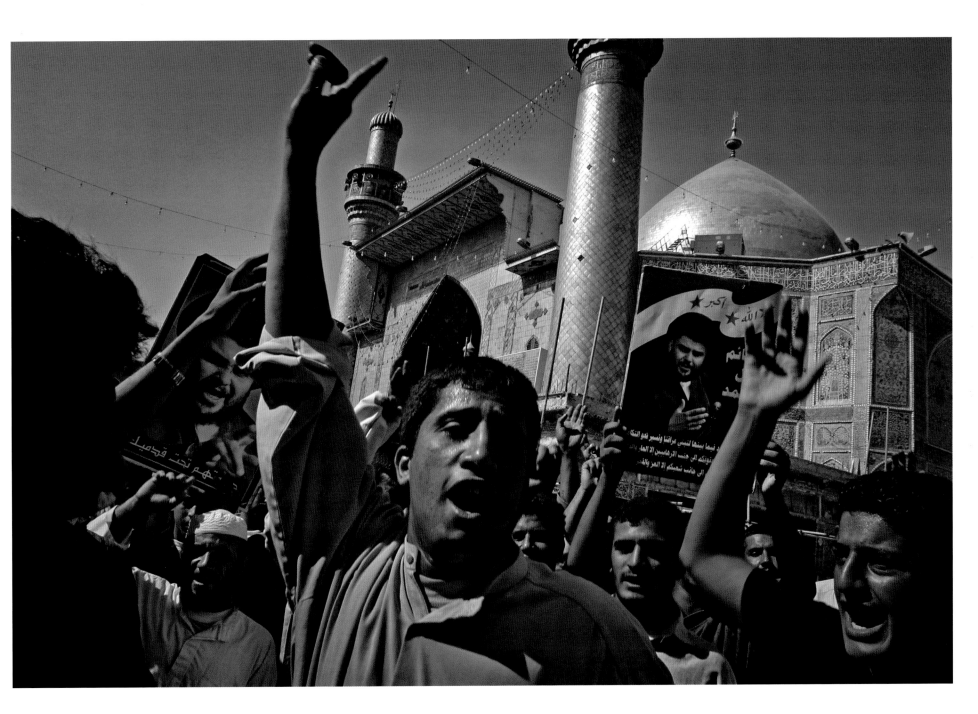

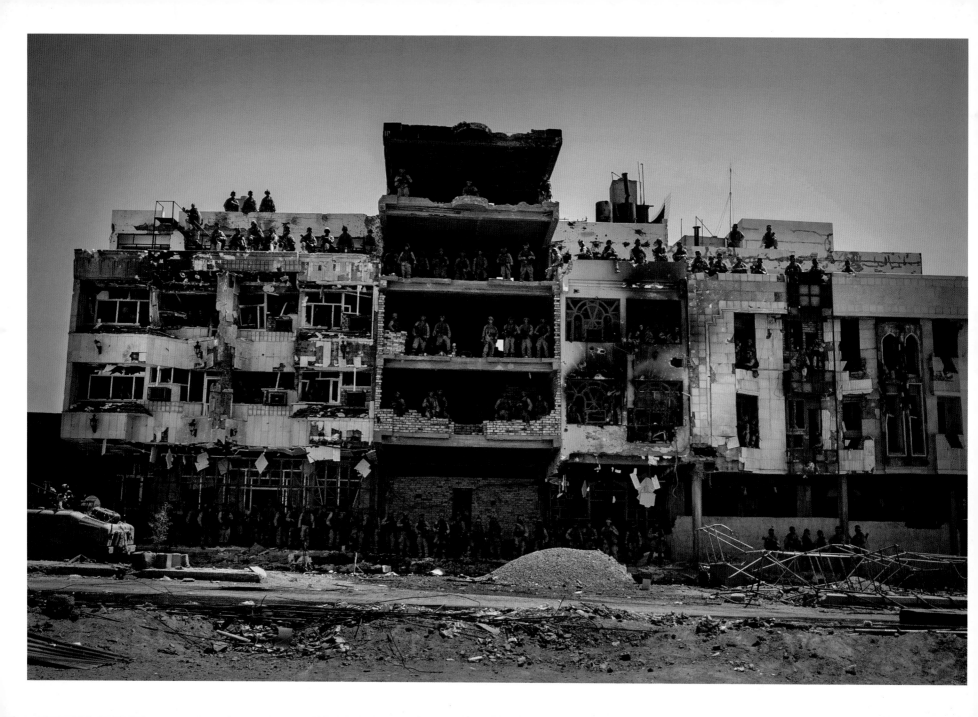

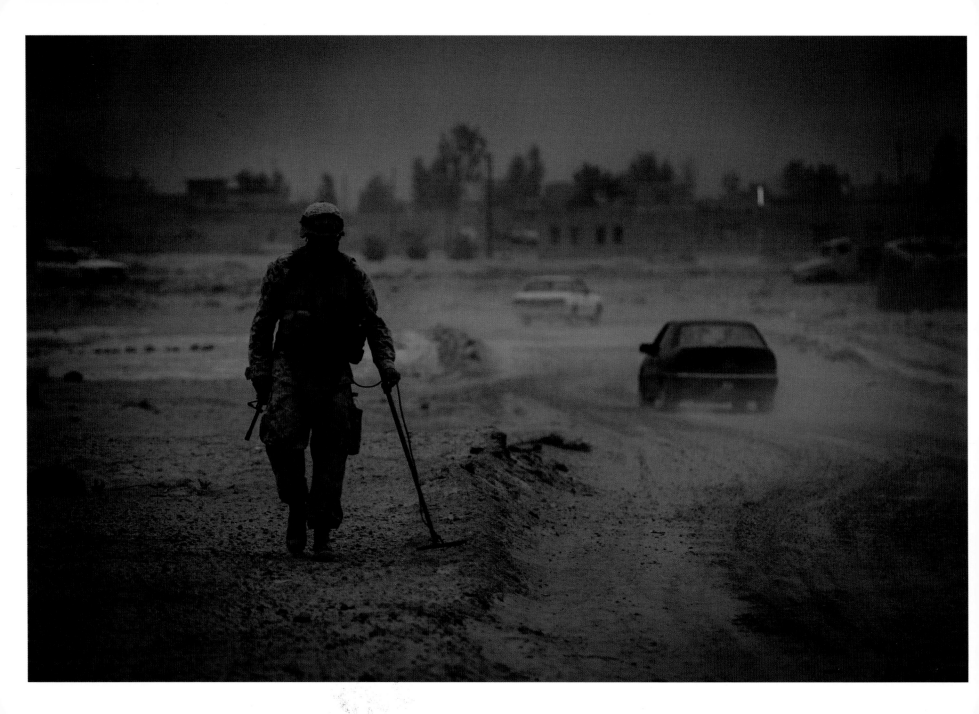

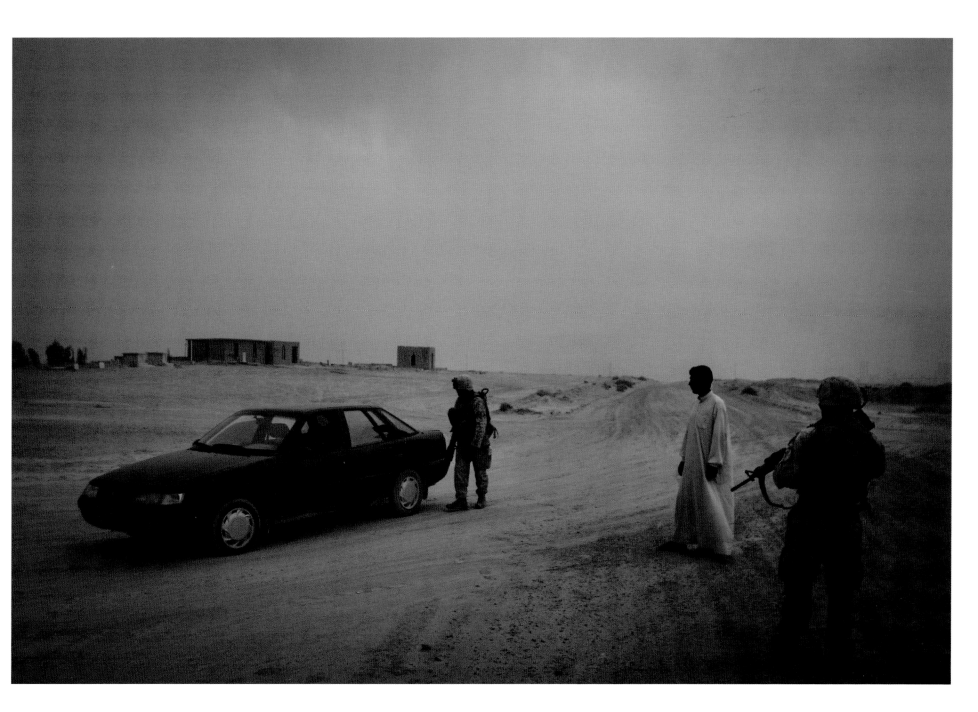

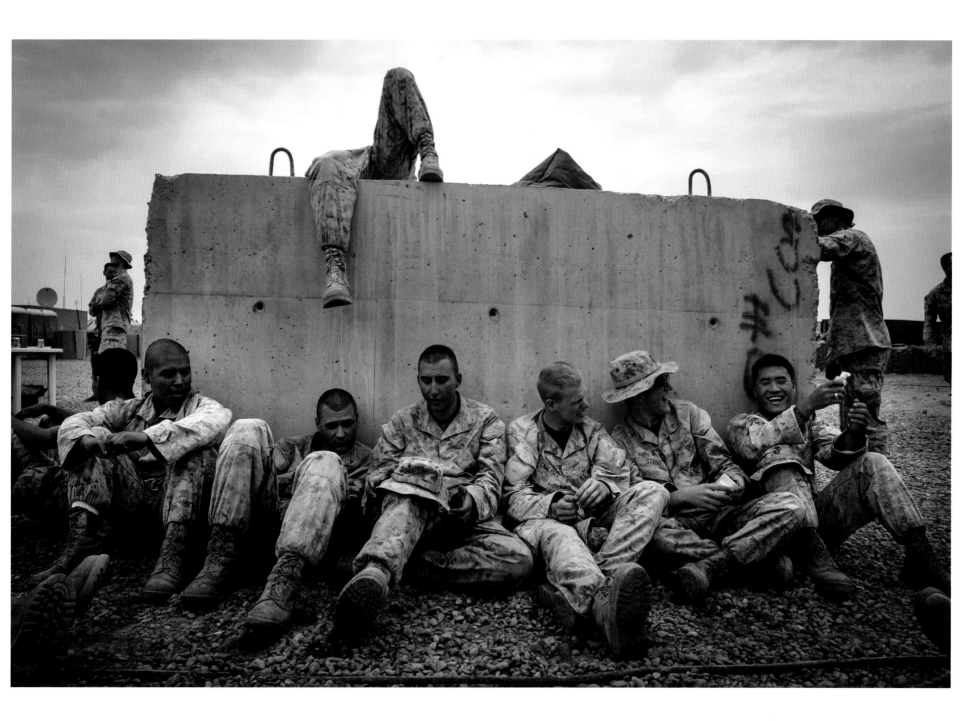

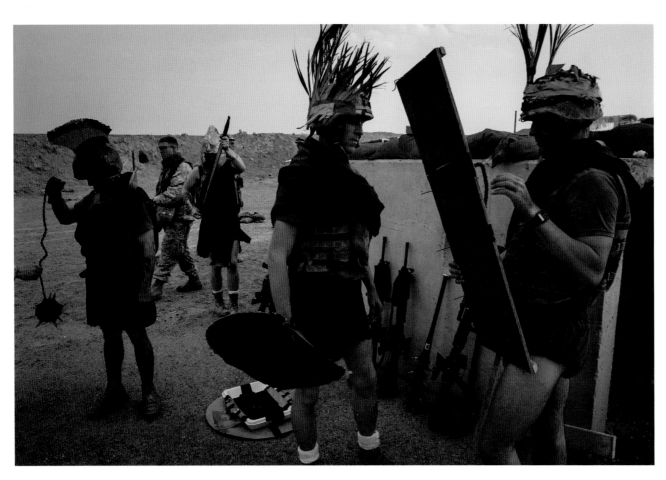
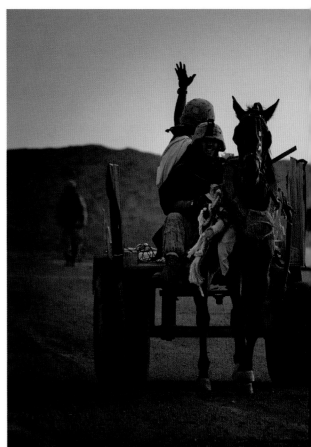

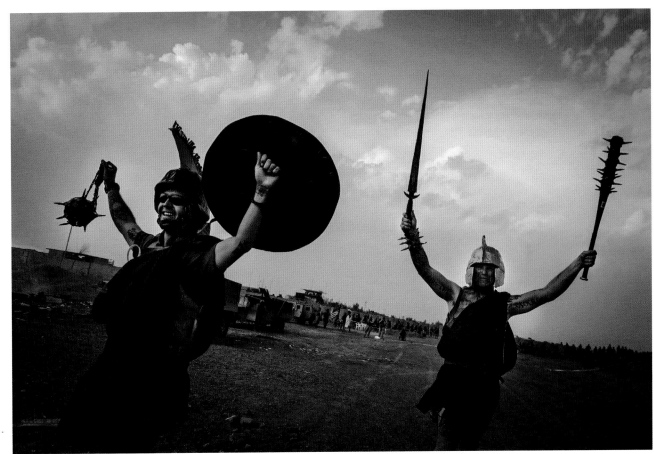

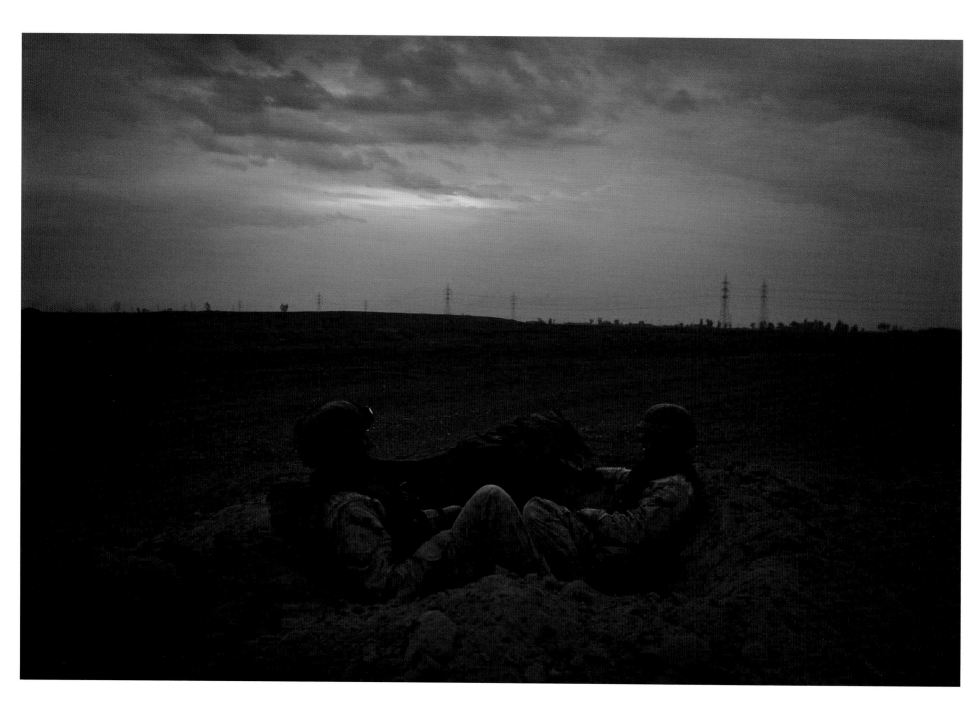

In an hour or so we will be stepping off for the assault on Fallujah. 3rd Battalion lst Marines is first wave. I am without fear. The only anxiety I feel is wondering if I'm in the right place, with the right unit. They say this thing will take 48 hours, and it wouldn't surprise me if that were true. My money would be on the idea that most of them have faded away. They have to know what's coming, and though they've shown themselves more than willing to throw their lives away for the chance to kill Marines, I have to believe they'd rather live to fight another day. Time will prove me right or wrong. It's hard for me to turn my mind away from the preparations— gear load, body armor adjustments, equipment maintenance, battery charges—to think of how I feel or what I expect. If I had to write a last letter, I'd want my loved ones to know that if anything happens to me that I asked for this, that I wanted this, and that I think it's important. I know that I have only a small part to play, a small contribution to make, but to me, sitting here now it is everything. These young men going in to fight this enemy are doing it for us; whether the reasons they are here justify the sacrifice is beside the point. They believe, and they are right, that we have asked them to undertake this conflict, and I want to make sure that what they do for us won't be forgotten.

Camp Fallujah, Fallujah
November 6, 2004

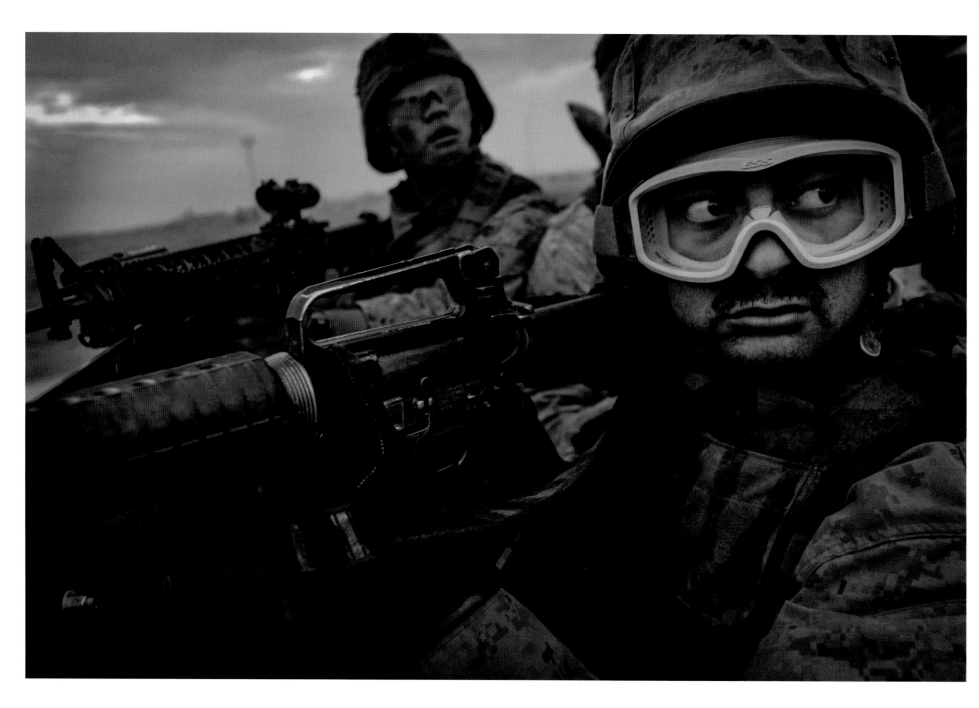

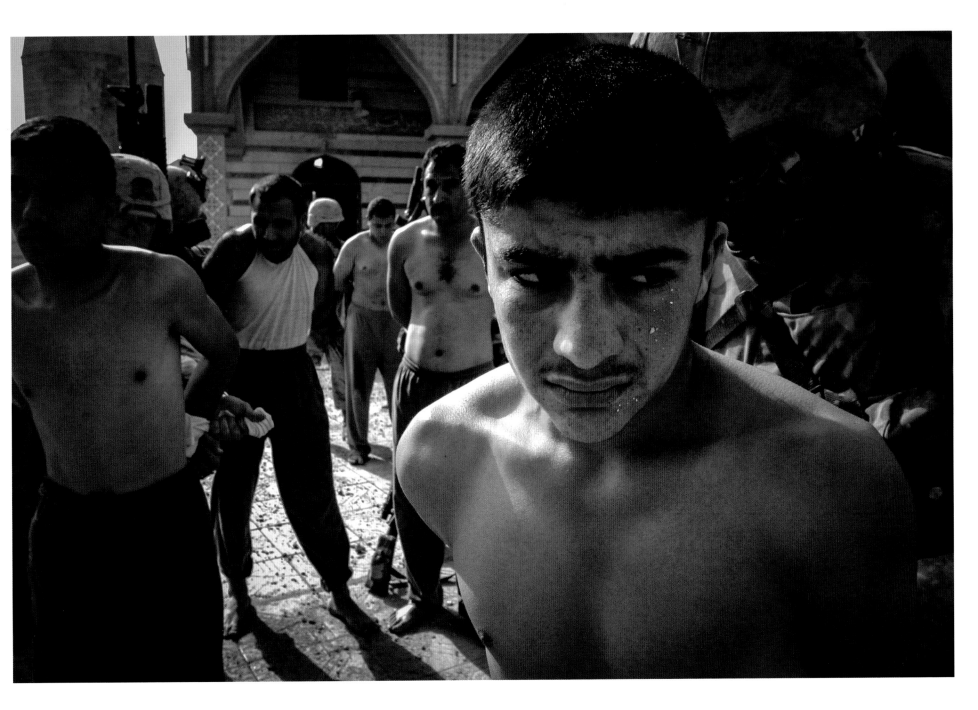

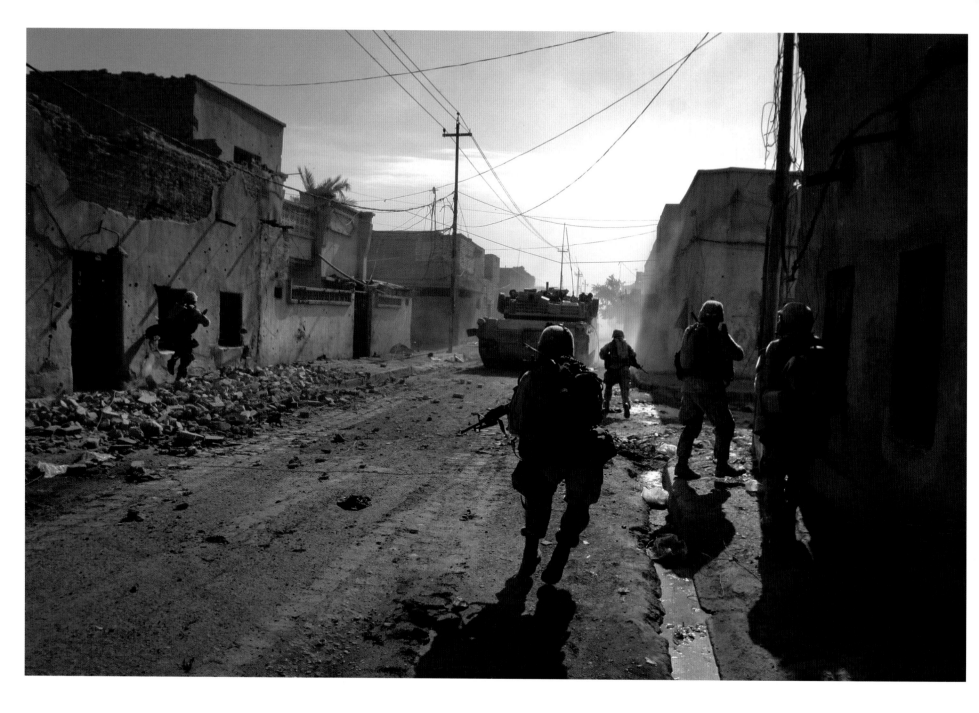

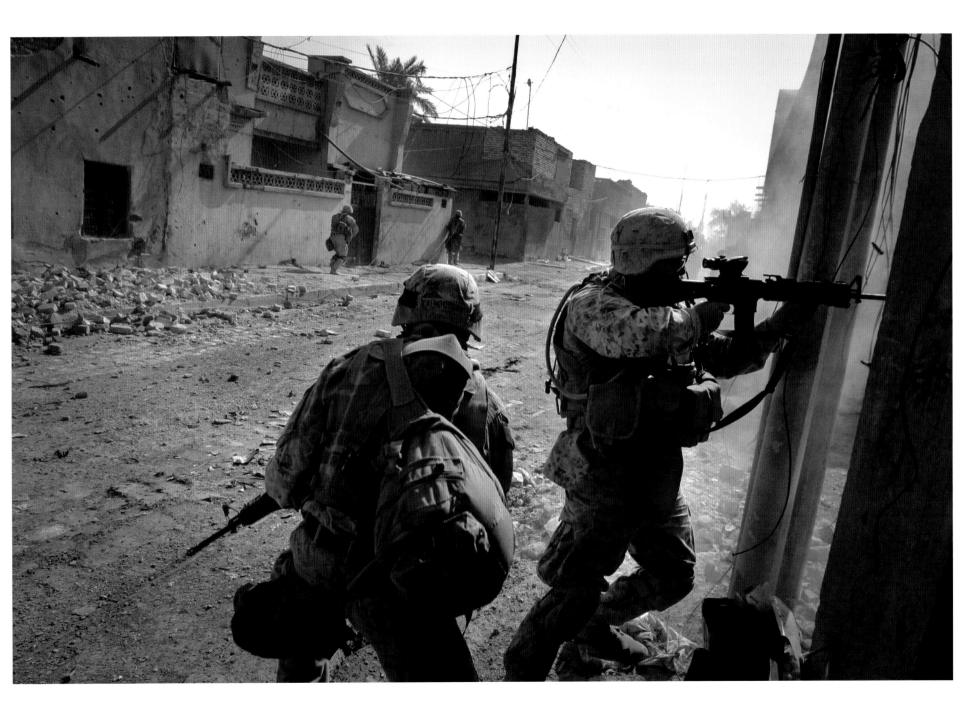

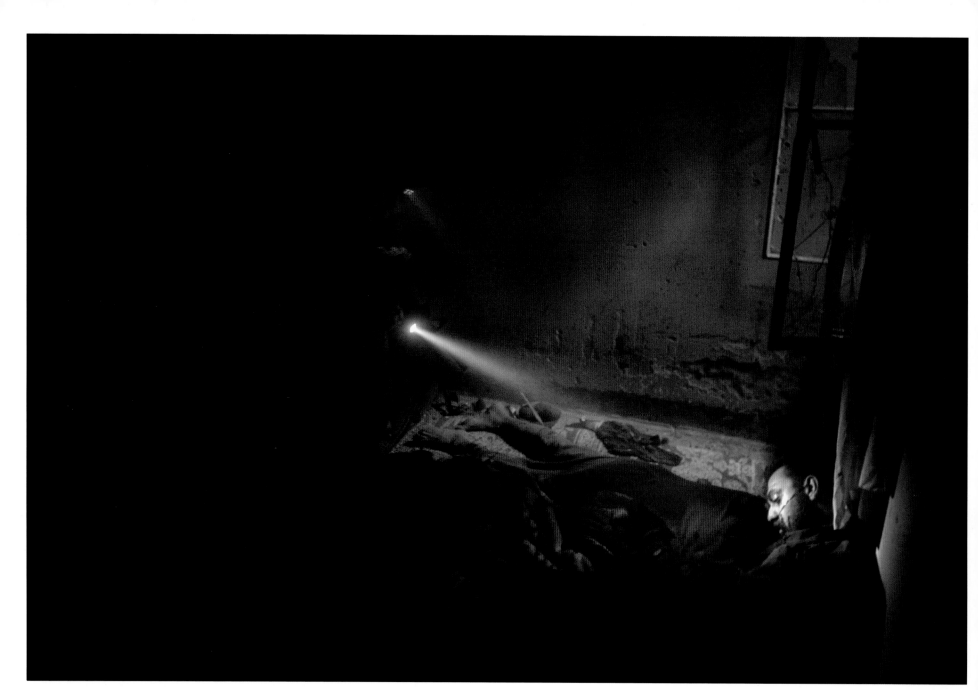

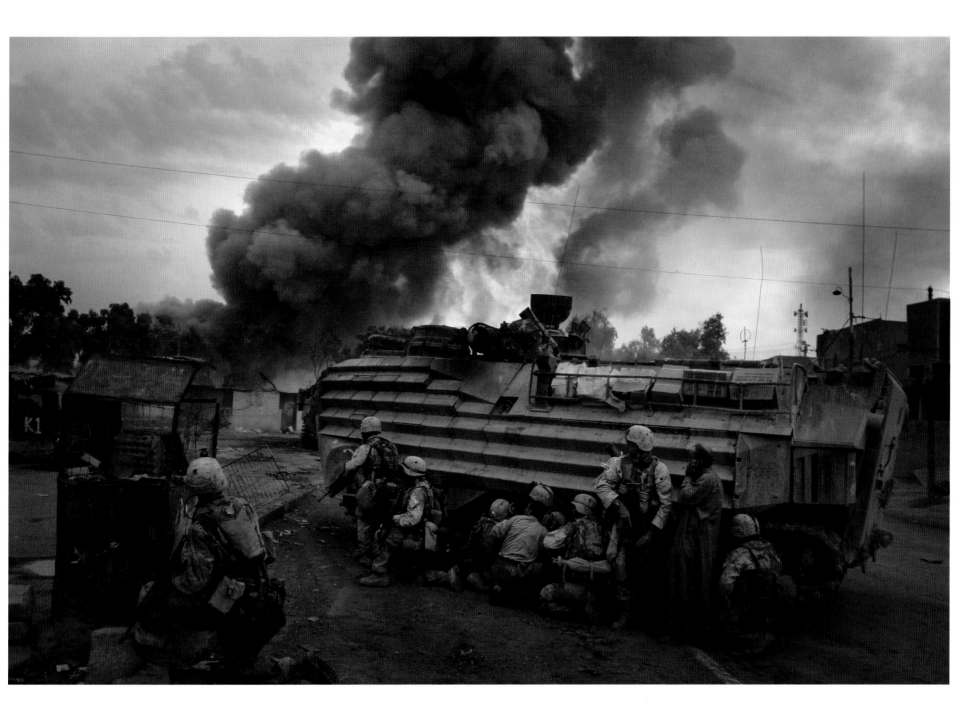

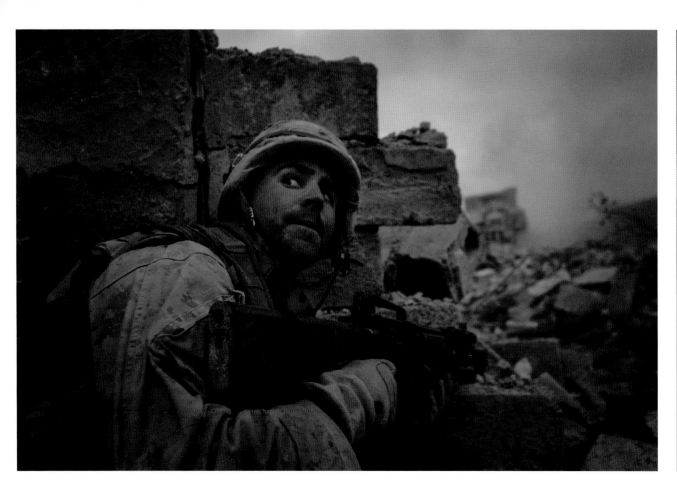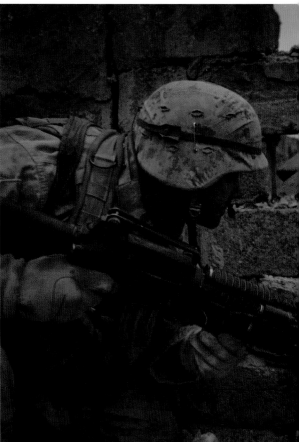

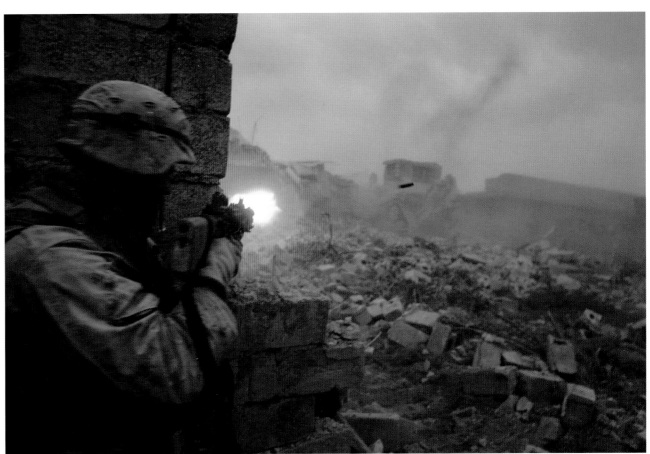

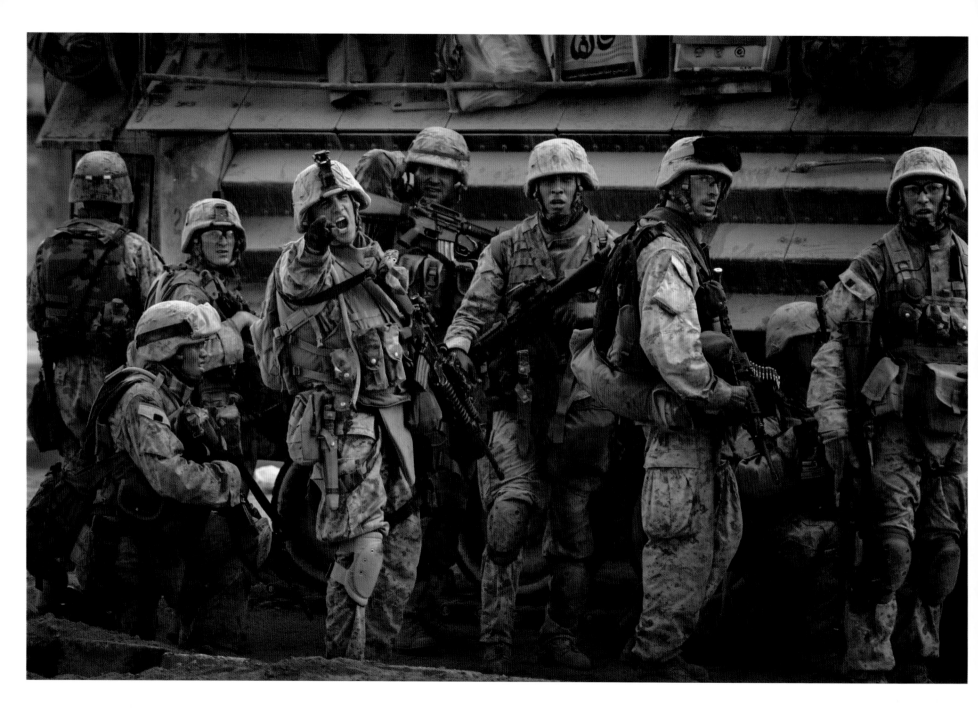

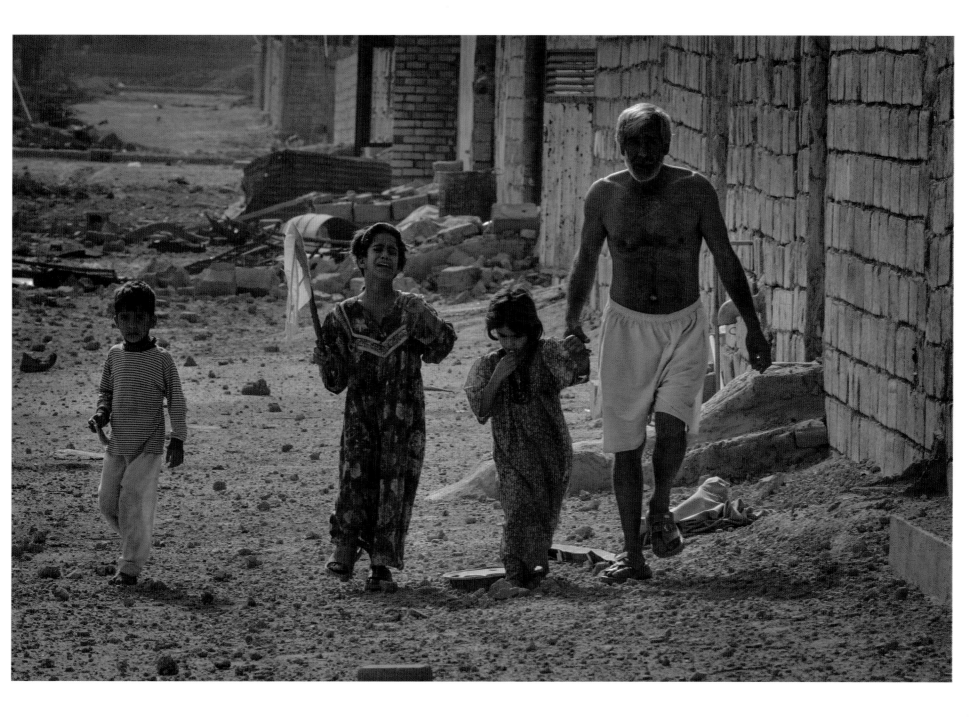

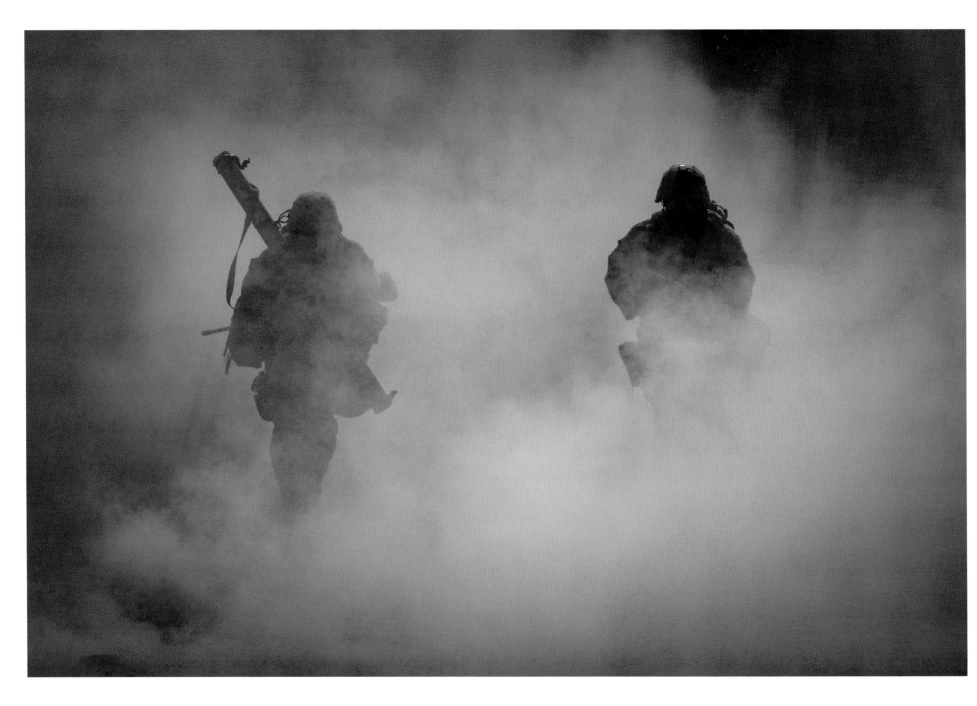

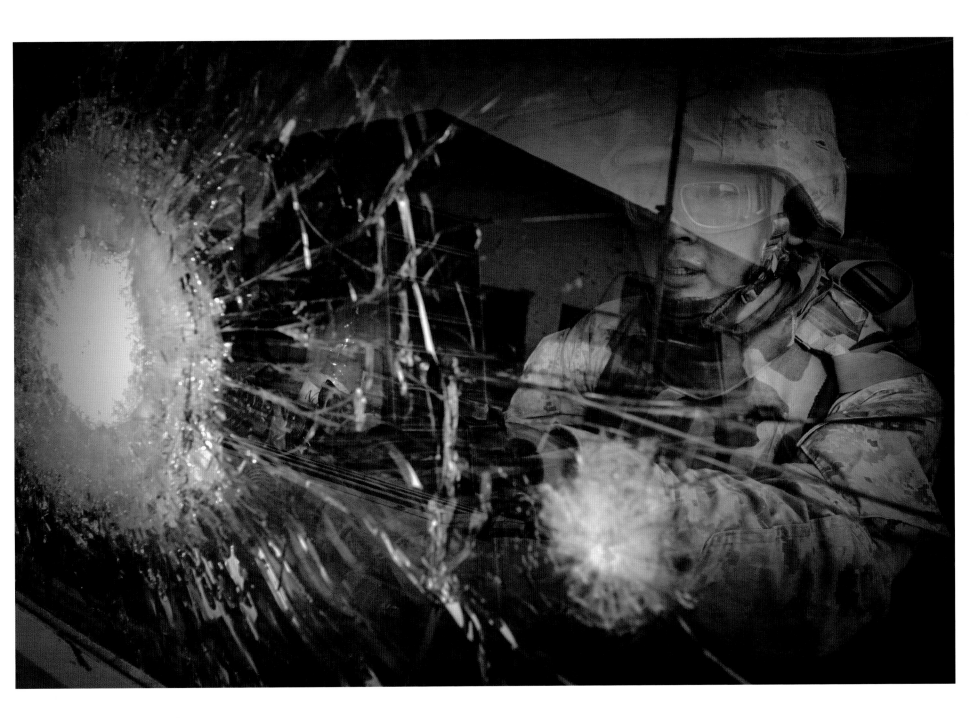

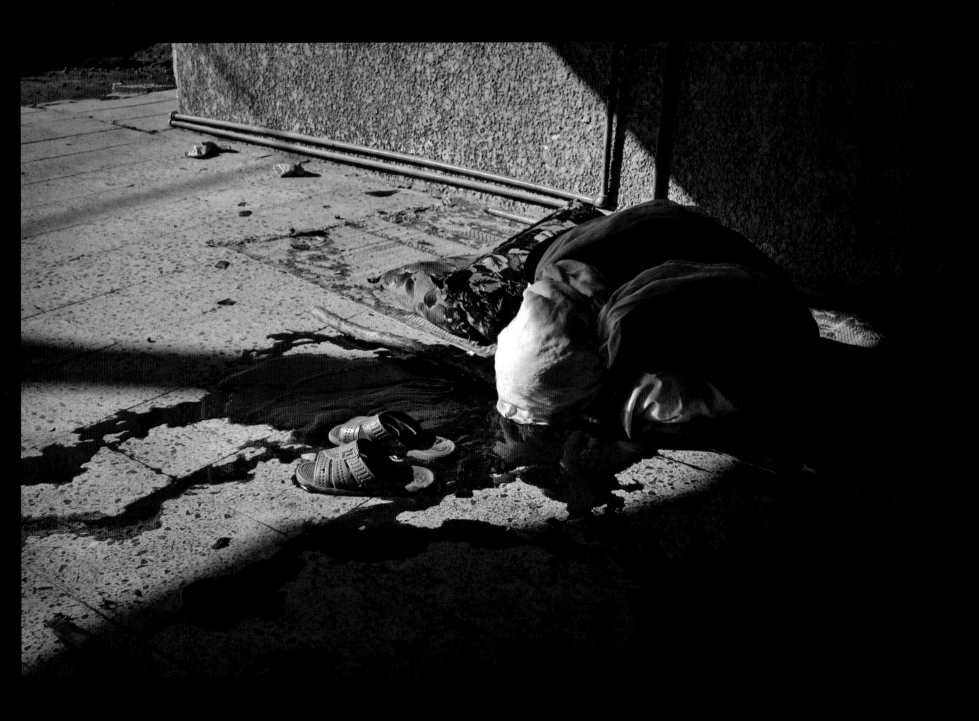

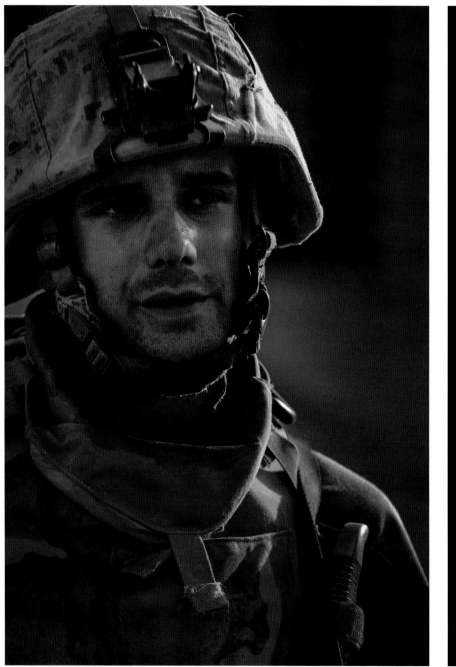
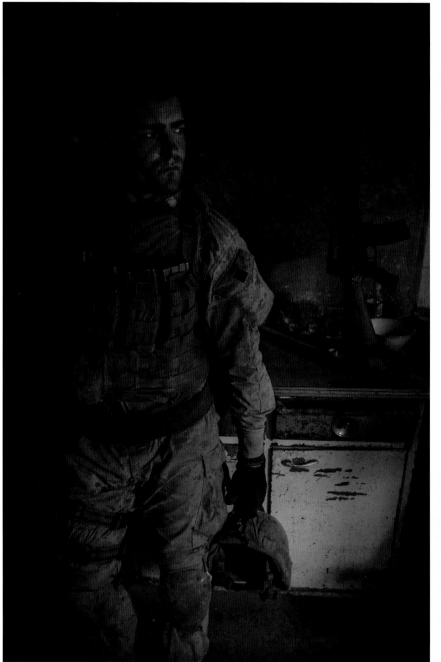

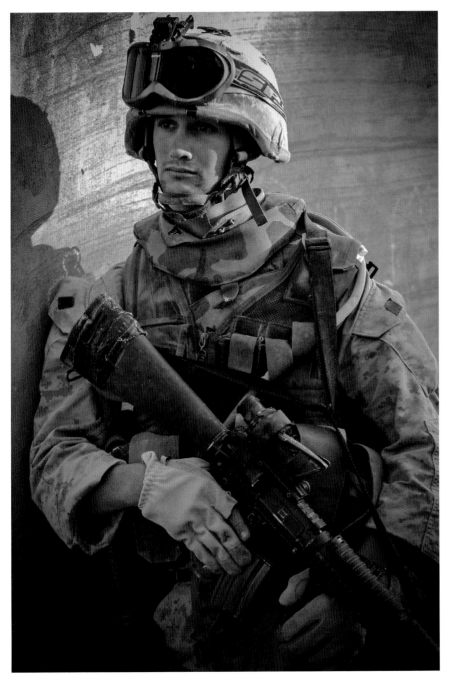
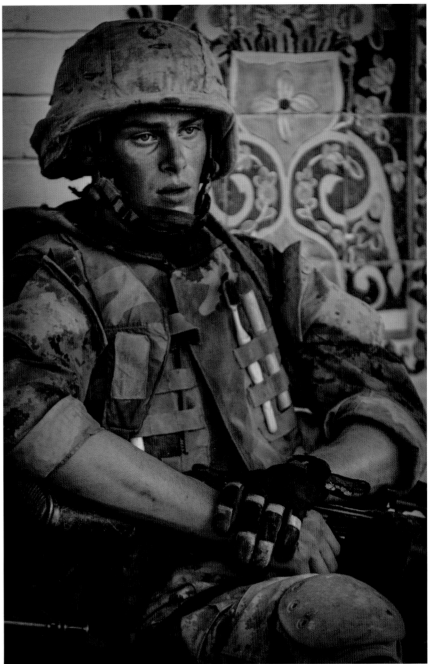

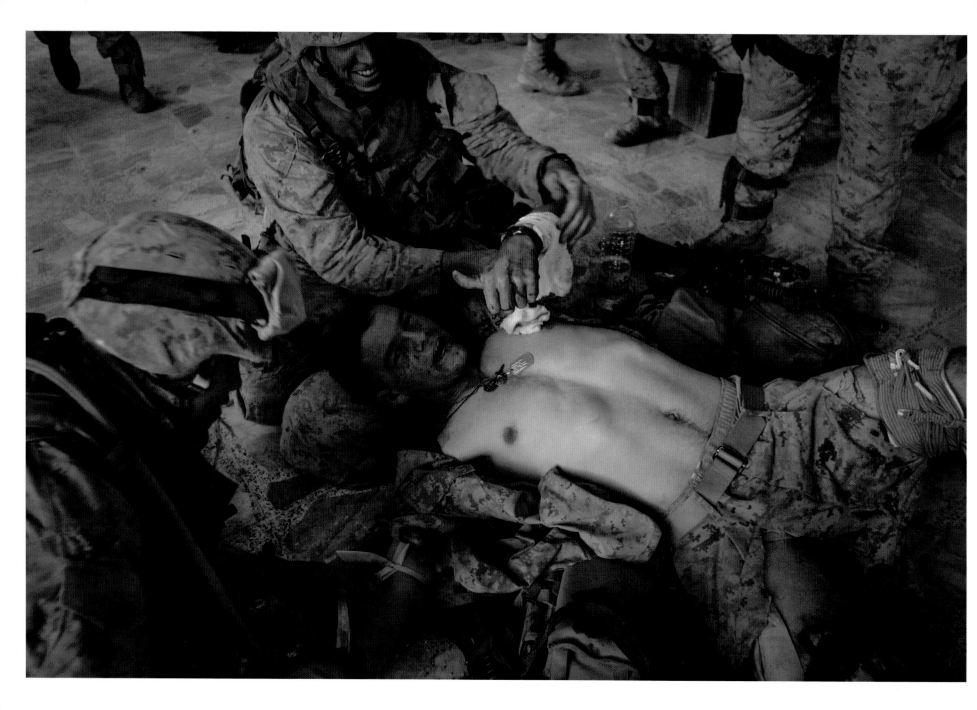

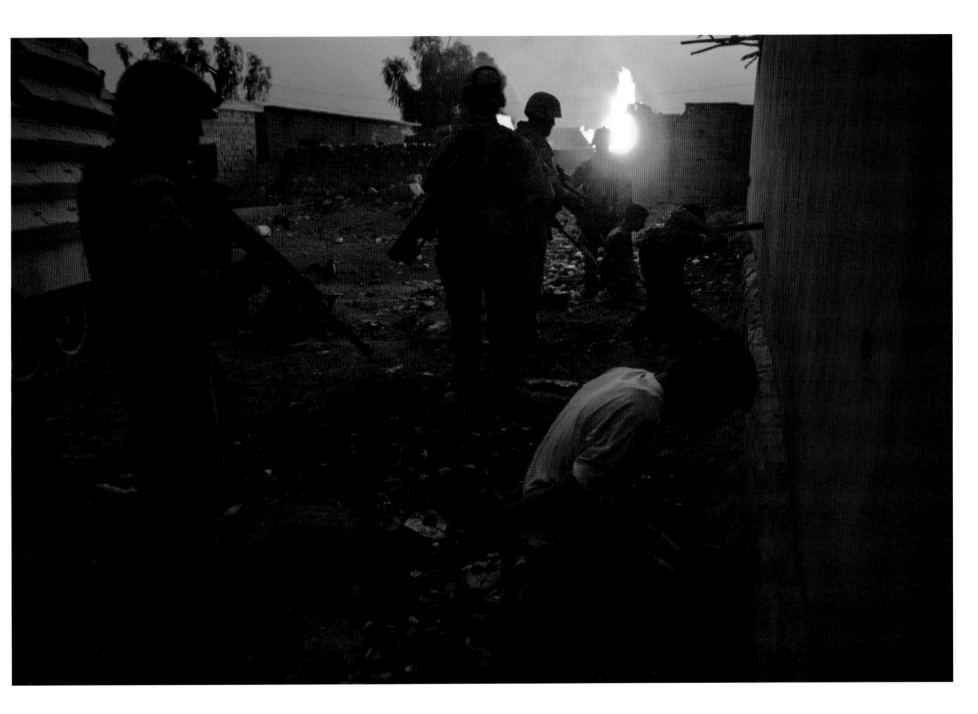

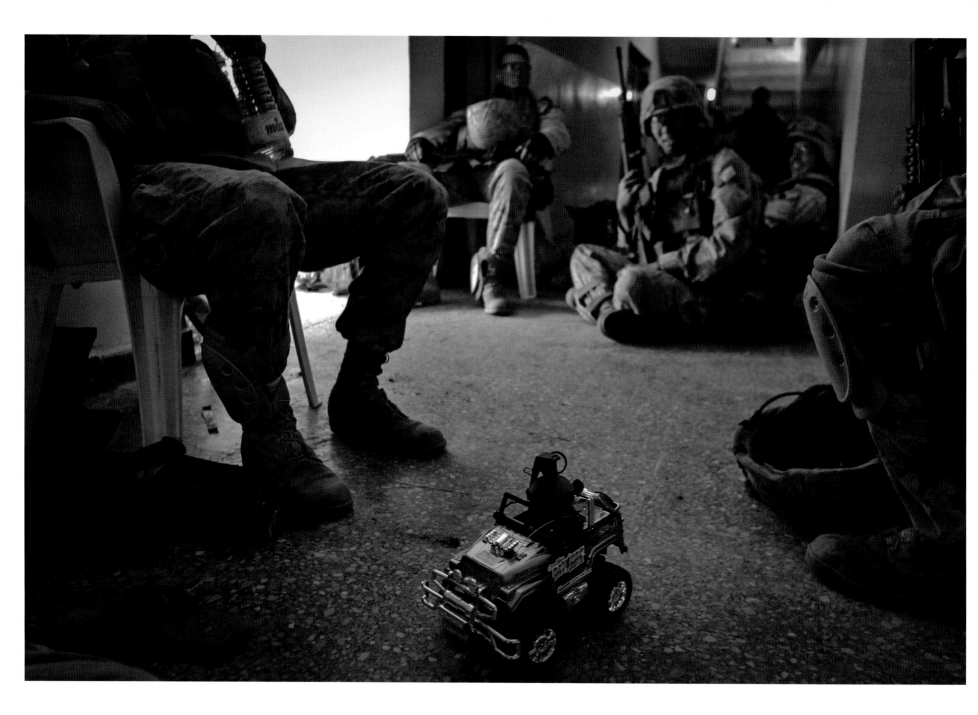

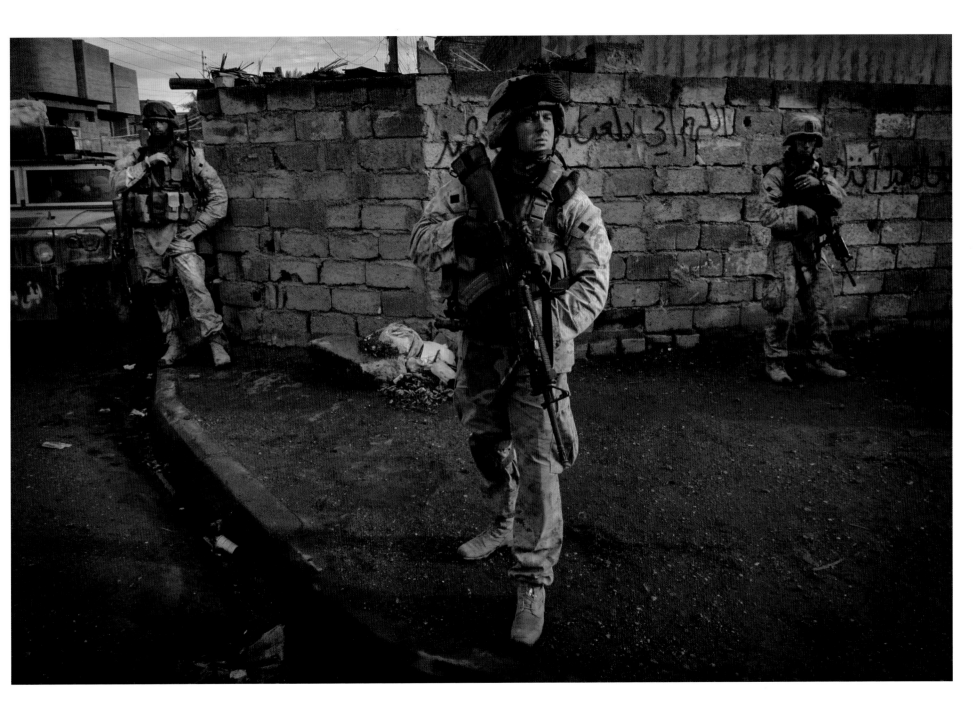

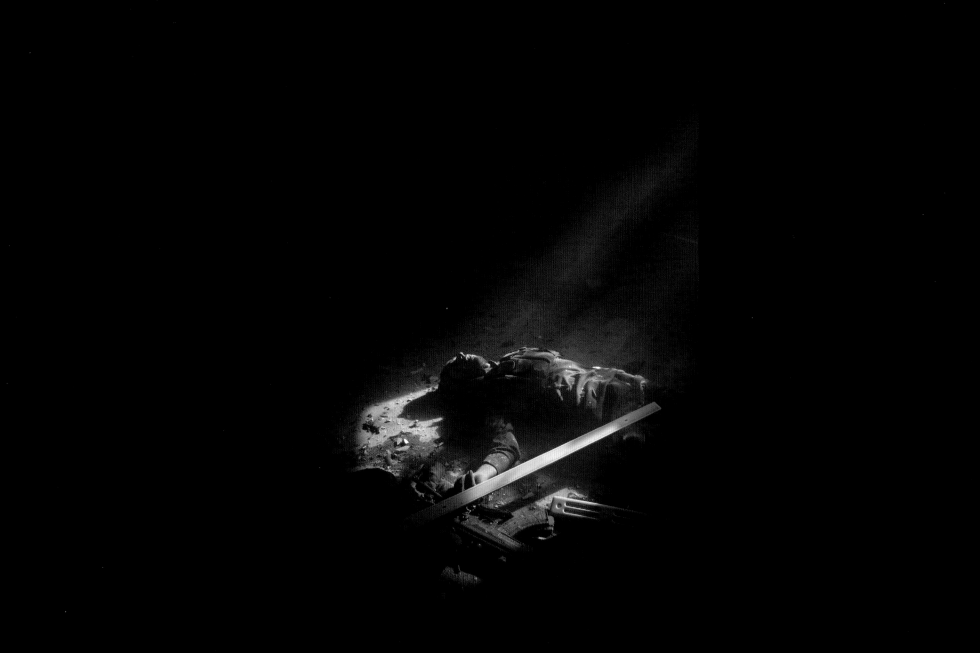

HELLHOUSE

I'll try to remember all of this, but I know already that some moments have become elusive and will remain so.

Third Platoon drew the morning's patrol, clearing the houses around our new base. We have maybe twenty minutes left before we go back in, and I give up and climb in the back of the high back to bullshit with Luse and get off my feet, giving my injured knee a rest. I have no idea what we were talking about—I was probably joking about my knee and calling myself an old man, which is what a guy on the doorstep of thirty can be when you're nineteen—when gunshots, dozens of them, smash into our conversation. What the fuck is that? 16. AK. Something else, too. I jump down from the high back, sparks of pain erupting from my knee, two or three Marines ahead of me, and sprint towards the gunfire.

Around the corner, through the first gate, up the steps, and in the front door. Once inside I find Carlisle and Weemer, then Staff Sgt. Chandler and Sanchez and Severtsgaard. The ground is littered with shell casings and there are two pistol clips lying by the doorway where they had been dropped—empty—one after the other. Weemer's 9. An insurgent lies dead in the corner, his head wrapped in a white-and-black checkered wrap, his soft face, bookish and bespectacled, marred by blood where Weemer dropped him with shots to the head and neck. What the hell happened? We came in and they were waiting for us. There are two more dead in the next couple of rooms. They wouldn't go down. Maybe they're wearing body armor. The guy in the corner wears a coat over a thick middle, but nobody checks—he's already dead. It's the guys who may still be inside who matter now. The rule book says push in and clear the rest of the house. This rule book is wrong.

Severtsgaard cracks the next door—the one in the corner and directly across from the entrance that leads into the largest room in the center of the house. He opens it a little wider and lobs in a grenade. One. Two. Three. The explosion—short and hard—rocks the house, and yellow-gray, acrid smoke escapes into our room through the door opened by the blast wave. They wait a moment for the smoke to clear—not long enough, but not that it matters—and Weemer and Carlisle enter the middle room, with Sanchez, Chandler, and Severtsgaard stacked against the wall behind them. Two AKs on full auto spray the room from somewhere. There are cries of pain and Weemer comes flying back through the door, past where I stand near the center of the room, and vanishes out the front door. (I never see him again; wounded, somewhere he is picked up and evacuated.) Carlisle is still inside, bullets in the legs and unable to move. Through the open door we can see him lying against the far side of the metal staircase, which begins just inside and leads up to a landing that encircles and looks down on the room. In the center of the room, another insurgent lies dead, staring pointlessly at the ceiling. Across from us two doorways lead away into bedrooms. There is another room beside ours with its own door, though we can't see it.

That's the floor plan. Remember it. A big room in the center of the house with four rooms leading off it, and an open staircase leading up to a landing that runs around that entire central room and looks down on it. Looks down on it like if you were the fucking muj and wanted to kill anyone trying to cross the middle of the house, that is where you would be.

Chandler gets everybody stacked on the wall again. If we're going to get this guy we're going to charge in there and get him or some stupid shit like that. The Training. Charge in there and get the motherfucker. Dazzling, headlong, shattering bravery. Maybe it might have worked if they had gone right up the staircase, but they didn't. They stopped. In the central room they stopped, probably to help Carlisle, maybe to search the other ground floor rooms. For how long? Ten seconds? Twenty maybe?

Outside, an AK has a trademark popping sound—POP, POP, POPOPOPOPOPOPOPOP—like popcorn. It's easily distinguishable from an M-16, which cracks and snaps with a sound more like someone breaking a branch over their knee. Indoors, when the two insurgents upstairs pour fire down on Chandler, Severtsgaard, and the rest, the pops disappear, echoing and melding into a stunning thunderclap of gunfire. They all go down except for Sanchez—shot through the legs and arms—and splinter as they're wounded, finding cover in the rooms beside and across from the one they left. Out of reach.

More Marines arrive. The rest of 3rd and their CAAT attachments are either inside now or outside evacuating wounded and setting security. Lopez and Wolf. Cpl. Mitchell and Van Hove, First Sgt. Kasal. Nicoll. They're all inside now. The situation is explained. The two entries. The wounded. The bad guys upstairs. Mitchell, Kasal, Van Hove,

Nicoll enter the room. What are they supposed to do? Marines are in there wounded, bleeding, maybe to death. This situation changes for the better only once we can evacuate them. It's fucked, but you gotta get them out. Knowing what they're in for, they enter, covering all the angles—the staircase, the landing, the rooms—and cross. Nothing happens. For a moment. Then the skies open up again and Mitchell, Kasal, and Nicoll go down. Since Weemer's team first entered the house at least eight Marines have been wounded, most seriously. At least five are trapped across the kill zone. This has all taken place in less than twelve minutes.

More guys come in, or were they here before? Who? Winnick, McGowan? They're stacked against the wall and someone reaches around the doorframe firing, spraying the ceiling of the center room, spraying and praying, and hoping to hit the insurgents upstairs. Fearful of ricochets, two Marines crouching in the corner at the end of the line pull the solitary piece of furniture in the room—an upholstered chair you could put a fist through—against themselves for cover. The chair and the Marines stay there for the rest of the fight.

We've got to figure out how to suppress the top floor, how to keep the muj tied up by fire while we get the wounded out. There are gun trucks outside. Can they hit the top floor with the Mark? Why send a Marine when you can send a bullet? I don't know if it's my suggestion. I don't even know if I said it out loud. I must have, but there's so much yelling back and forth—sometimes over the gunfire, mostly from anxiety and confusion—there's no way for me to know if

anyone even heard me. Then Norwood's in the room. OKAY. My trucks are outside. Where are our guys? Where are the bad guys? Can we hit them from the street? Rapid fire. Not waiting for the confused six-person answer to come back to him, he moves into the doorway leading to the center room to see for himself.

The first morning we entered the city, Sgt. Norwood was part of the CAAT (Combined Anti-Armor Team) section attached to Jesse Grapes' 3rd Platoon to give them added firepower. Humvees with .50 cals. TOW missiles. I took a picture of him just as the sun was breaking through the haze and smoke from the night's bombardment. There's nothing really happening in the picture, but he's standing there in an intersection when most of us were still sticking close to walls and doorways, his weapon lowered but set, one leg forward of the other like he's ready to move. There's a light in his eye from the rising sun—the first thing that caught my attention. He looks focused, determined, prepared, and almost heroic. I'm glad that I took it.

Norwood moves into the doorway crouching, anxious to find a way to help the guys on the other side. I follow right behind, not even an arm's length, to photograph the moment. Gunfire explodes in the doorway. The air turns hard and violent, angry. Lethal. A round strikes Norwood in the temple like a blow from a hammer, driving him to the ground, killing him instantly. He's there and then he's gone, and he never makes a sound. Other rounds disintegrate when they strike the floor, spraying fragments. There's a feeling like being hit with a baseball bat and I stumble back

with my shins, just above my boots, bleeding and blackened where the bullet shrapnel has burned and cut its way across and into my legs.

Norwood. Winnick and McGowan pull him out of the doorway, checking his pulse. "He's gone." I see his terrifying wound and feel myself collapsing into the black, irresistible finality of it, feel my life flowing toward it. I raise the camera. I'm horrified that I do it, that I have to do it, at this moment for that purpose. I feel empty. One frame. There's the one frame. I need to stop now. Isn't that enough? Through the viewfinder I can see Winnick raise a hand in a small protest. I lower the camera.

More Marines arrive outside—the QRF from the Palace. Second Platoon. Bonaldo is inside. Everyone is yelling at everyone else—the Marines inside are all yelling at the Marines in the yard. There are wounded inside. We can't get them out. The sergeant from CAAT has been killed. Don't come in. The yelling brings me slowly back with the realization that in the chaos of all of this yelling, nothing is being understood. I go outside to explain.

Lt. Jacobs—Second Platoon's commander—is outside just beyond the front door. John, there are guys wounded inside in rooms we can't get to because the muj are upstairs firing down on anyone trying to cross the center of the house. It's then that I realize that the room Chandler fell into after he was wounded has another door leading outside, right next to the main entrance. Chandler's in there. I reenter the house. I can hear Chandler screaming as they pull him from the house, blinding pain from his shattered knee. Jacobs star

bodily order out of the chaos, trying to find a way out. Jesse Grapes, the lieutenant for Third, sees to Chandler's evacuation. Jacobs pushes in more guys to the front room, but no farther. Norwood is carried from the house. They yell to the wounded Marines: are there windows, doors on your side, anyway out? There are windows but they're covered by metal grates. We've got to get through to them.

Outside, Jesse Grapes—sledgehammer in hand—starts smashing, clawing, prying his way through the steel grate that's keeping him from getting into one of the far rooms. Somewhere behind the house—in a place I never see—Marines begin to tear their own way into the room where the wounded wait. Jacobs moves Marines into the kitchen—the room where Chandler lay. Once Grapes—with Boswood—makes it through their window, there are uninjured Marines in all four of the downstairs rooms. With weapons in every doorway now, Jacobs elects to risk the crossing again.

A pummeling, blinding volume of fire is unleashed from the three other doorways toward the landing above just before two Marines, their weapons left behind, rush from the kitchen and across to the wounded—unharmed. The fire comes again and they carry First Sarn't Kasal through the kill zone and out of the house. He's pale, the crotch and thighs of his trousers bright red with blood, but he's responsive and still has his sidearm clenched in his right hand when they carry him Christ-on-the-Cross into the front yard.

They took no fire. Maybe the insurgents have been killed or wounded. Wishful thinking. Maybe they're out of ammo. Keep your fingers crossed.

The same two Marines run the gauntlet again and return with Nicoll. Stumbling over the dead fighter as he crosses the threshold, we have to grab the first Marine by his flak and drag him through to safety; Nicoll's stretcher, locked in his grip, is dragged along, too. Nicoll, the funniest guy in the company, a guy who joked about the lance corporal promotion party he was going to throw just before he finished his four years of enlistment, a guy now famous for his costumed antics at the chariot races held before the assault, lies on the floor, bled white. His face is a pained, scared grimace. His hands are pressed tightly over both ears, blocking out the gunfire that in the now-quiet house only he can hear. The lower part of his left pants leg is awash with blood, the broken bone pushing out against the fabric of his trousers. The wound will cost him his leg below the knee.

Circling around to the far side of the house, I climb through the window and into the room that Grapes and Boswood opened with the sledgehammer. A dead insurgent is curled up on the floor—the last of the three killed when Weemer first entered the house. Jesse, his uniform soaked in the blood of the dead insurgent, which has pooled in the doorway, lies on his side across the threshold, his weapon trained upward toward the landing. Boswood sits astride him, covering the staircase. Focused on finding the right angle to photograph their visually incomprehensible but necessary arrangement, I realize the extreme danger of their position only afterwards. Lying there in that doorway to cover the evacuation from the next room, if something went wrong there was nowhere and no way to run.

When the rescuers have finally removed the last of the wounded from the room beside ours—by ripping the window and grate from the wall with a chain attached to a Humvee—Jacobs calls to us to see if we three are the last in the room. Suddenly enraged, I kick the fighter lying at my feet, snapping his head back, and yell to Jacobs, yeah. If I'd had a weapon I would have shot the dead fighter in the face. We crawl back out the window the way we came in.

Back in the kitchen, Jacobs prepares to demolish the house. Gonzo puts the finishing touches on a 20 lb. satchel charge. He and I stand there, alone now, screaming profanities, racial epithets, and gibberish at one another to keep up the illusion that Marines still occupy the house as everyone else withdraws. After a minute or so, Gonzo pulls smoke on the satchel and, last to leave the house, we dash out the front door, across the street, and into an empty lot, joining everyone behind a wall to await the explosion in safety.

The explosion is a loud and low rumble—nothing after the aural violence we have experienced inside. Through the clearing dust, the house has been reduced to a pile of rubble, the blast even flattening the wall that surrounds almost all of the houses in Iraq. We clamber up on the debris pile, looking for bodies or body parts, and at first find nothing.

The call comes to climb down, and we begin to wearily walk back toward the Palace. As the rear of the group passes the pile, someone sees him. One of the insurgents lies dead half buried in the rubble. Everyone draws near for a moment to examine the corpse and then moves away satisfied.

exception is Winnick, who draws a knife and pulls back the lifeless head, intending, for a brief moment, to sever it from the body. Jacobs's instant reminder that he would have to live with that for the rest of his life turns him aside, and he drops the head in disgust, walking away.

I walk over to the remains to snap a picture. As I kneel in front of it, framing, out of the corner of my eye I see something move in the pile. Maybe 8 feet away, a second insurgent is pinned under the rubble, buried up to his rib cage. He is staring at me with eyes wide and black with rage, death, and madness. In his outstretched hand is a grenade. I yell the warnings "There's the other one!" and "Grenade!" and run as he throws it at me. Everyone else follows suit, running in all directions, and the device detonates harmlessly. An instant later a dozen scoped rifles train on the fighter, and the Marines behind them fill the air with their rage and fear. When the fire abates, Jesse Grapes, whose platoon has suffered so much in the house, approaches the corpse and puts a three-round burst into it to make sure. Not satisfied, Winnick, his K-Bar fixed to the rifle in his hand and a wounded comrade's weapon slung over his shoulder, sinks the bayonet into the carcass with three quick jabs and then wordlessly walks away. The fight at the Hell House is over.

Forwarding Operating Base Hotel, Najaf

December 12, 2004

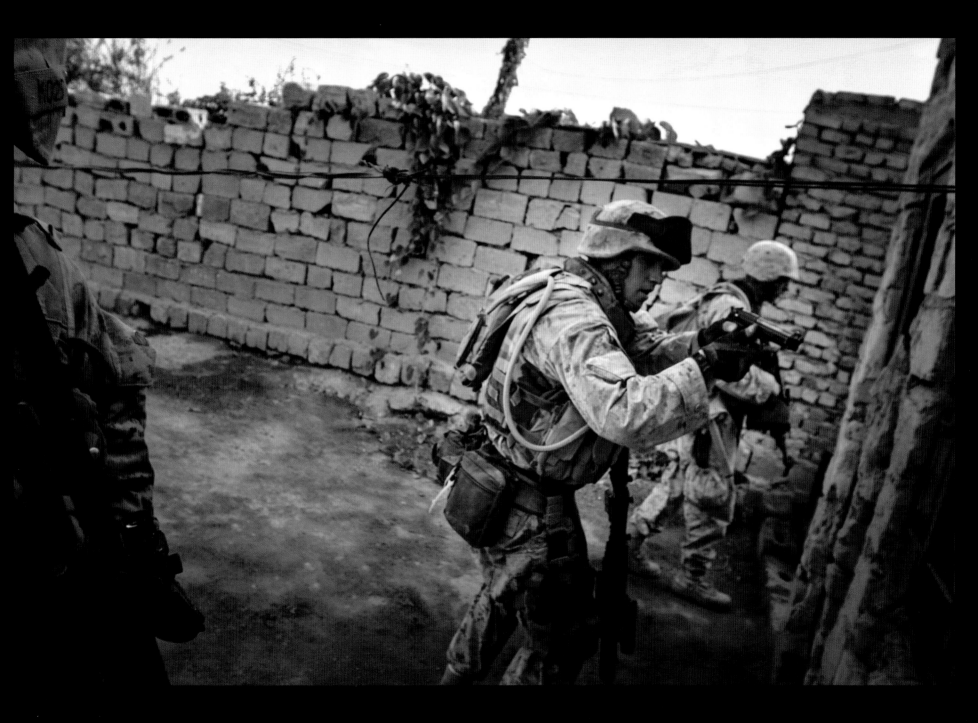

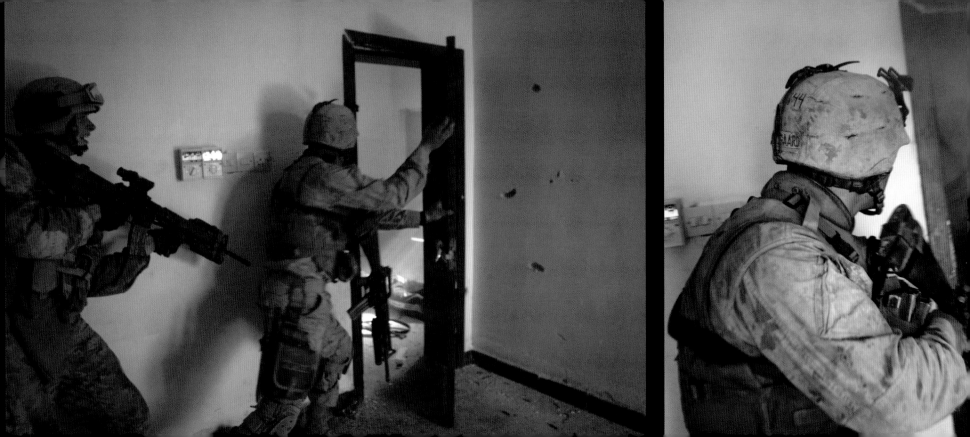

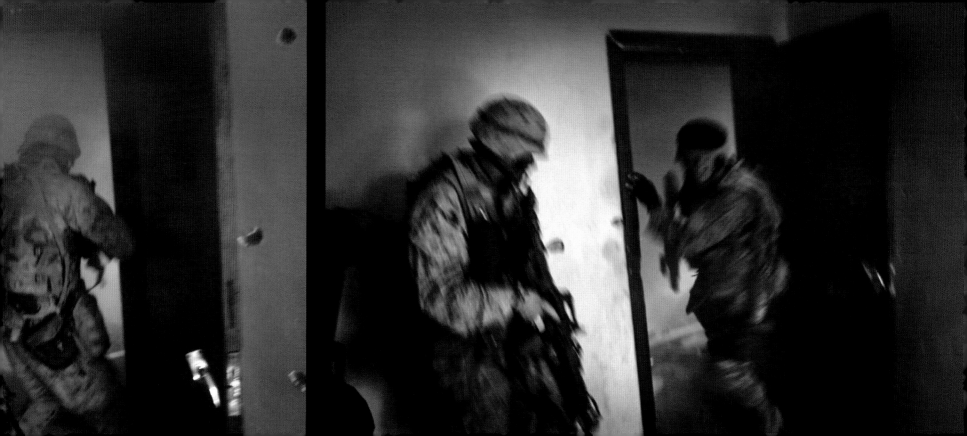

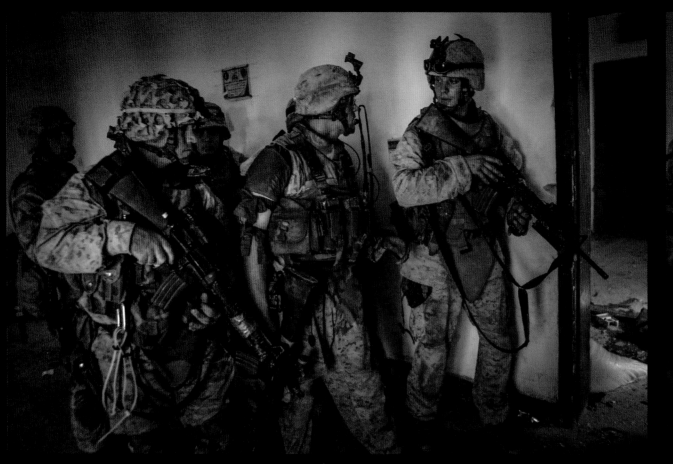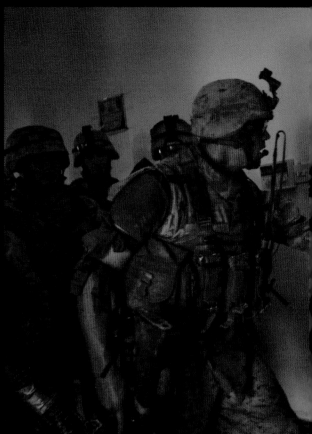

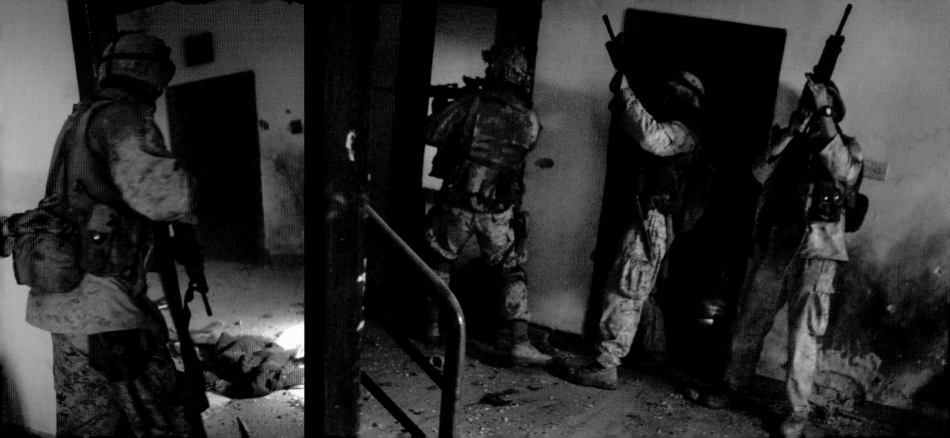

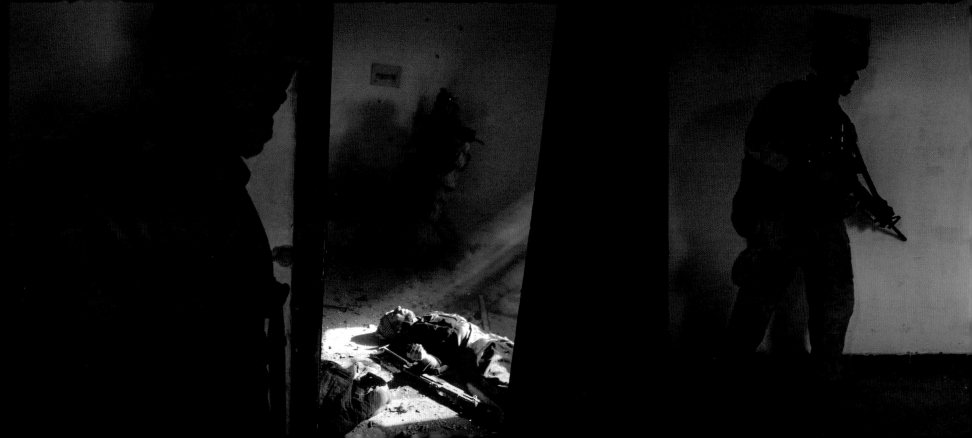

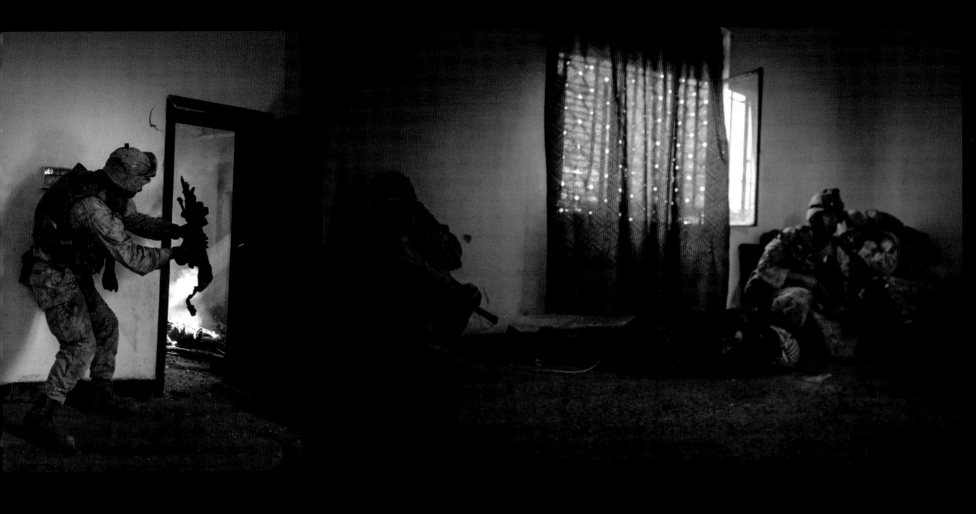

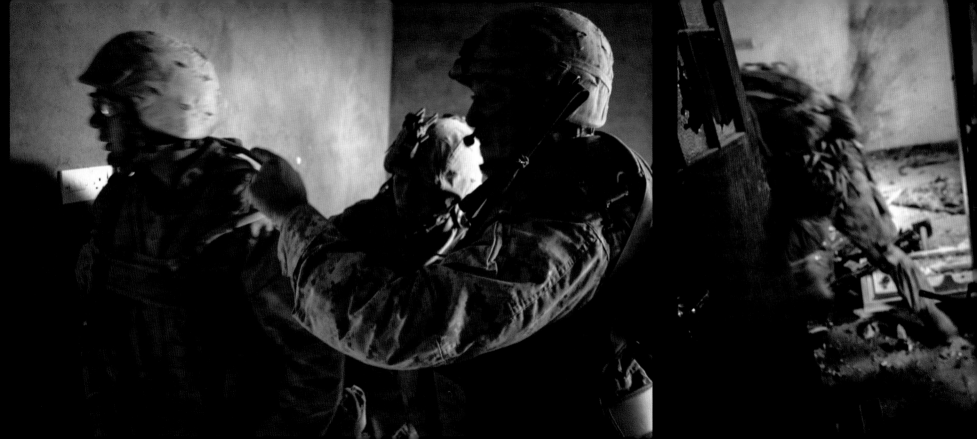

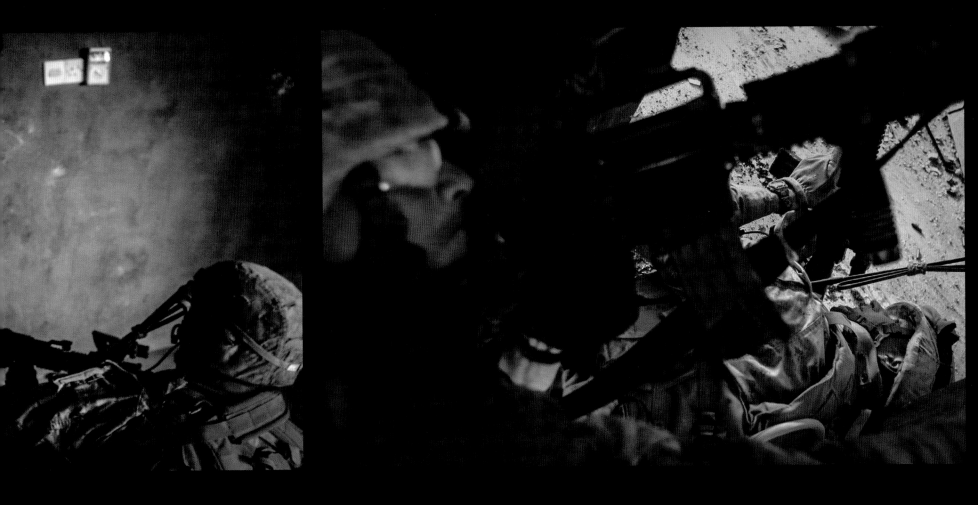

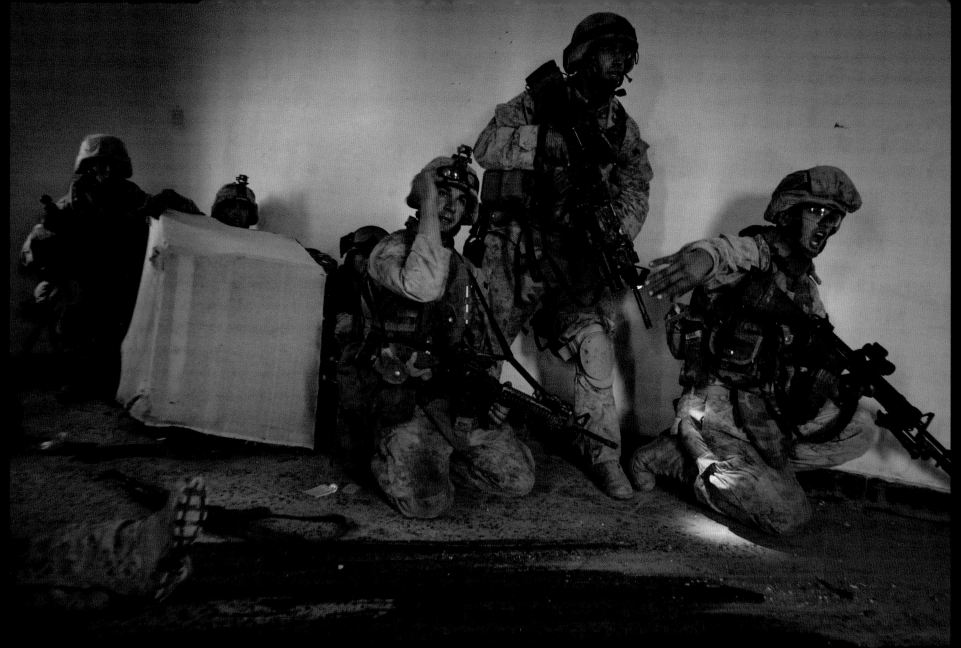

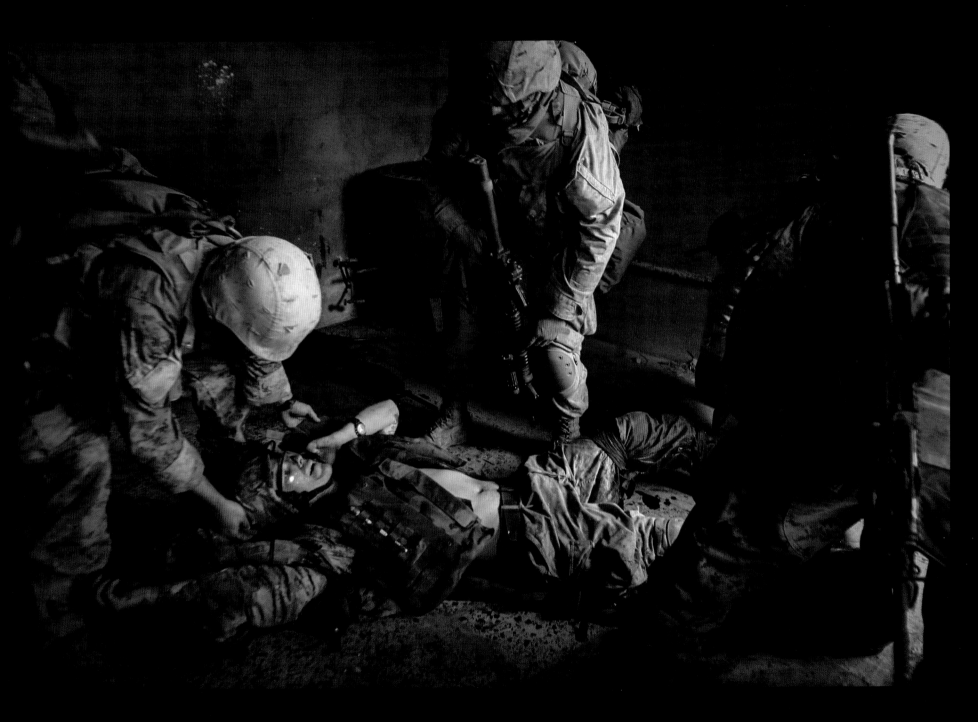

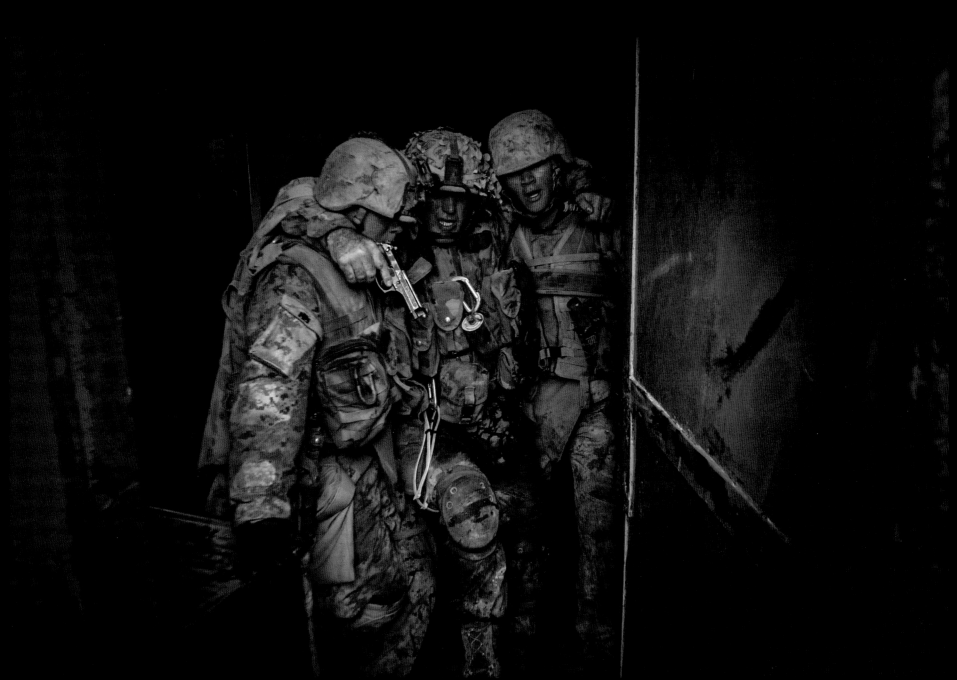

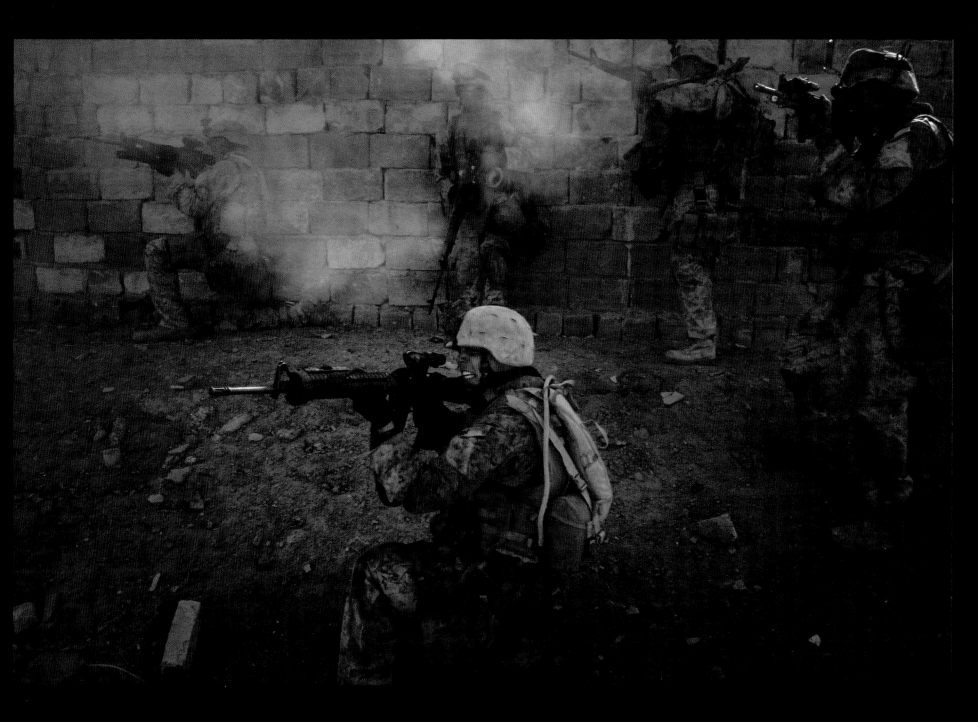

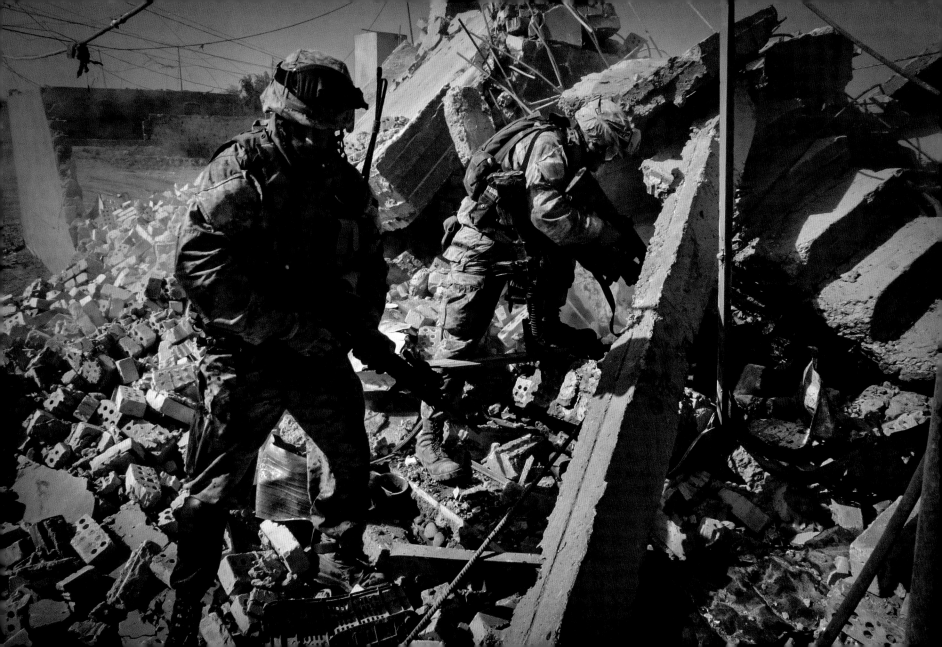

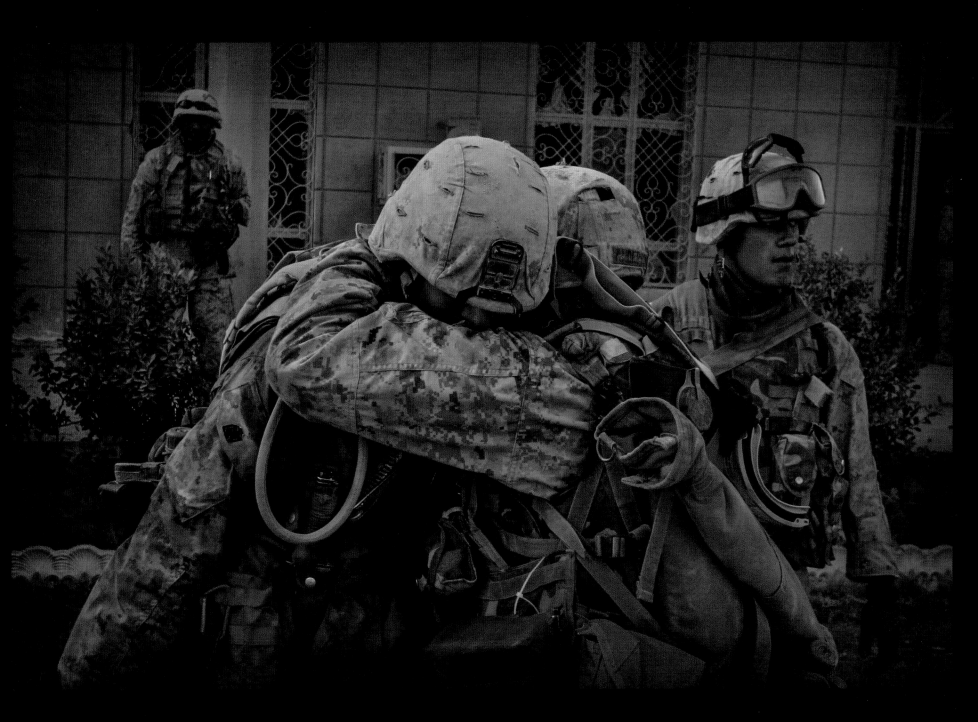

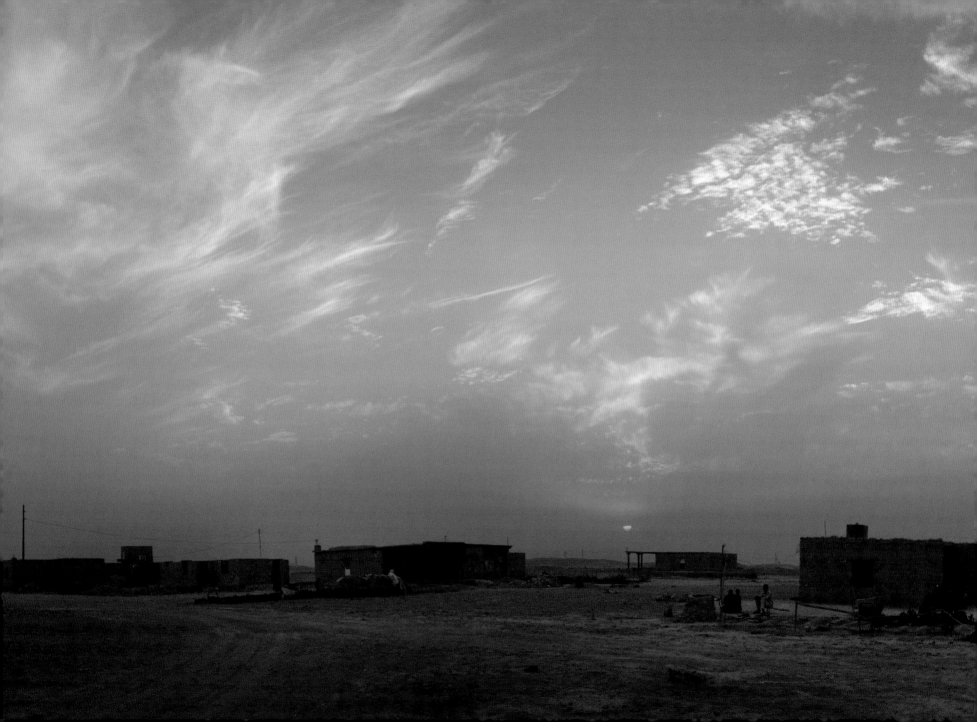

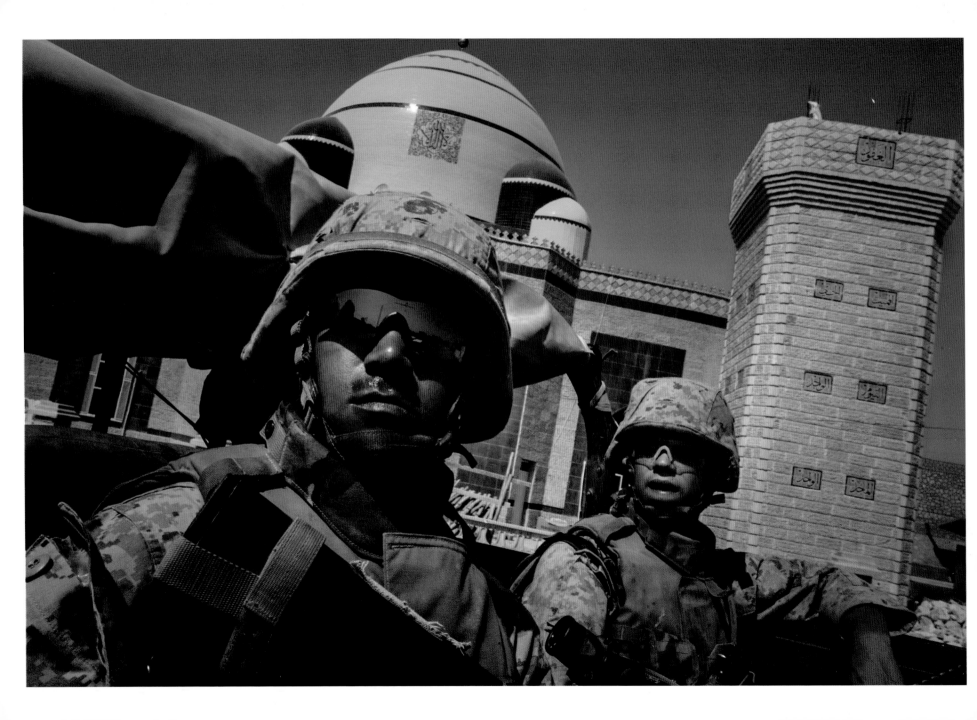

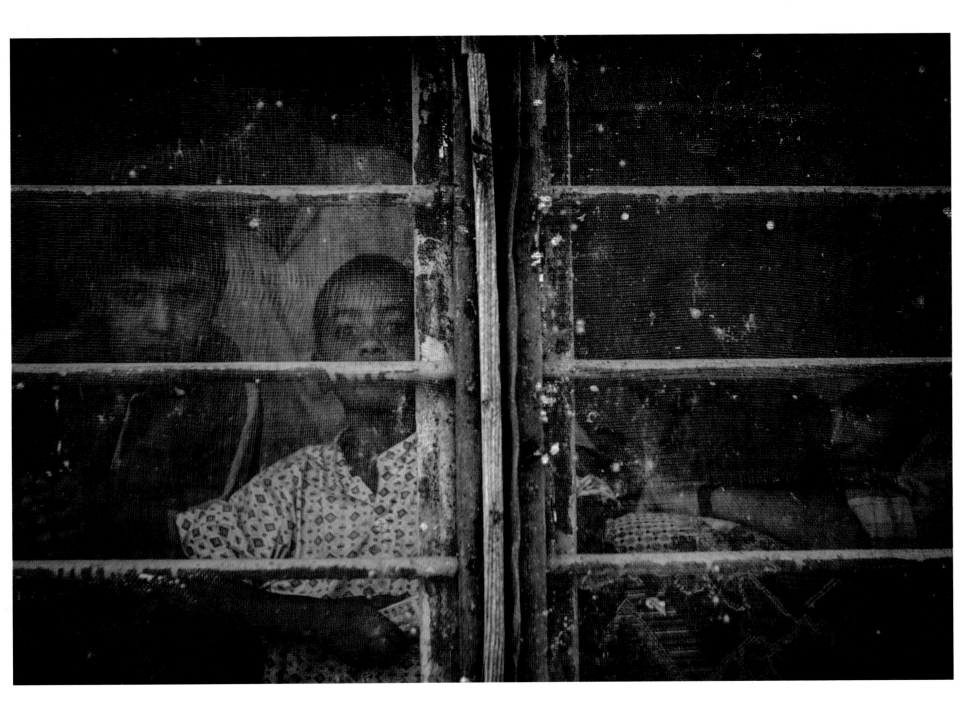

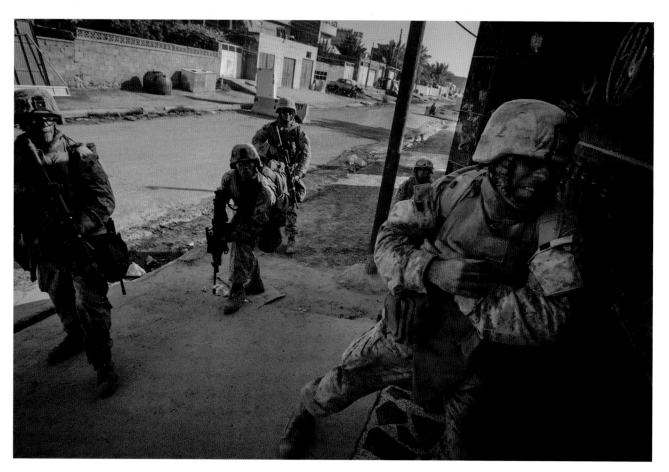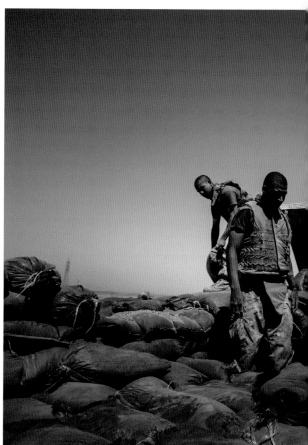

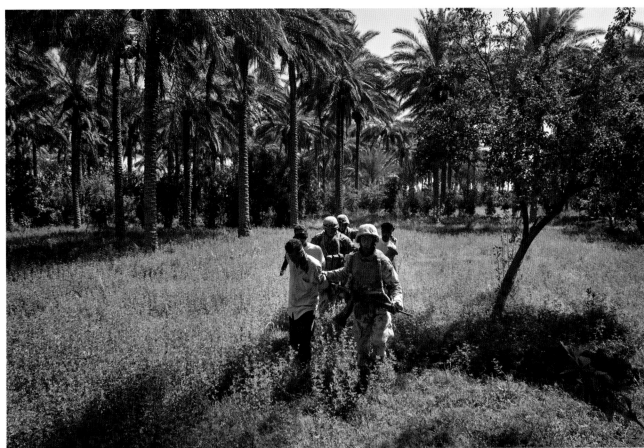

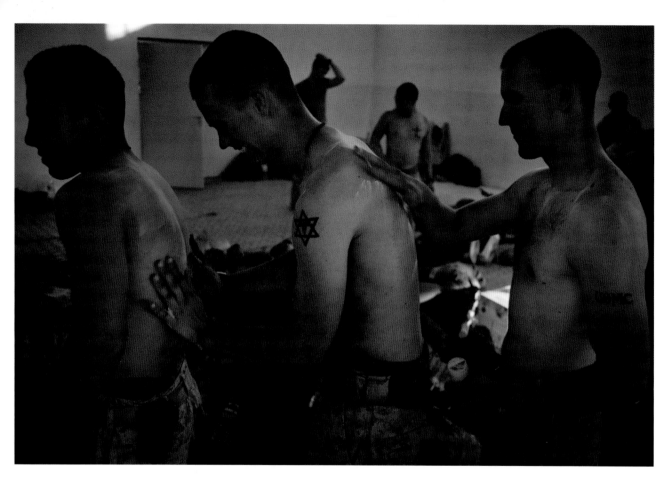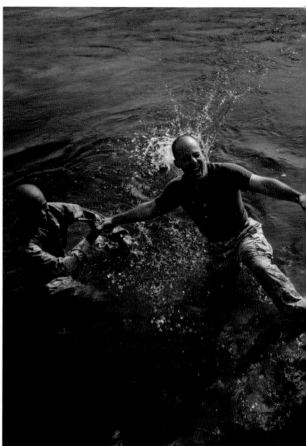

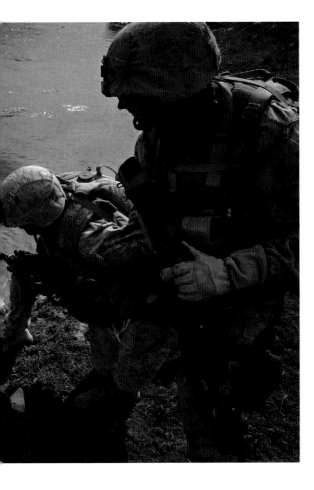
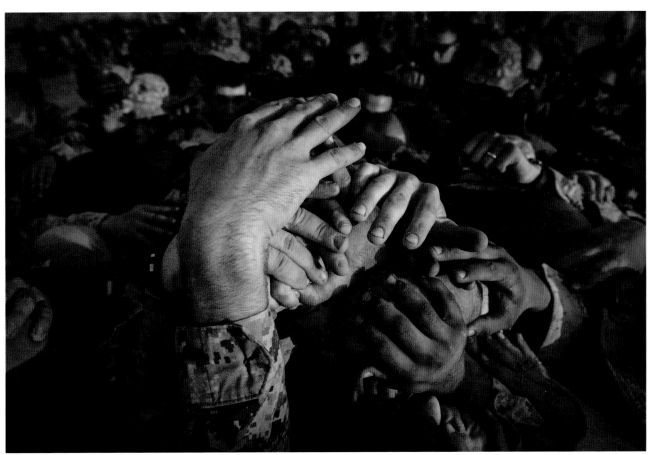

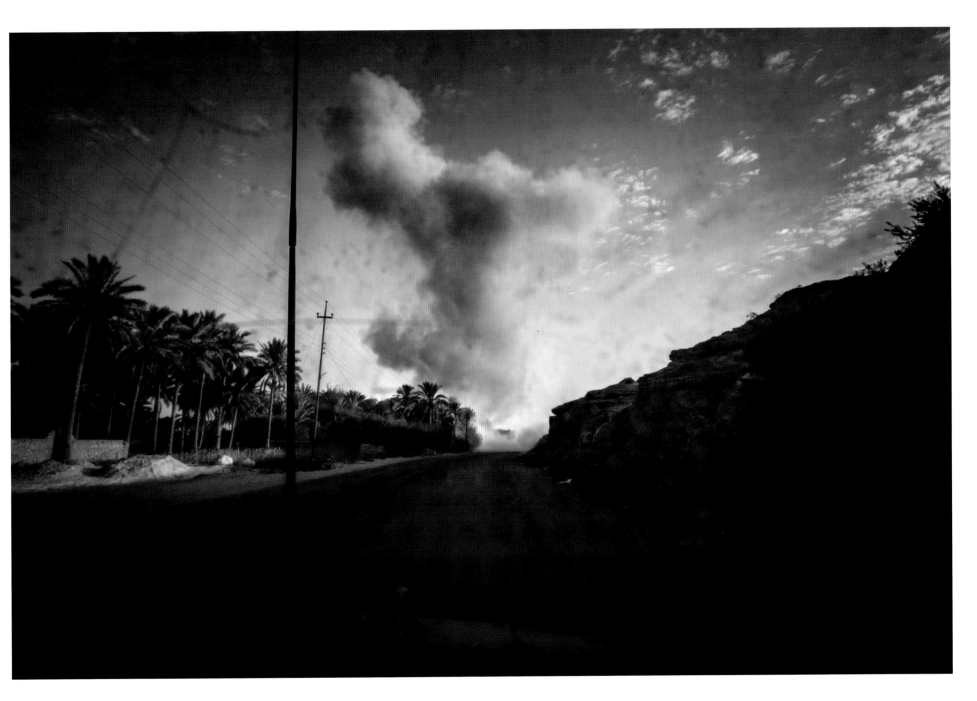

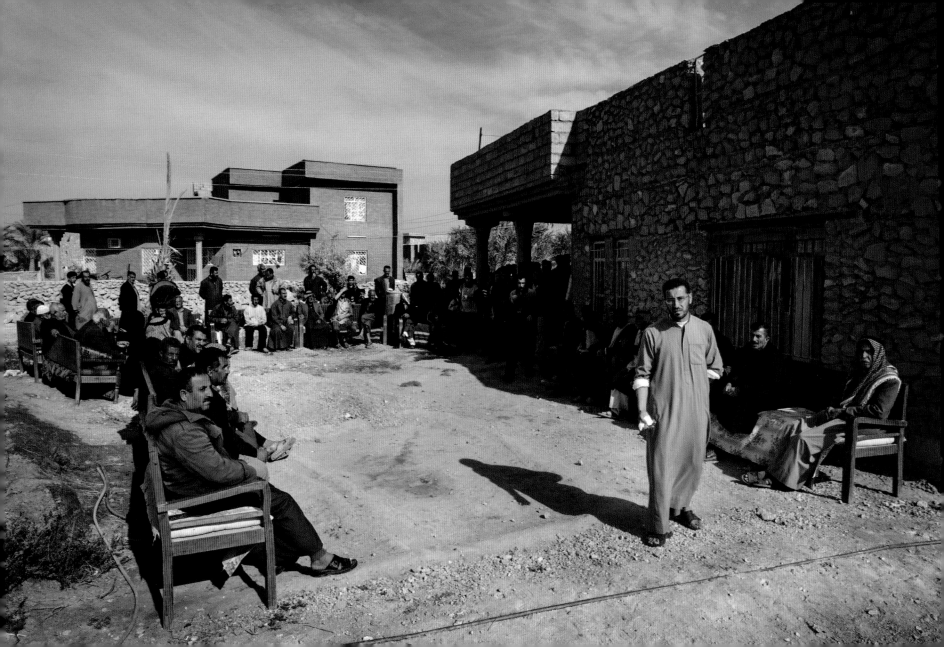

Kilo Company knows when they'll be back even before they get home. September. Seven months like clockwork. In Iraq again—of course, I went back with them—it was like we never left. Iraq becomes your reality—just behind, or just ahead, or all around you.

By October, they were lined up out in the desert outside Haditha behind the tanks and the tracks, waiting to assault another city from the desert before dawn. Kilo Company was in the lead—the tip of the spear. They expected a fight. The reservists had been chewed up there. We'd all heard about the fight at the hospital where the insurgents used the patients as shields; the sniper team rolled up—that track, however many tons of steel and aluminum—ripped in half and lifted into the air like a crumpled scrap of paper. There were funerals all over Ohio.

Then with Kilo in front, 3/1 walked into Haditha like it was just another patrol.

Where did the insurgents go? Nowhere probably, just slipped back behind the counter at the butcher shop and the bakery, back into the classroom, back into the palm groves, back into the mosque. The next weeks and months I was there, Kilo never found any of them—at least not one with a rifle in his hands. Found lots of guys whose names showed up on lists: "suspected associate of . . .," "possible financier for . . .," "former regime this or that . . ." Cuff them and blindfold them, fill out a statement, send them up to regiment, and hope it does some kind of good. Mostly though they found IEDs, scores of IEDs. IEDs in the desert. IEDs

under a beautiful new coat of asphalt. IEDs in the holes made by old IEDs. IEDs in the walls of buildings. IEDs in the filth on the sides of the road. IEDs in that garbage can that was empty when we passed by an hour ago.

The Marines bust their asses, running five, six patrols a day, and they still manage to plant them. Some fourteen-year-old kid rides out to the edge of town on his motorcycle. Should have connected the blue wire first. Nothing left but engine parts, blood, and an ID card. Mother says they haven't seen him for a couple of days, that is he's been hanging out with his new friends, but he's a good student, would never get mixed up in something like that. "Sorry, ma'am, we can show you where we found him." How many patrols a day to stop that?

After the referendum I headed west, out to the Syrian border and Al-Qa'im. It was the last place I hadn't been; just wanted to take a look around and stumbled into the biggest operation in a year—biggest on paper anyhow. To the grunts it ended up being a "dump-ex"—an exercise in getting rid of all the extra ammunition they made you carry. Since the big battles of 2004, the insurgency had learned the important lesson: when the Marines line up in the desert you leave or go back to your day job. If you really want to kill yourself, you might as well do it at the wheel of a car loaded down with explosives in the middle of a passing convoy or in front of a Shiite mosque. No sense being shot in the head while standing in the middle of the street fumbling with an RPG. The Marines ripped the place apart, but mines, IEDs, and a handful of guys too confused to know when to leave town left more Marines dead than it could ever have been worth.

When it wrapped up after a couple of weeks it was time to go back to Haditha.

November 19 I was doing one last load of laundry, soaking up a little more contractor chow, and lying in my rack watching DVDs. It's hard to shake the feeling now that if only I had gone back a day or two earlier, I could have put myself between the Marines and the Iraqis, and whatever did or didn't happen that day, it's hard not to hear a voice saying, "if you hadn't wanted to sit on your ass maybe you wouldn't need to be writing this now."

All I knew when that patrol stepped off two days later was what I had been told—that an IED had killed Miguel Terazzas and then they had been fired on, that there had been fighting all over town that day, and that a lot of insurgents and civilians had died in the fighting. The two Iraqis who stepped out to speak with the patrol from the crowd of men at the house where the bodies had been returned to the families volunteered that insurgents lived and worked out of this neighborhood, said they were afraid of them. They even asked the Marines to please come and stay here, stay in this neighborhood so that there would be no more fighting.

When they saw me—the guy with the camera and the beard and no rifle—they asked me to come in and photograph the dead. No Marine tried to stop me, even though it was dangerous for them to wait. Inside the house they showed me the bodies—uncovering two as they led me to the pair of rooms where they lay—questioned me, without expectation of an answer, why it happened, and asked me to take the pictures

and show other people what I had seen. No one screamed murder at me. No one was hostile to me. No one assaulted me, though, having removed my armor to set aside its implication of violence, I would have made an easy target. There were only so many pictures to be made there, and soon, mindful of the Marines waiting outside and the volatility of the situation, I withdrew to the street. It was over in maybe ten minutes.

Of course, now I've gone over that day, and those that followed, in my mind a thousand times, been poked and prodded about it by writers and editors and men with badges, but no matter how many different ways I go at it, I can find nothing in my memory that should have raised an alarm. Everything I saw inside that house squared with everything I had been told. Afterward, no one tried to stop me from taking the pictures or sending them to the outside world, though lots of the guys saw them after I took them. God knows what might have happened that day, but I never saw anything to indicate a breakdown in discipline as extreme as the worst of the accusations. In the days that followed there were no whispers, no looks, no hints.

People die over there all the time, are dying right now. A room full, a house full, a street full of the dead is the numbing backdrop of everyday life in Iraq. In my mind, as I walked out of that house, I only felt that I had made yet another mute, useless record of it. Only time will tell whether I was right or wrong.

New York, New York
June 29, 2006

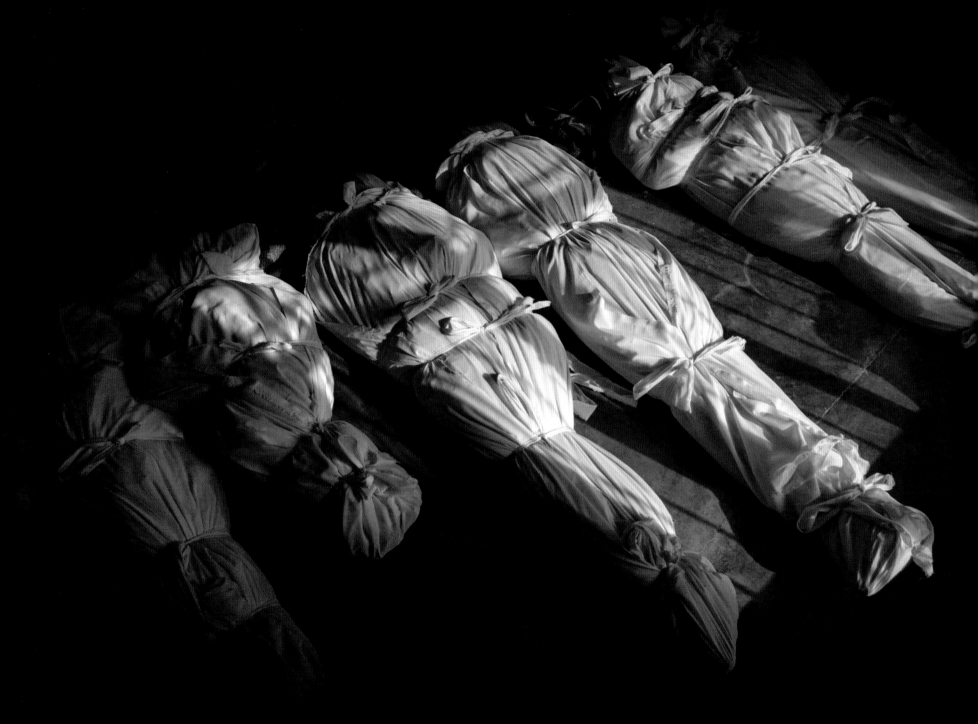

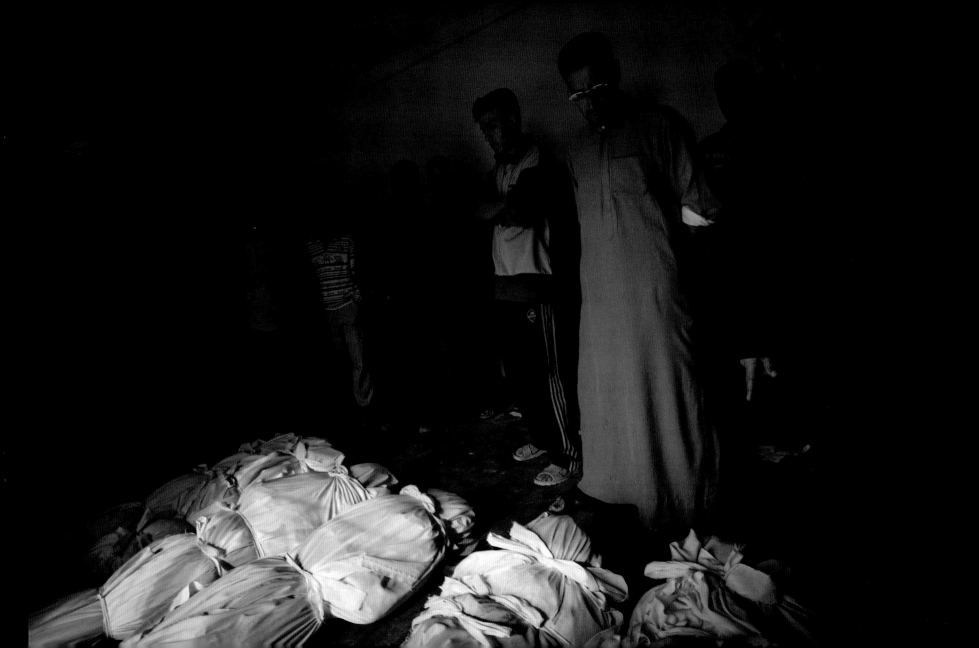

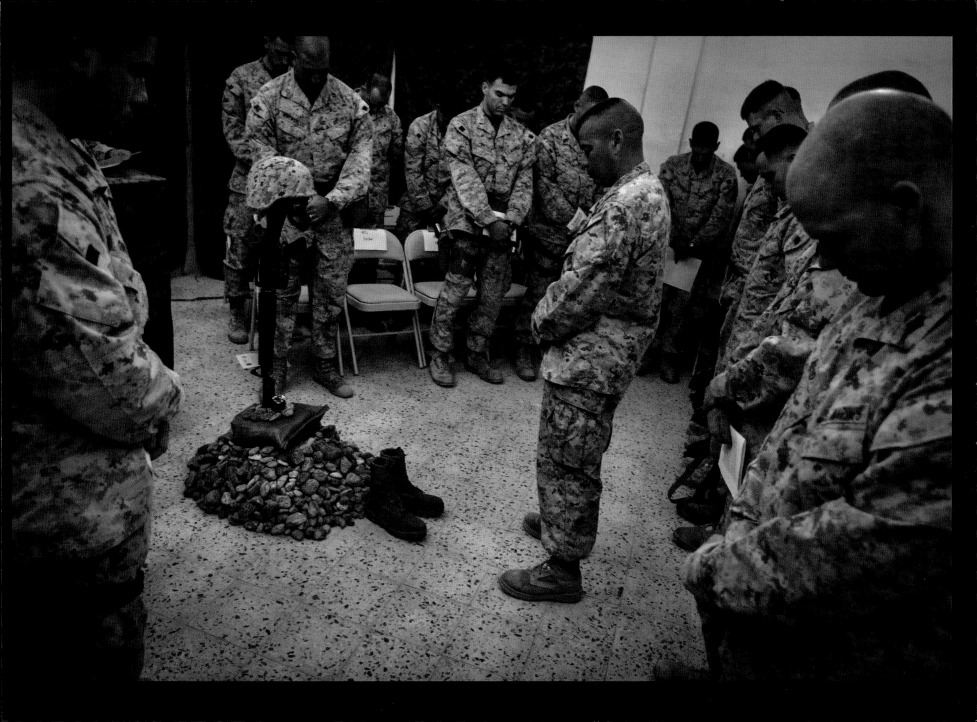

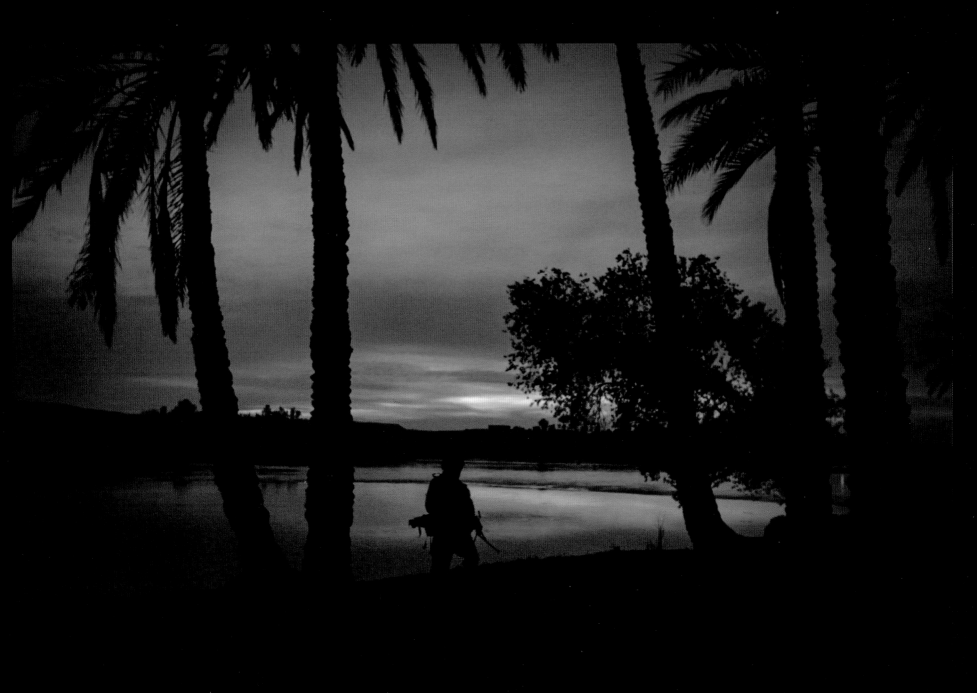

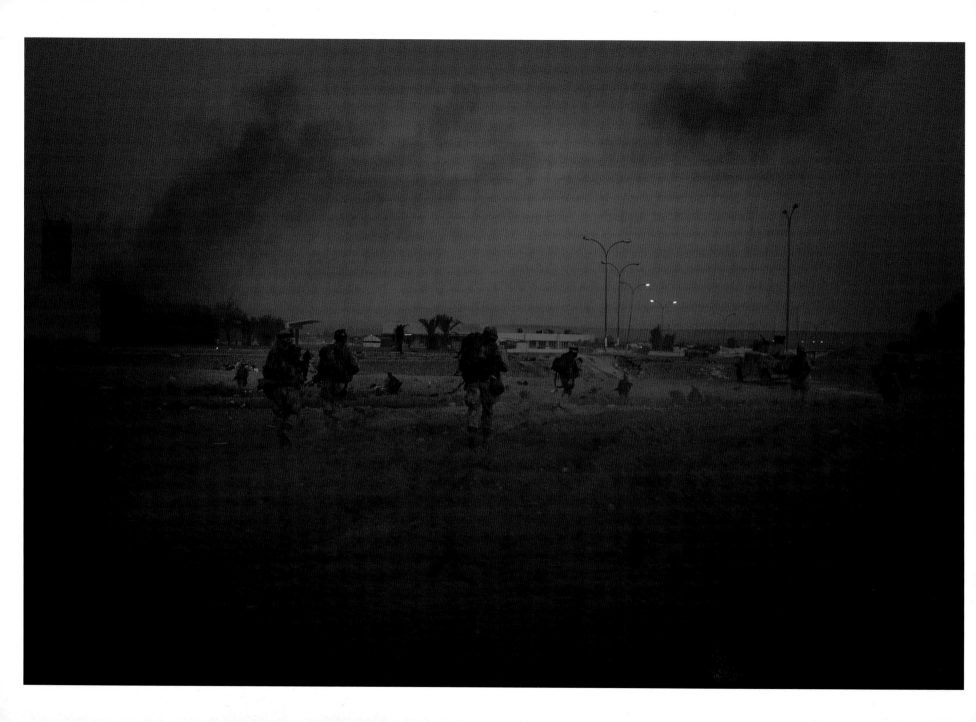

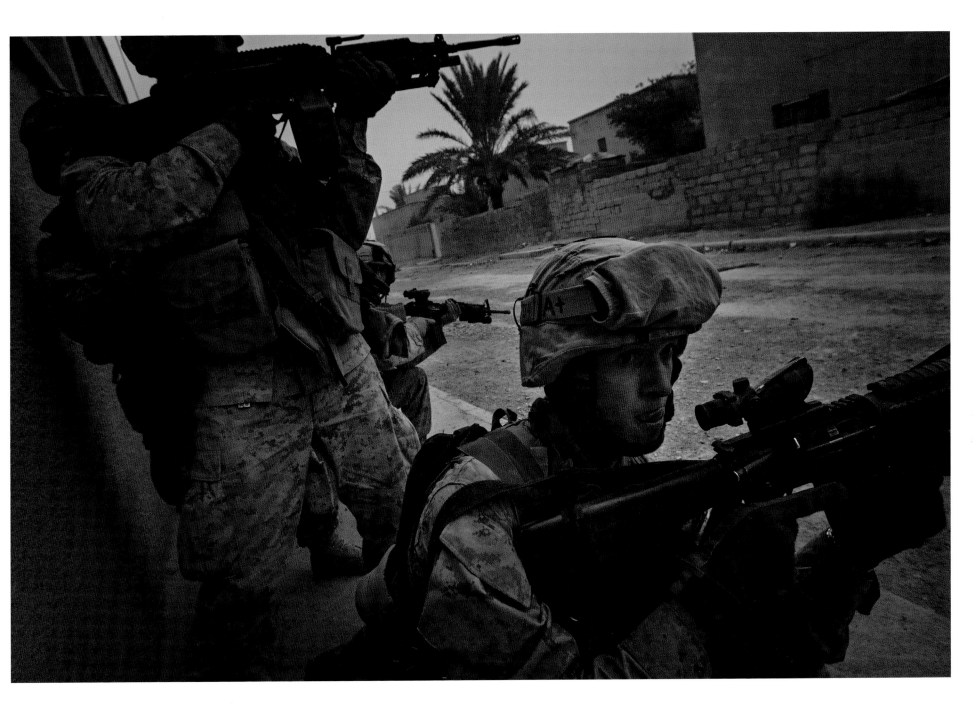

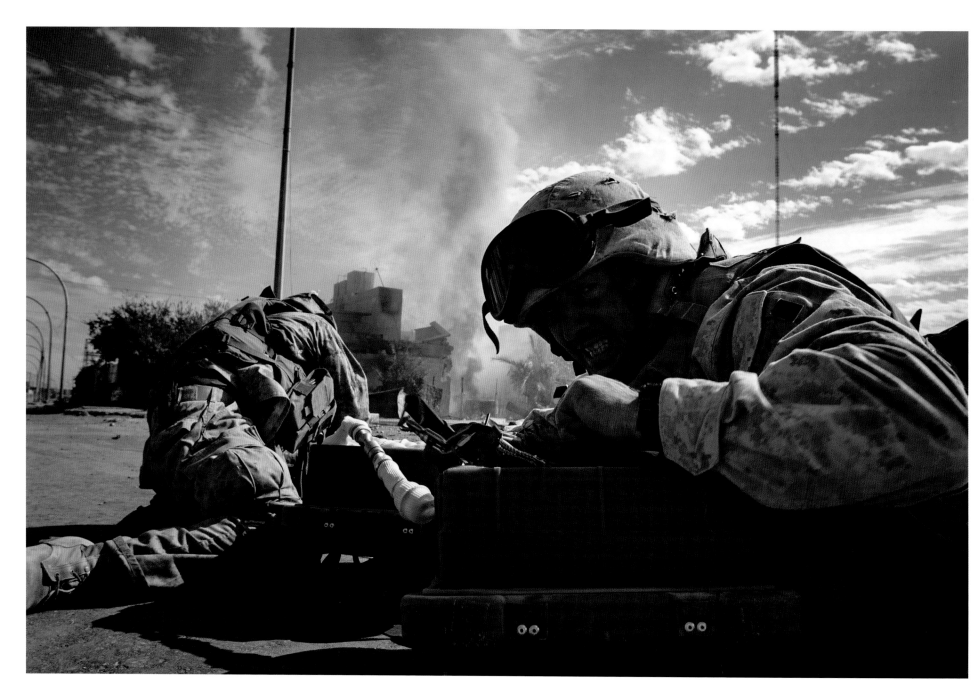

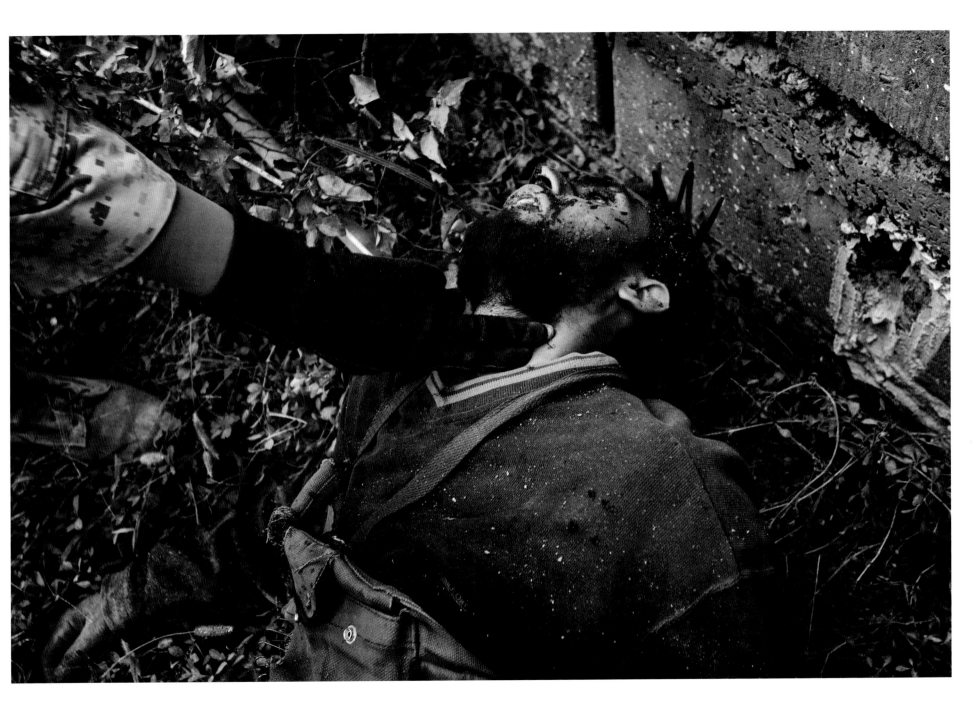

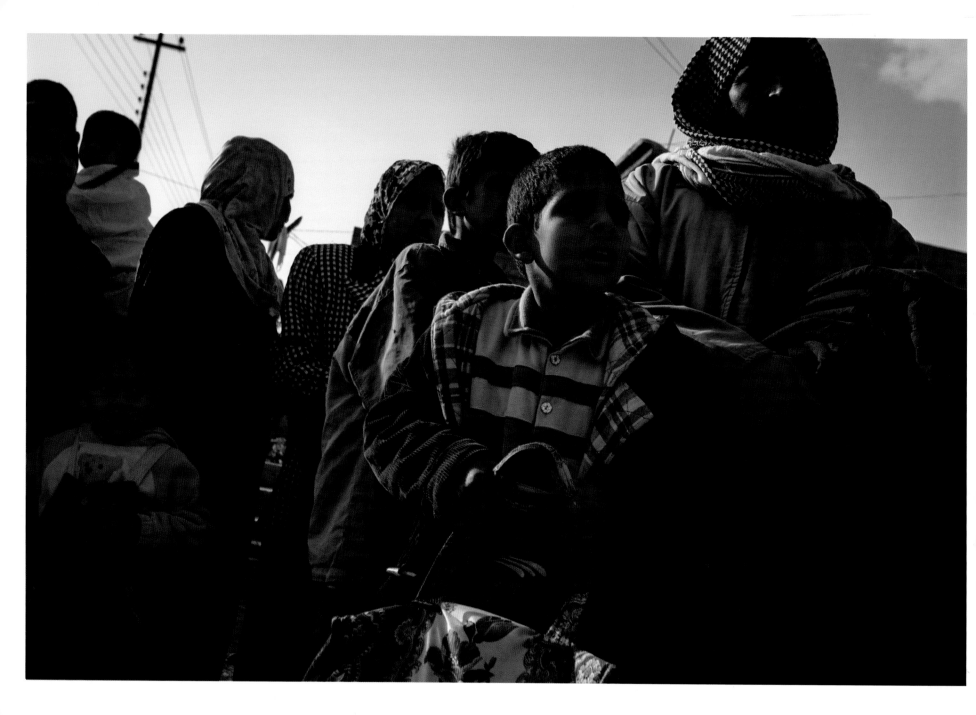

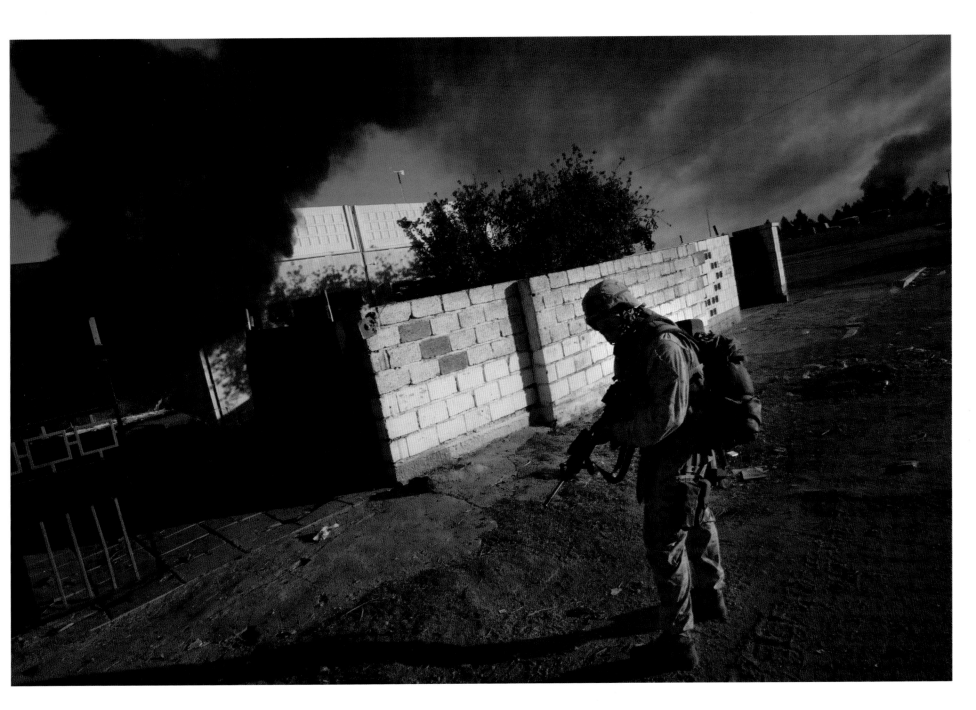

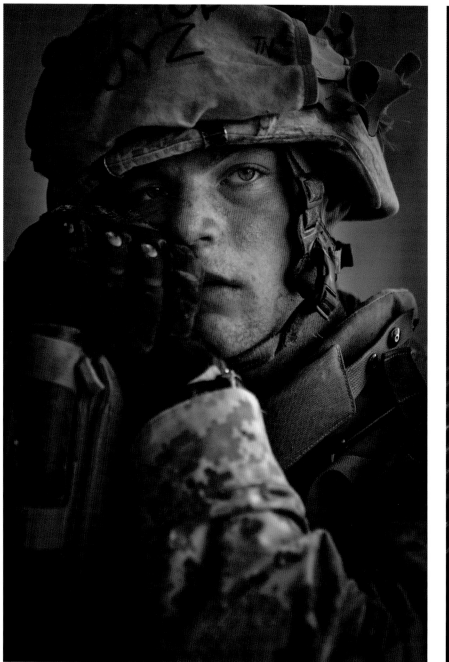
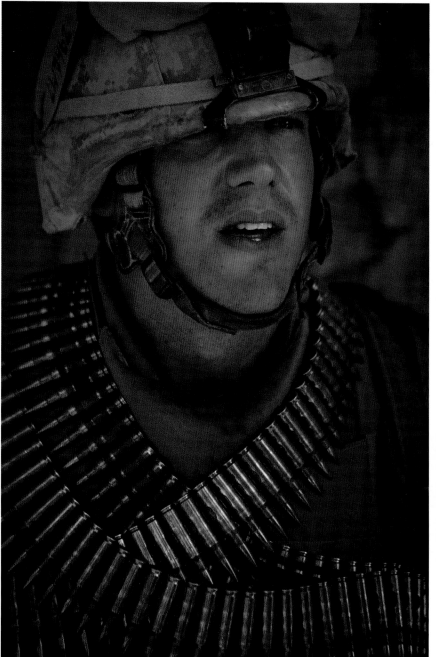

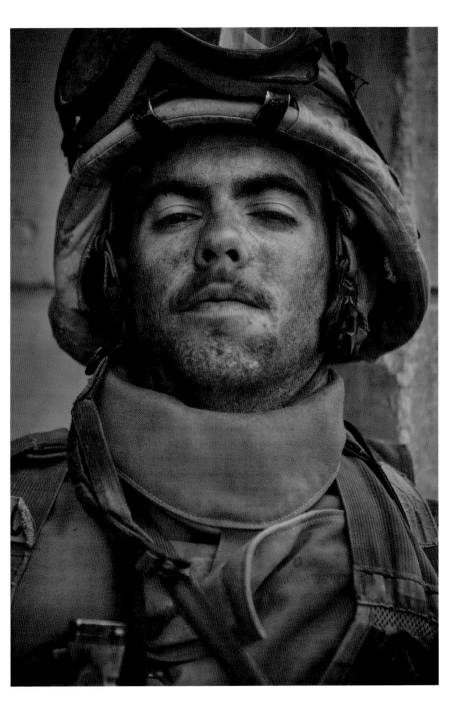

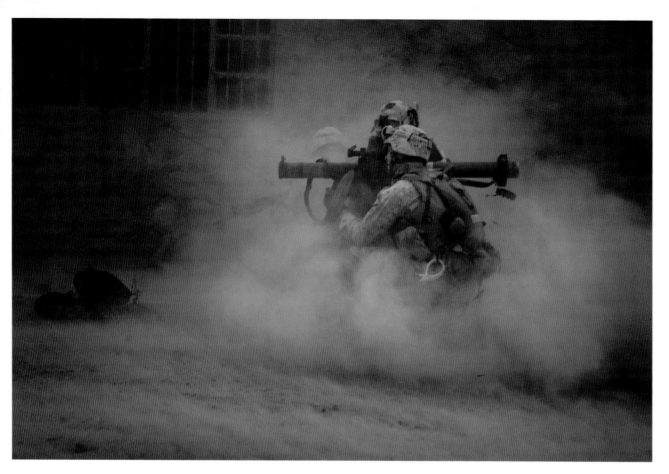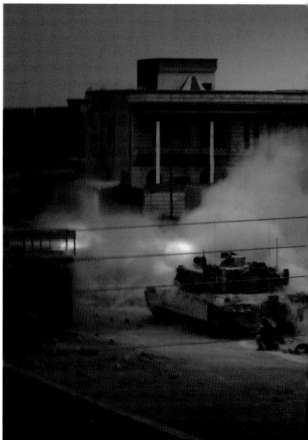

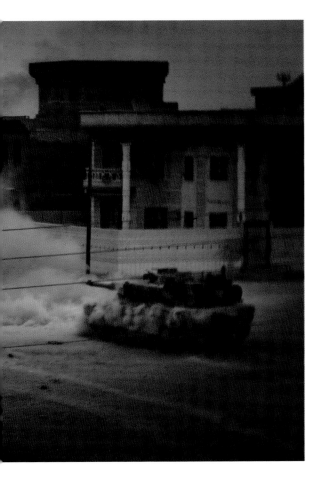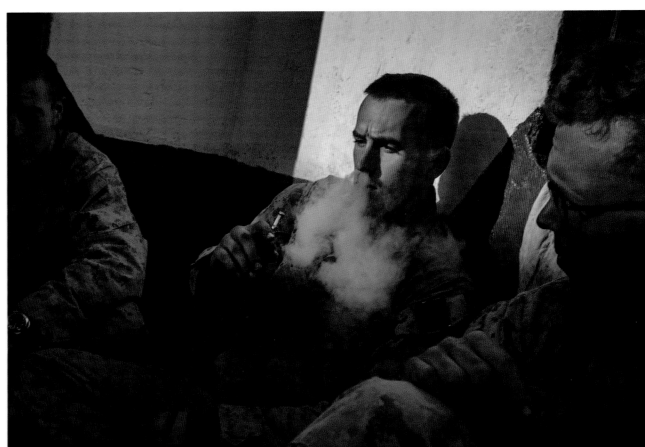

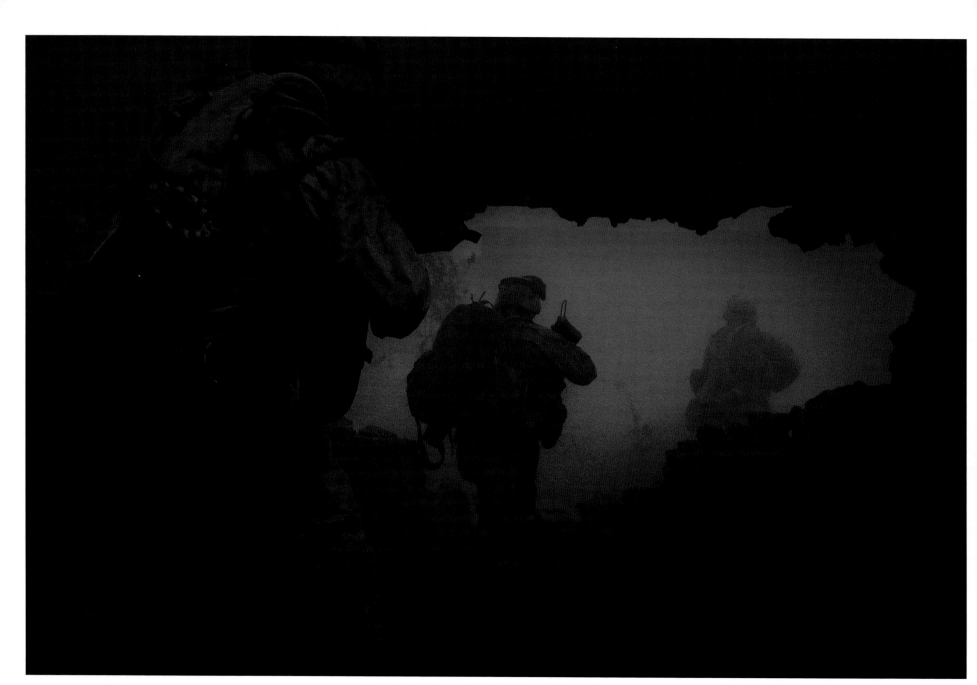

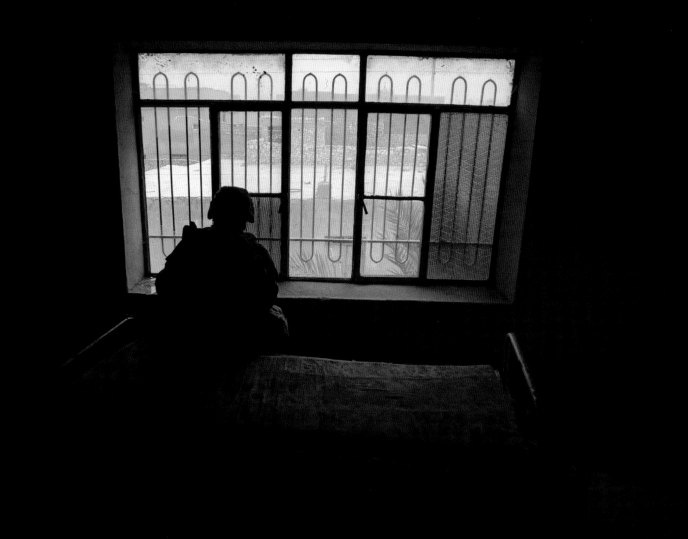

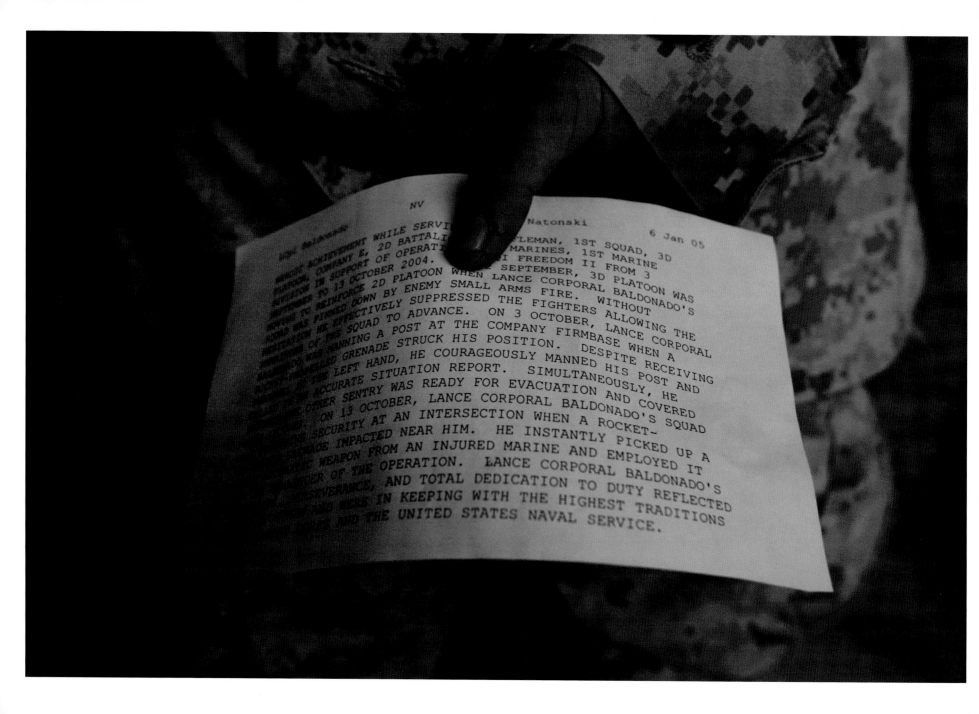

DEMOCRACY

I hope I'm wrong, but does anyone seriously believe that January 31 the bad guys are going to wake up, smell the democracy in the air, and decide, "Fuck it. We had some fun there for a while—I mean, who doesn't love a good explosion?—but let's get with the program, jump onboard, join the team, and come in for the big win." Is this what people who cut off their neighbors' heads with pocket knives, car bomb children, and drag burnt corpses through the streets can be expected to think?

Look, we're here, we created this situation, so we have to do whatever we can to undo the damage Saddam did, right our wrongs, and try to leave this a better place. More than that—like some of the Marines have said—we better make damn sure that the Americans who have already died over here haven't died for nothing, for a mistake. Just as we make sure that there's not one more American or Iraqi walking around living, breathing, and dreaming right now who has to die unnecessarily.

The Marines know that nothing will likely change in the days after the vote. They play a game of inches here. Day by day, you pull the weapons off the streets. You keep your eyes and ears open, keep looking for the bad guys, and wait for a lead or a lucky break. Leave the door open for the few brave folks to bring you the piece of intel you've been hoping for. If things go your way long enough, it all starts to move in your direction, and you have a few good weeks. IEDs become scarce. Nobody snipes at your guard posts. You don't check your watch to see if it's Mortar Time. Maybe even the ING shows up to work for a while.

If anything, for now the approaching election is making things worse. Three times in as many days, as I've tried to write about the situation here in Ramadi and the upcoming vote, a gun battle or incoming mortars—or both—have interrupted my attempts. Yesterday, I stopped writing to photograph Marine snipers and mortar men repulse an attack on the main government building. One minute I'm writing and the next—200 feet away—I'm making a picture of a sniper blow a hole in an insurgent's chest as he and a comrade tried to fire a jerry-rigged air-to-surface rocket at the Marine fortifications. By way of comparison, a month ago, when I arrived in the city, I was photographing the delivery of hospital supplies and Santa Claus.

Some folks say the increasing attacks are a sign of their desperation as they try to derail the elections, but to me it's apparent that they still have the initiative and the will. They know they can't defeat the Americans. The Marines aren't going anywhere. If, like yesterday, initiative and will leave a couple of their foot soldiers dead in the streets, no big loss. They're not looking for victory, just maximum damage. Besides, the Americans are not the real targets; it's the Iraqis. The assassination campaign against "collaborators"—translators, the guy who works in the laundry at the Army base, children attending the opening of a waste treatment plant because the Americans were handing out candy and pencils—kill enough of them and you can keep the society scared shitless. That's how Saddam pulled it off for thirty years, and these are his guys.

This is all assuming that here in Ramadi there is going to be an election at all. The people here don't even know where the polling places are going to be set up. That's classified. On a patrol a few nights back, I walked into a home where the Marines had moved in to place shooters on the roof to provide overwatch protection for the guys in the street. An NCO was talking to the man of the house, who was a doctor of some sort and spoke decent English, in the variety of speech usually reserved for toddlers, the mentally handicapped, and immigrant bus boys. Vote good. Everybody vote. Vote for Iraq. Vote. Vote. Vote. The man looked back and forth between the Marine and me with an expression at once confused and amused. Really? Where? Here in Ramadi? When, January 30, right? Really? Are you sure? Ramadi? When it was explained to him in sentences complete with verbs that the locations for the voting would be released at the last possible second to keep the insurgents from flattening them or lacing them with booby traps and IEDs, he smiled and said simply, "Good plan." At least you guys aren't completely lost.

Forward Operating Base Blue Diamond, Ramadi
January 10, 2005

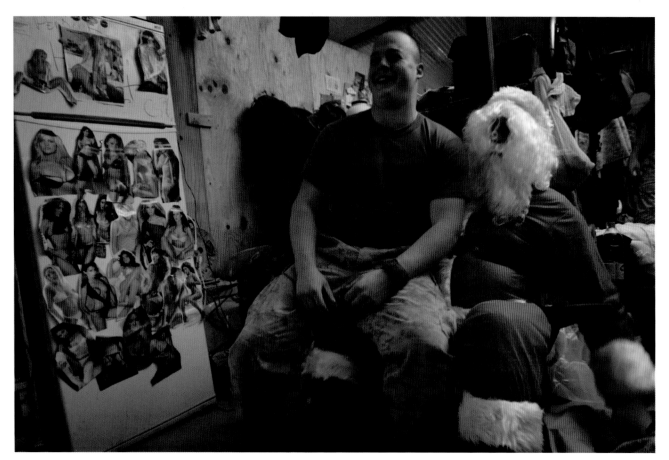

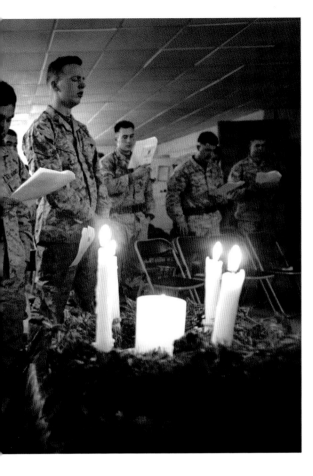
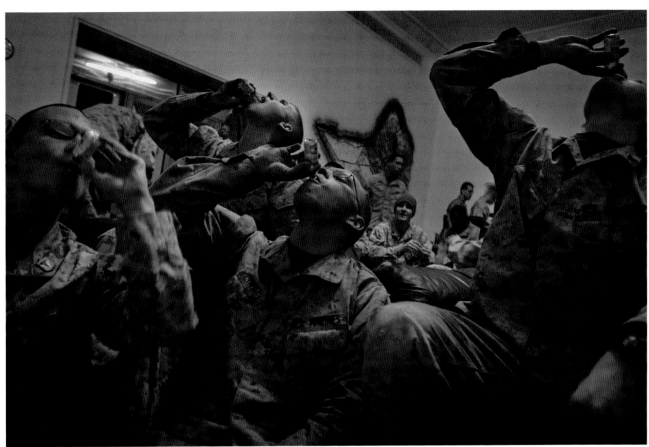

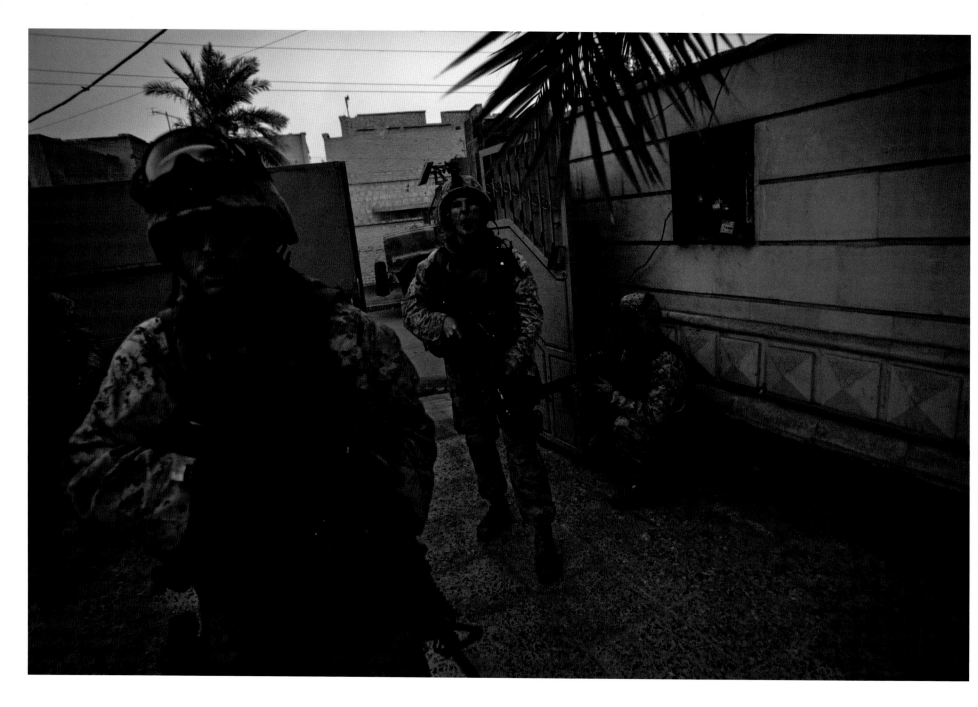

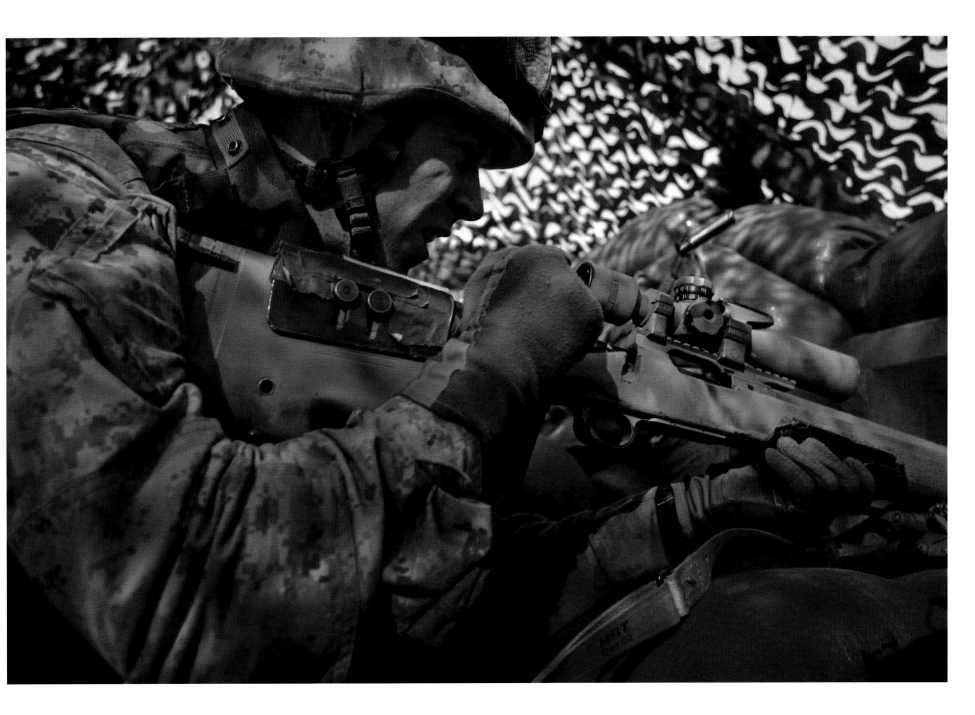

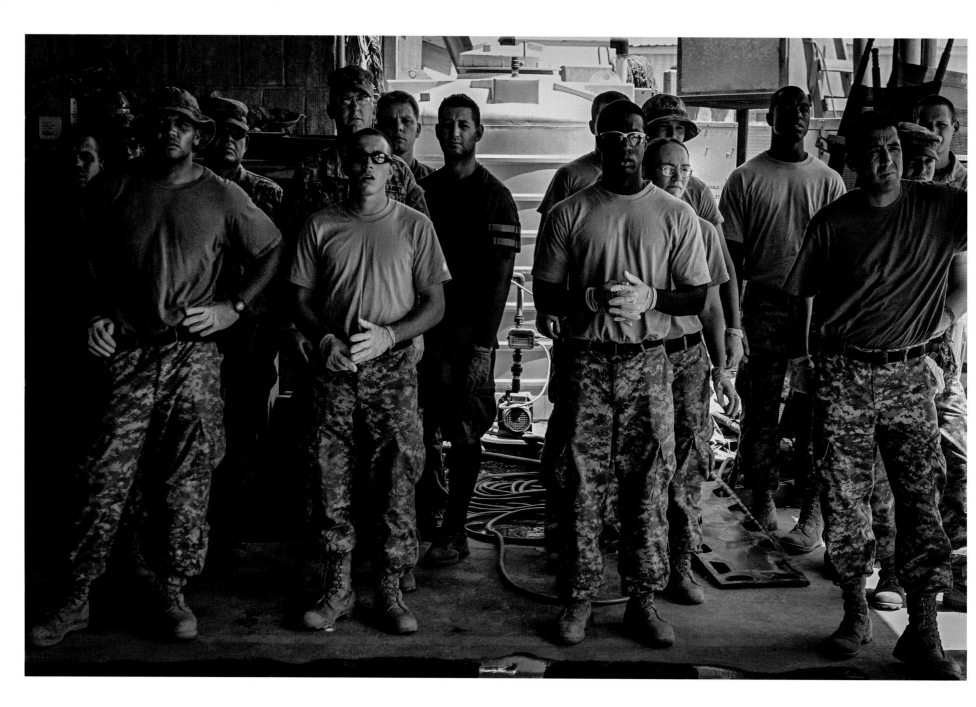

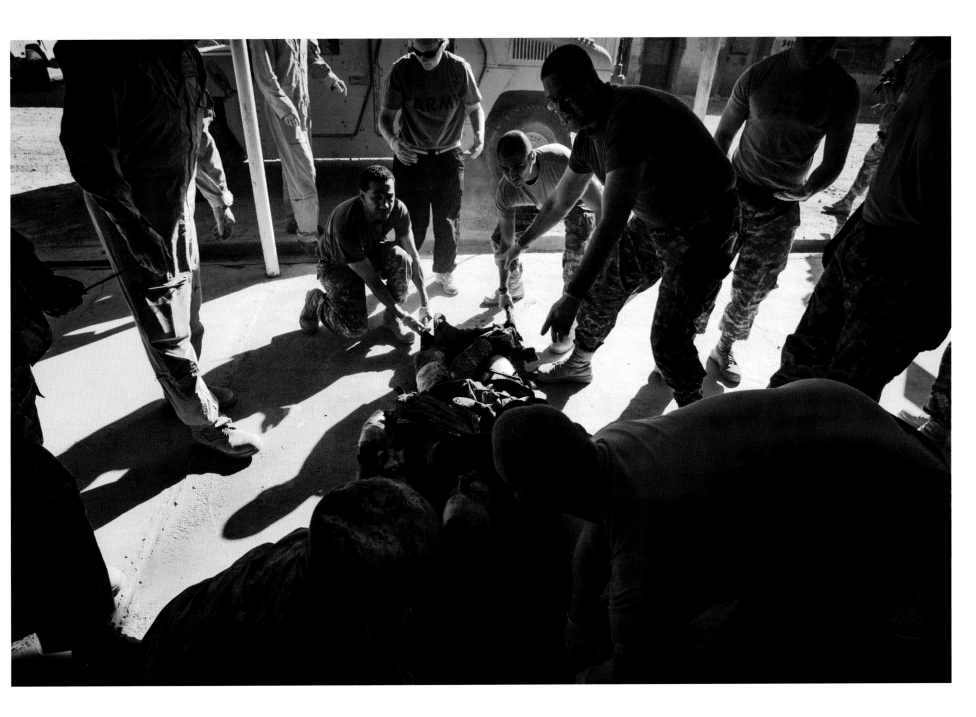

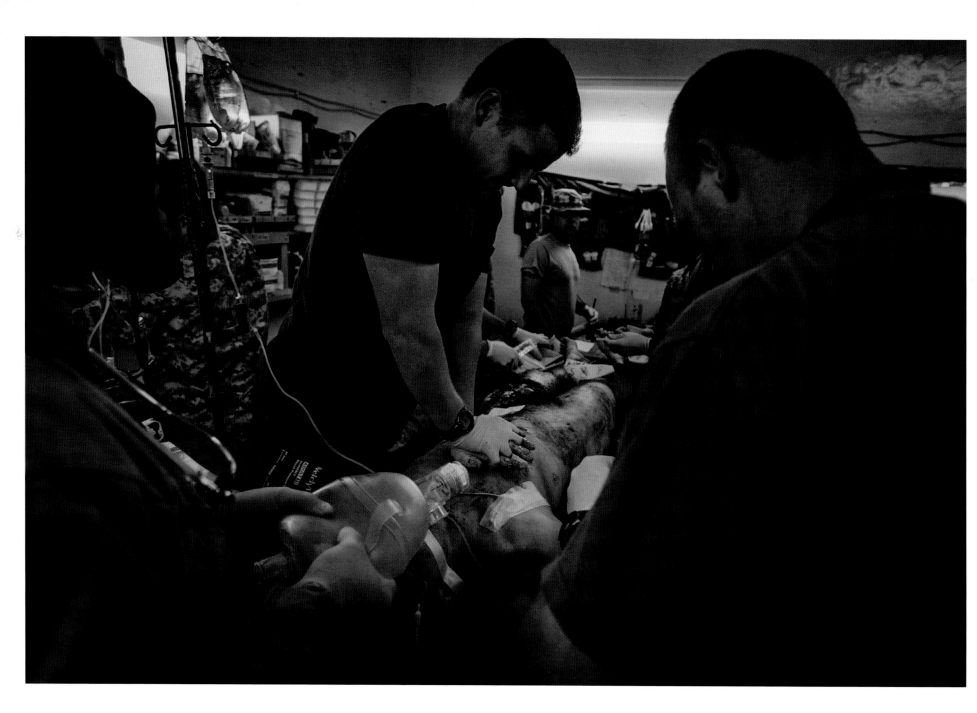

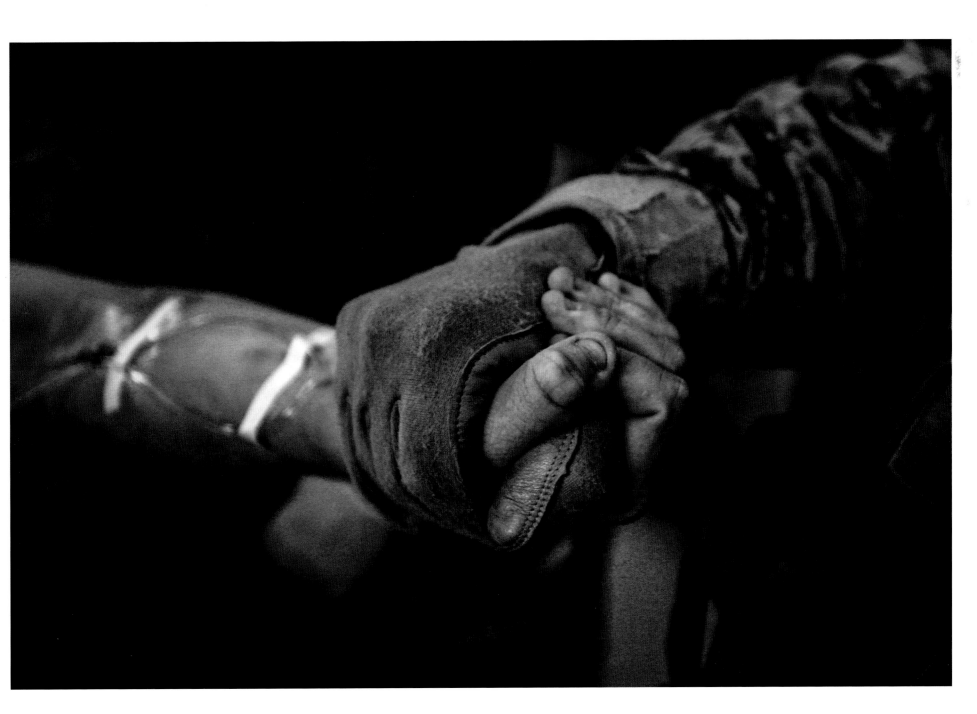

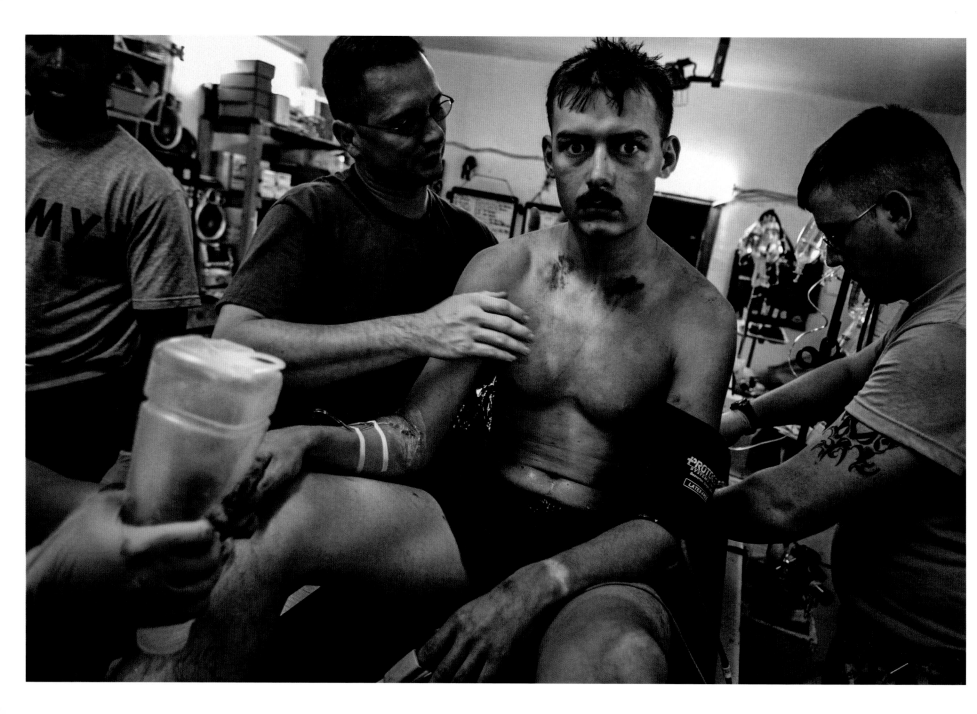

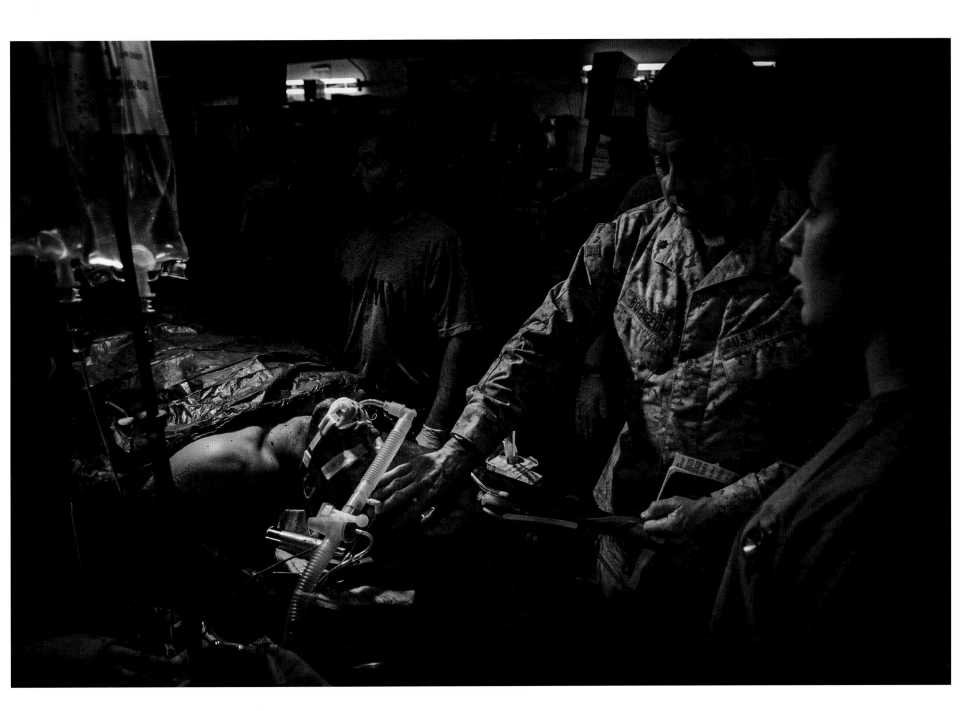

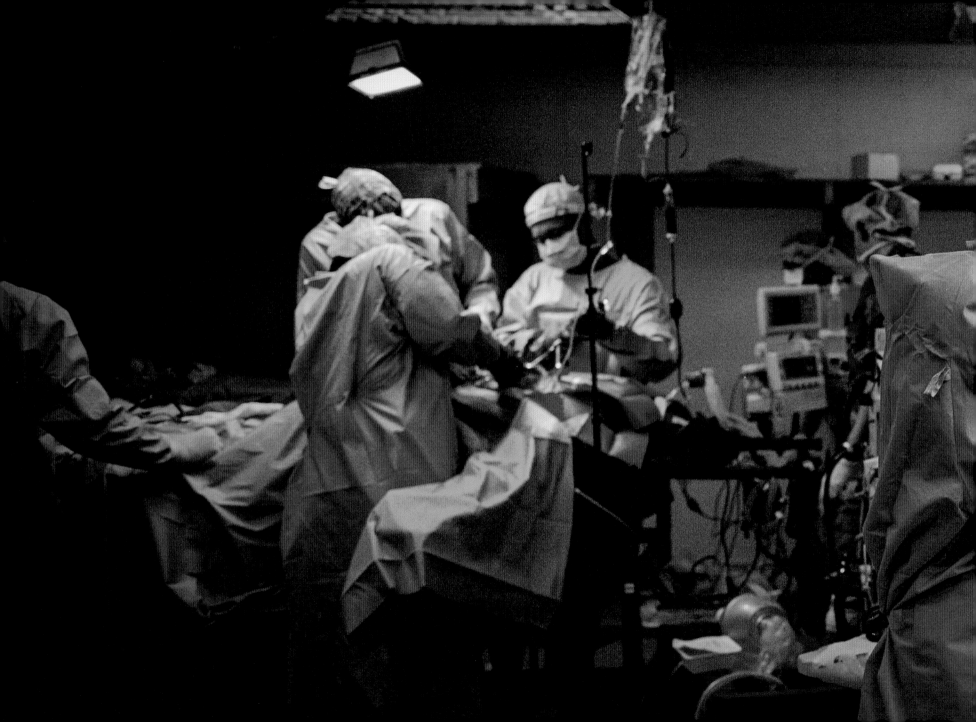

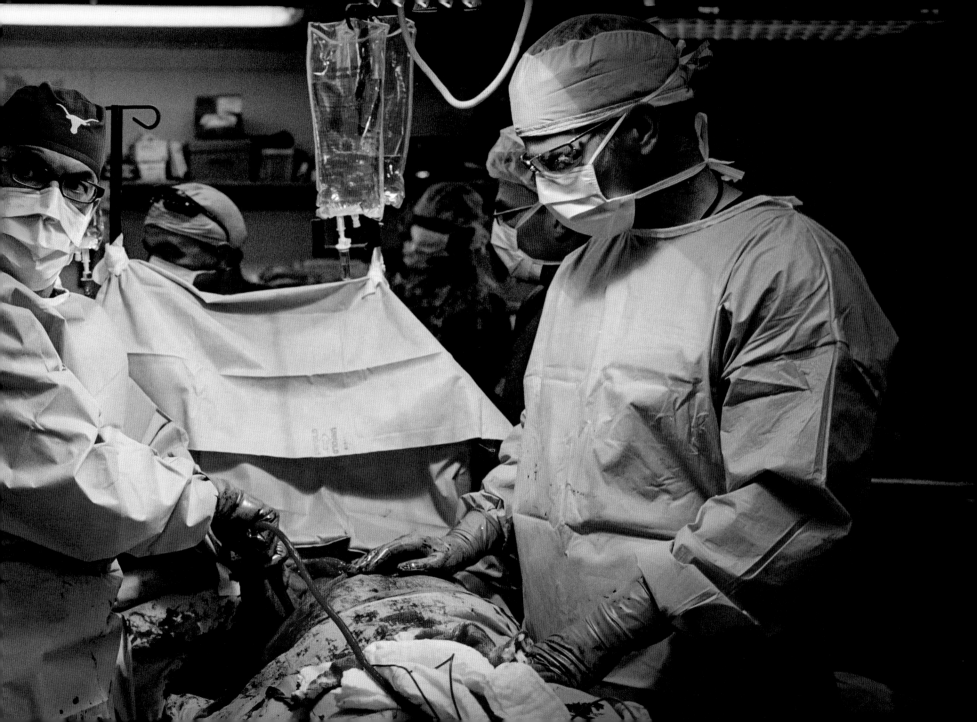

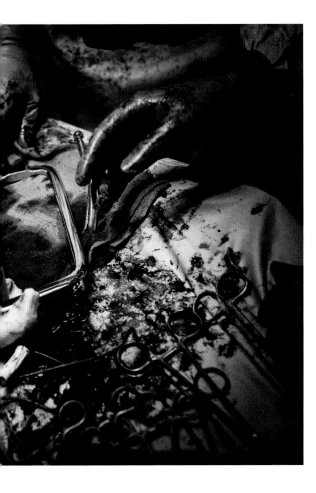
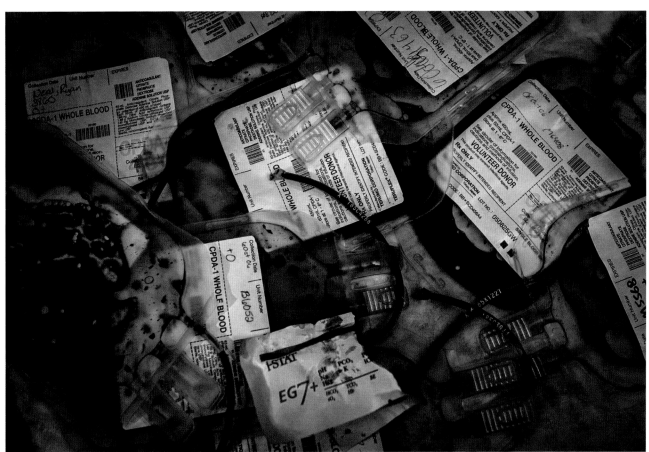

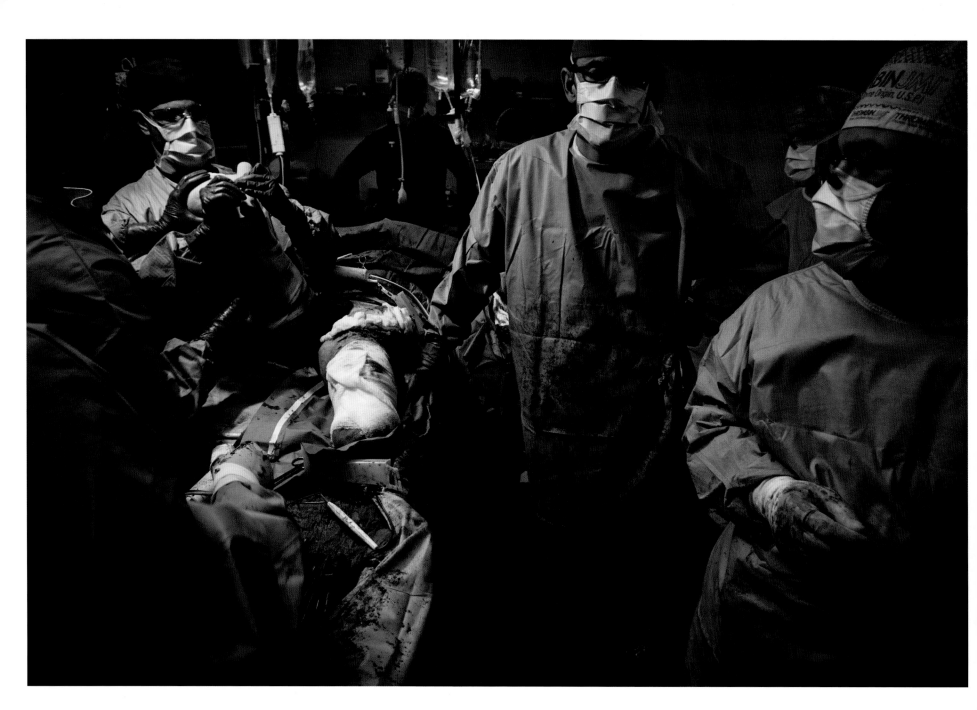

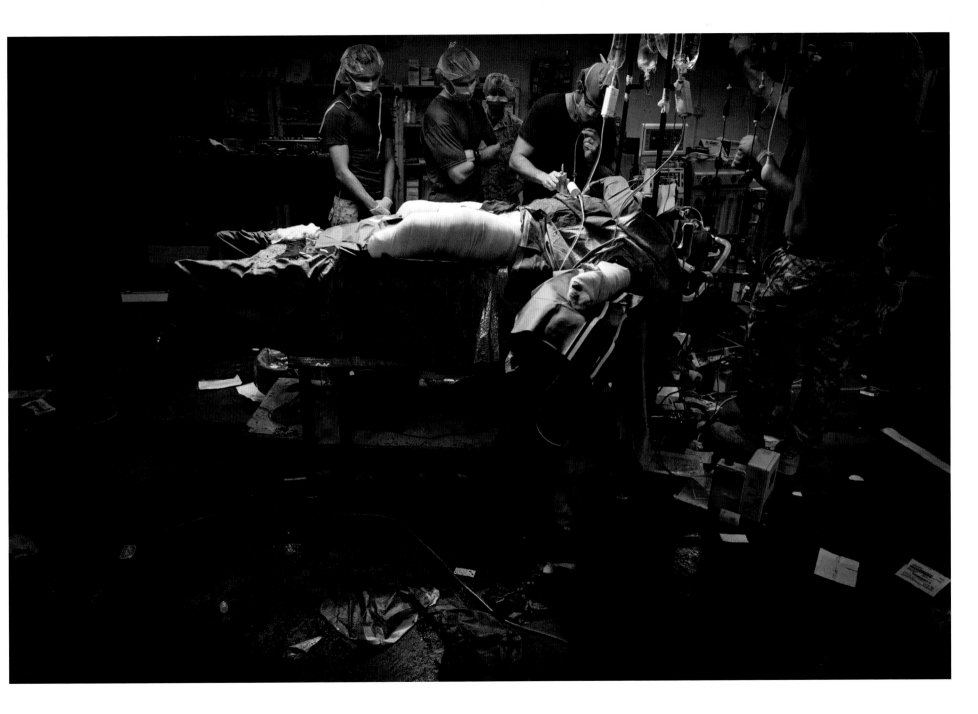

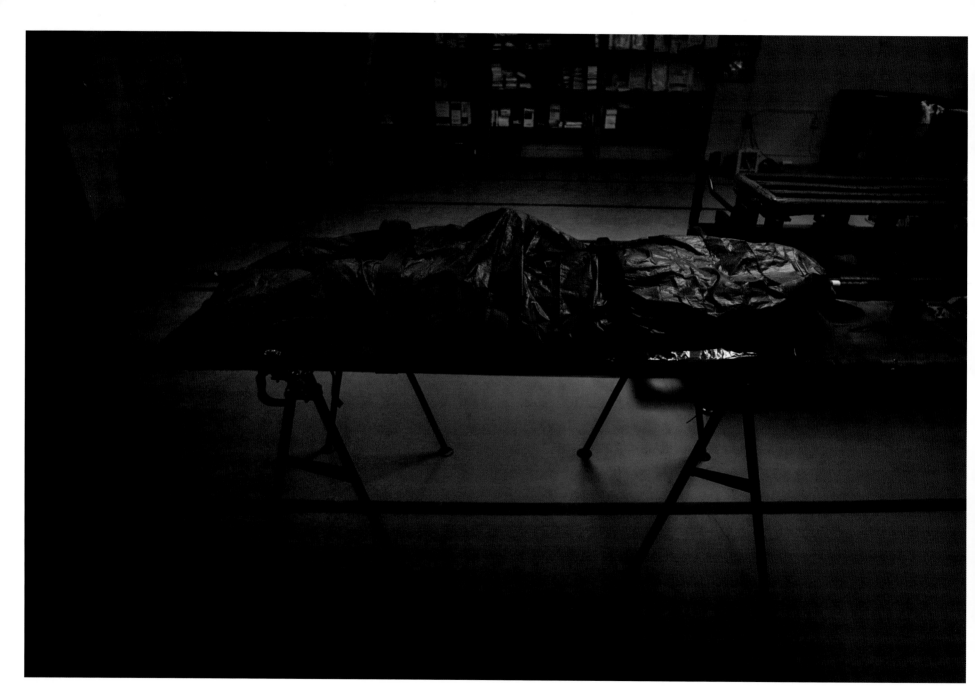

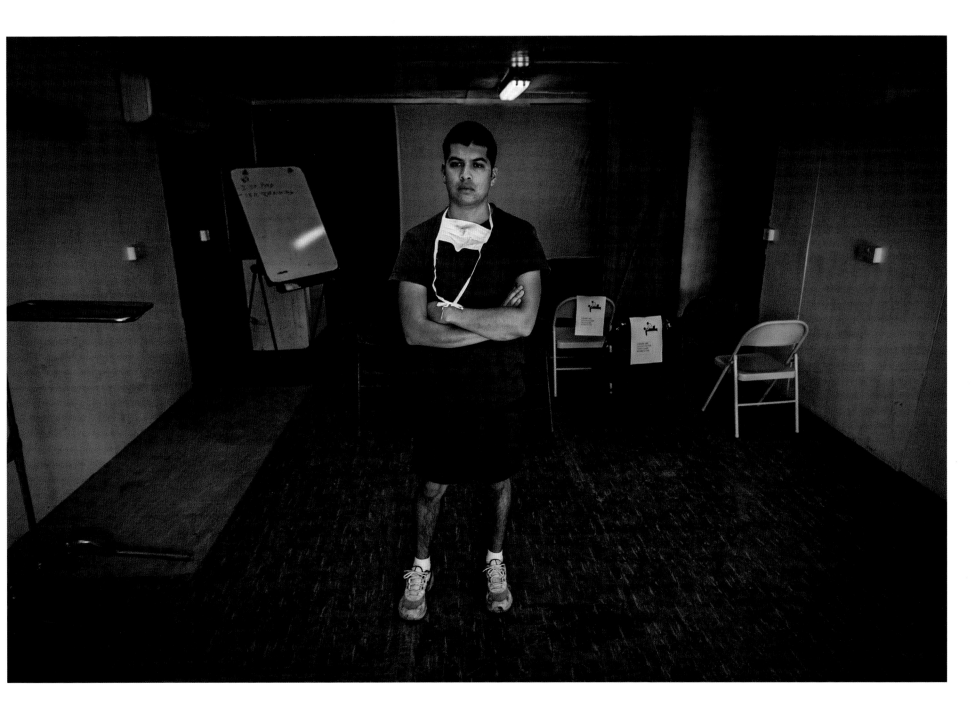

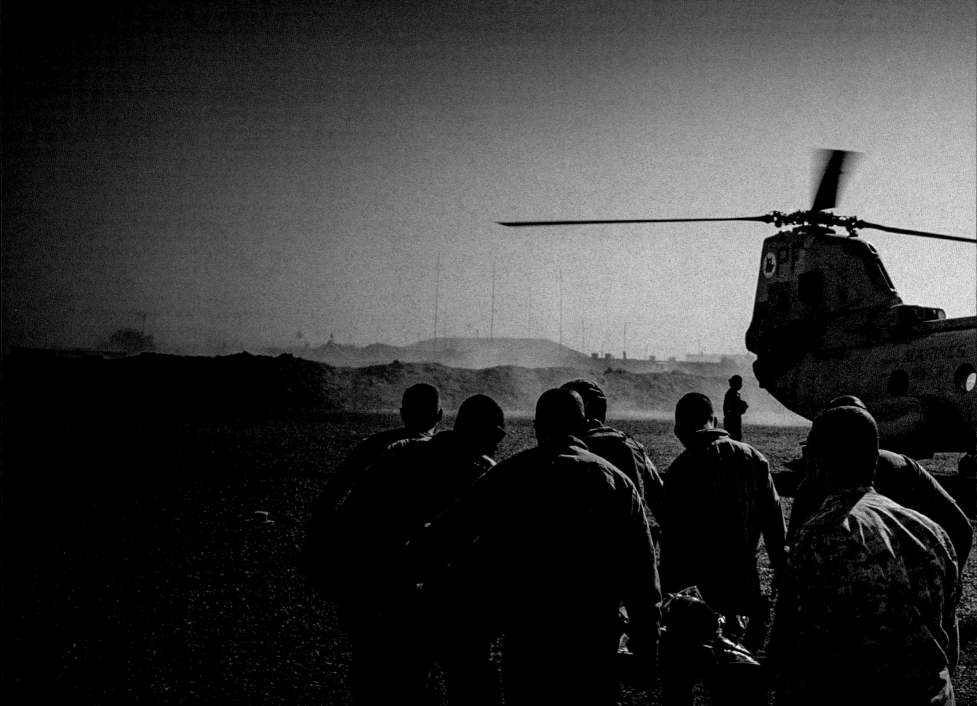

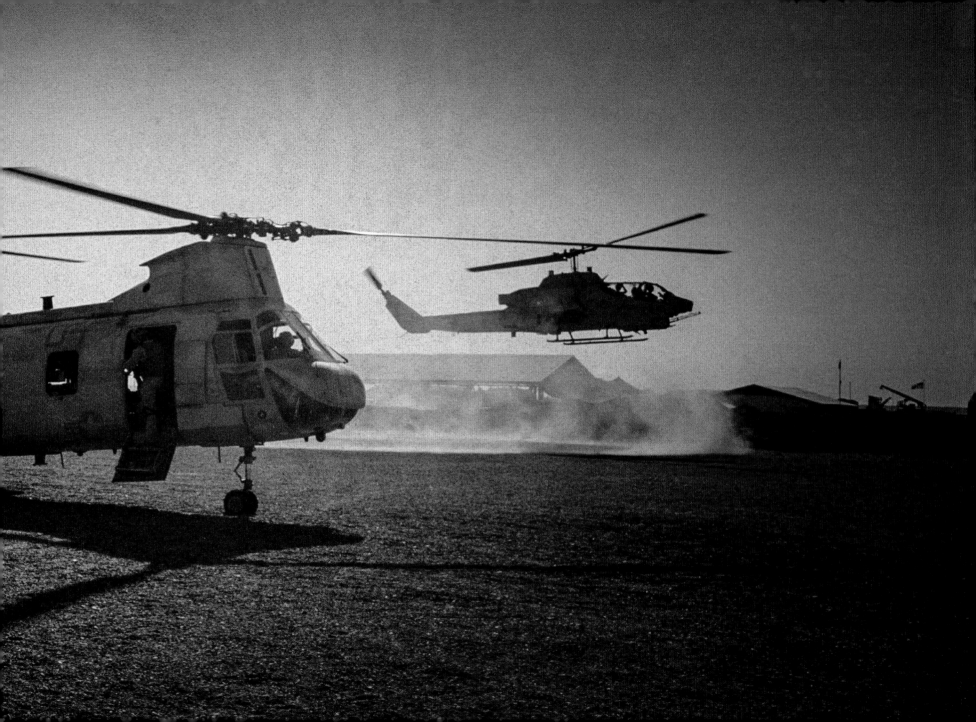

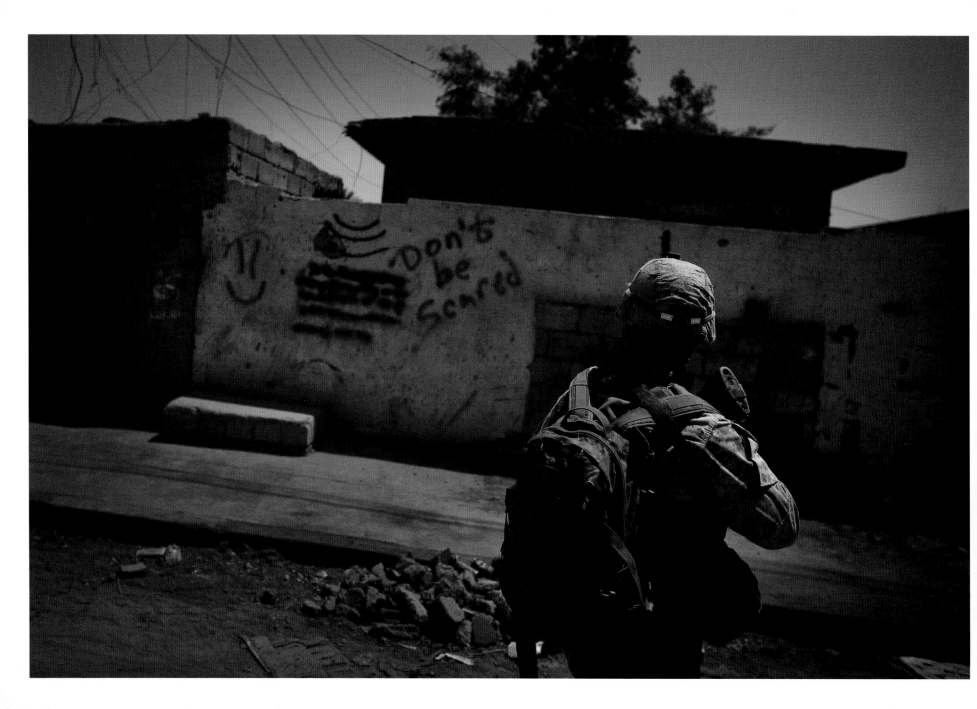

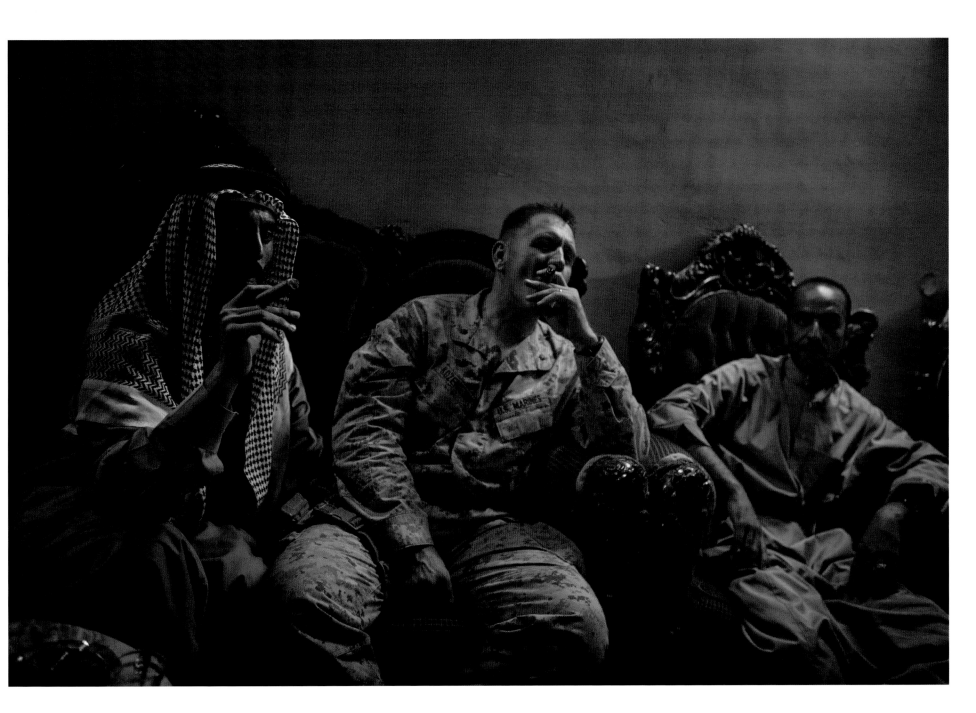

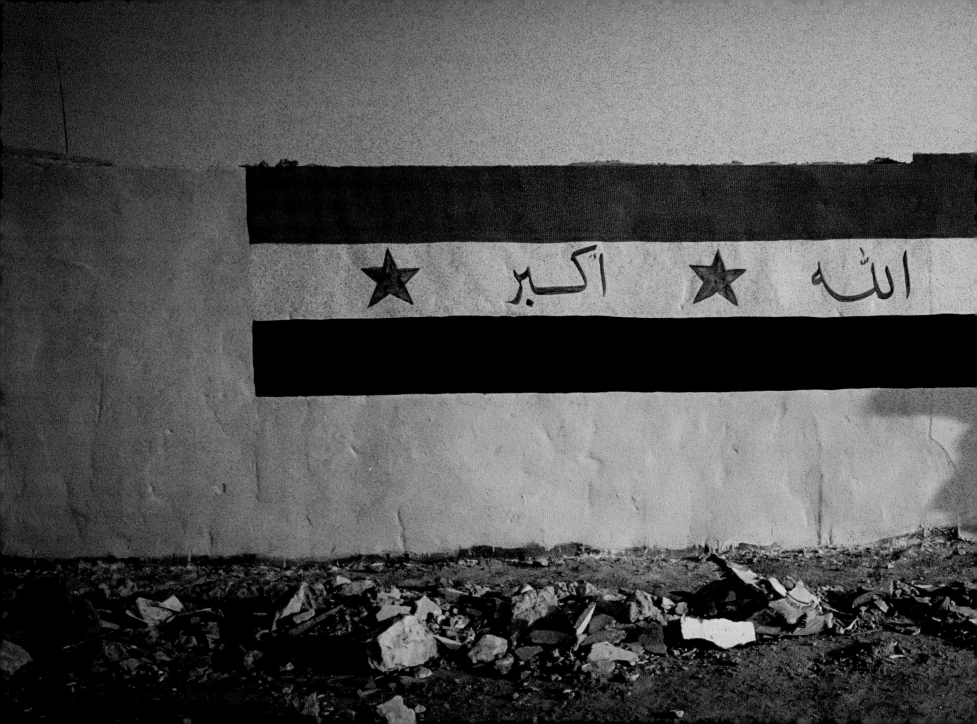

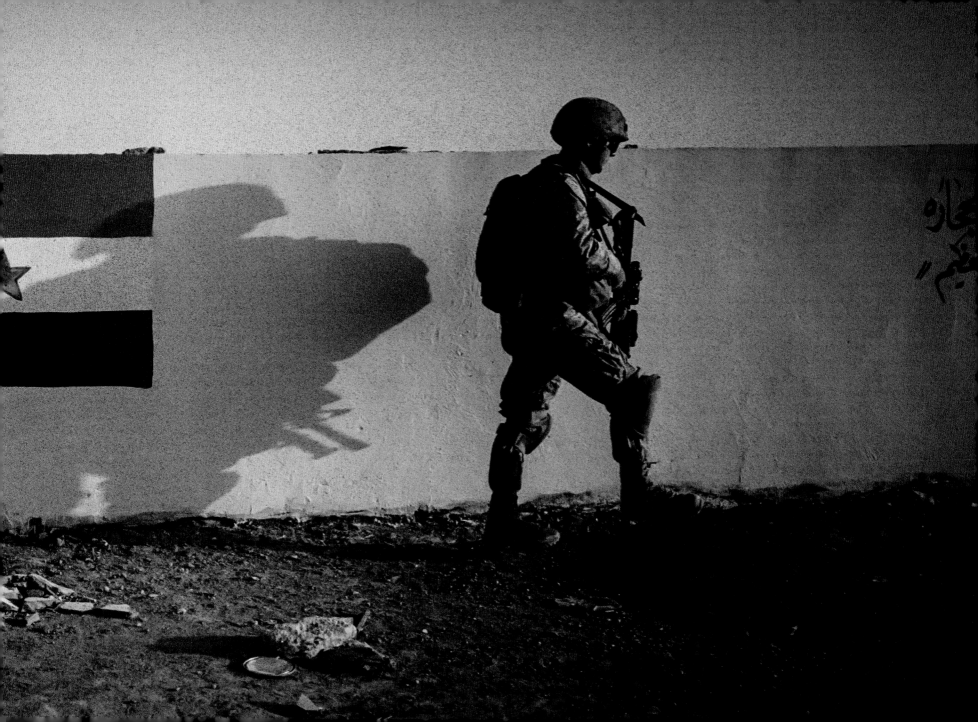

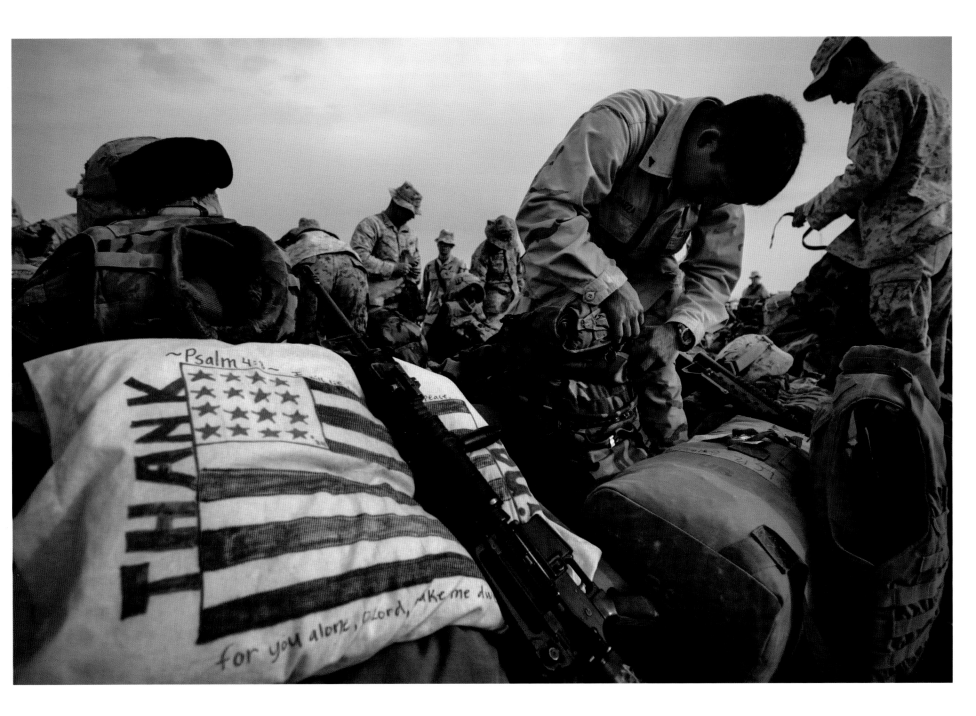

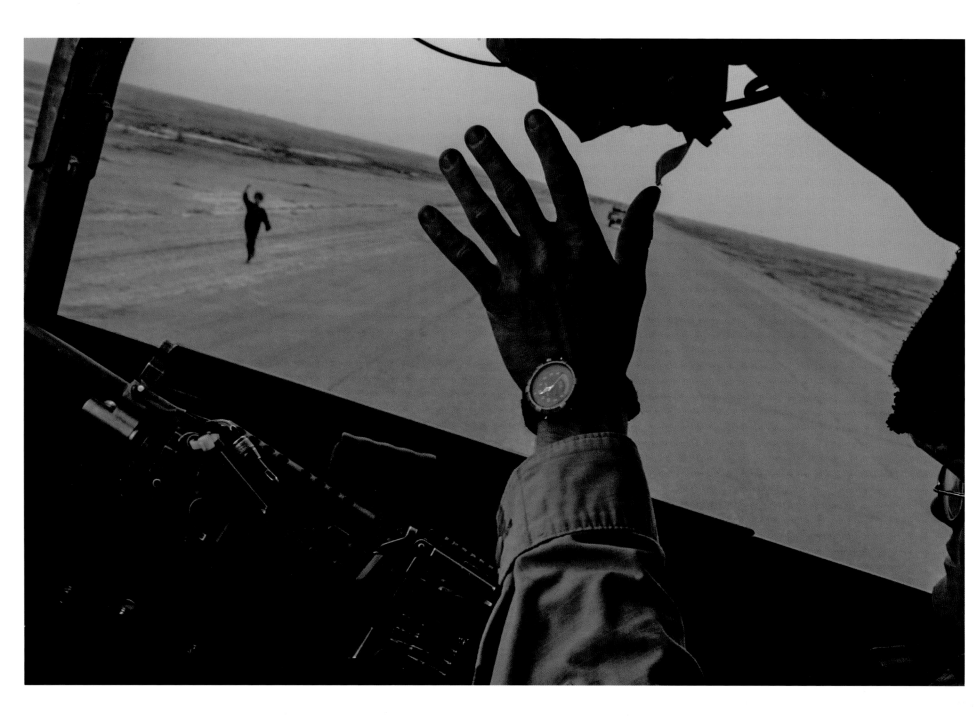

Seventeen days. After nearly nine months away it comes down to seventeen days. Content for so long to check off the months, now I mark the hours—whether those diminishing hours will lead to freedom or the resumption of my sentence, I'm not really sure. I have the best of all worlds here: I am fed, clothed, and guarded. I go where they go, and when all hell breaks loose I feel the same crystalline rush. I am invited into the bonds formed by combat and the nearness of death. I am given all this without ever having to wonder about the lives I have obliterated, about the friends I could have saved, about sacrifices without victories. To be given this, all that is asked of me is that I do my job.

To get beyond the nostalgia for these things, a nostalgia that has begun to set in even while I am still here, it is necessary that I remind myself of those things about home—such as I have one—that wait for me when I return. The vices come to mind first because they are easiest, though I think of them now without much interest. Mostly it is the freedoms I look forward to. The freedom to go where I want and when I want, to leave my house without body armor or automatic weapons. The freedom to have a conversation that doesn't include the words Iraq, hajji, mortars, chow, EAS, or whatever-hundred-hours. I miss the freedom to have a decent meal, to order off a menu, to have friends who know me apart from my camera. I miss being able to not see the same faces everyday, to be anonymous, to be alone. I miss human touch. There are freedoms, though, whose return fills me with dread. I fear the freedom to awake each day and have that day fulfill no purpose, to wake up to a world where history is not being played out on my doorstep, the freedom to live in a miasma of endless phone calls, bills, emails, errands, and appointments. I fear the freedom to live in the future and not the present.

Whether the Marines share in these thoughts I can't entirely be sure. For all of the hardships and bullshit, though, many of them will miss this place—miss the action, miss the sense of purpose, miss the ability to act, miss being able to pull the trigger. Back in Pendleton or Lejeune, the food and the barracks suck and there's the salute-the-officers nonsense you'll have to put up with again. Even worse, you know now that the qualifications and training you'll be put through have nothing to do with the realities over here. What does humping around Pendleton have to do with spotting IEDs at 50 mph, or searching for weapons in an amusement park, or fighting in a cemetery? How can they train you to pick the worst guy out of a crowd of not-quite-as-bad guys? But you'll survive, and you'll miss it because it's real. Maybe the most real thing you know. And that's good, because unless you're getting out, you'll be back. Which I guess makes two of us.

Forward Operating Base Duke, Najaf

January 17, 2005

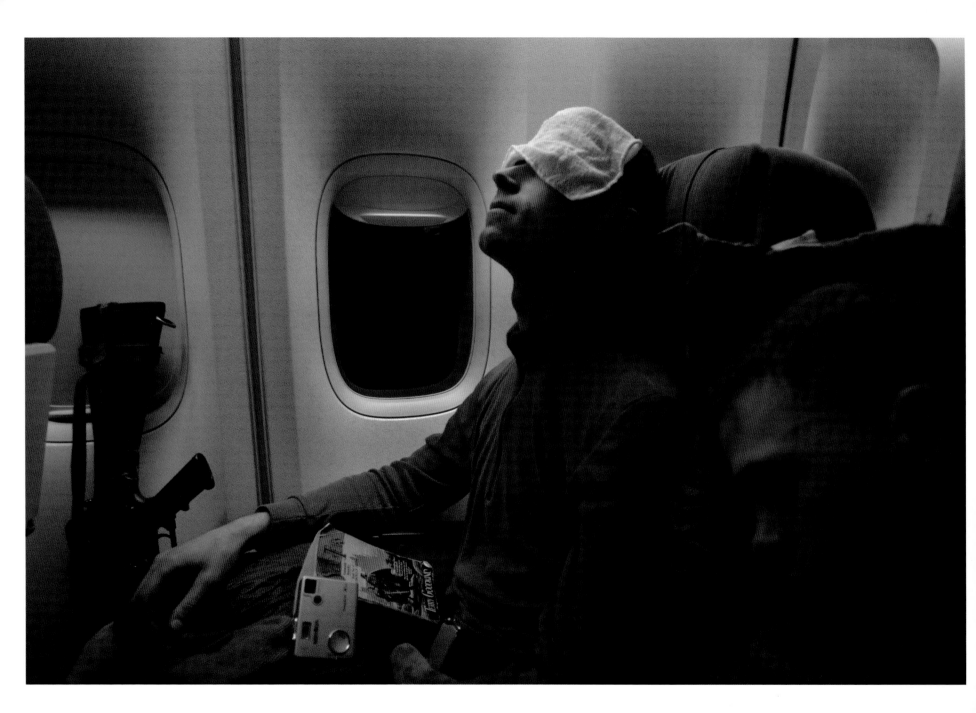

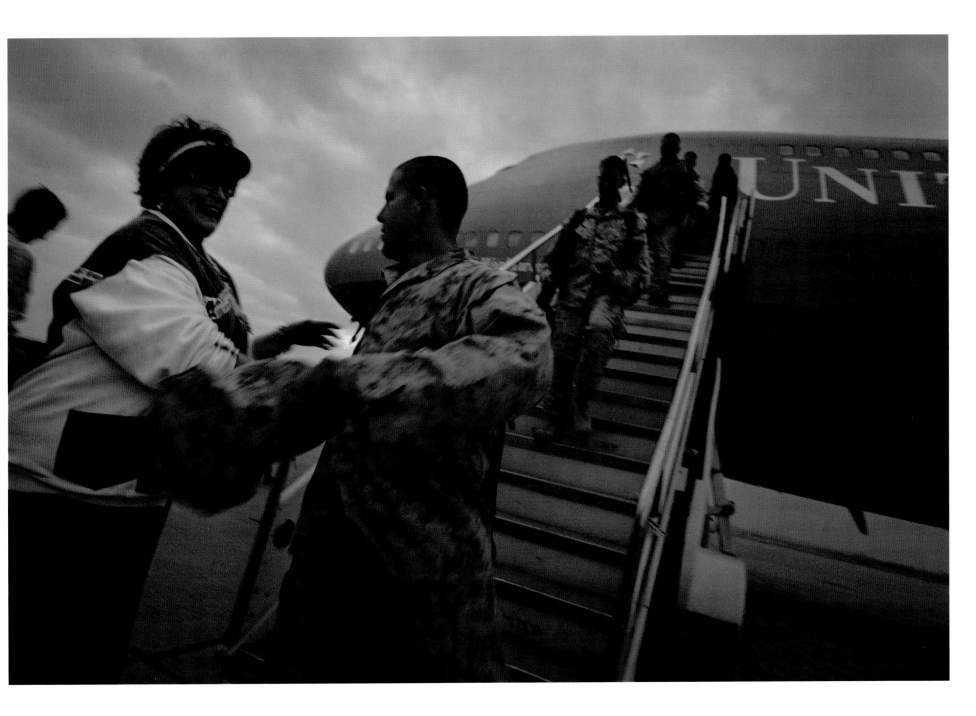

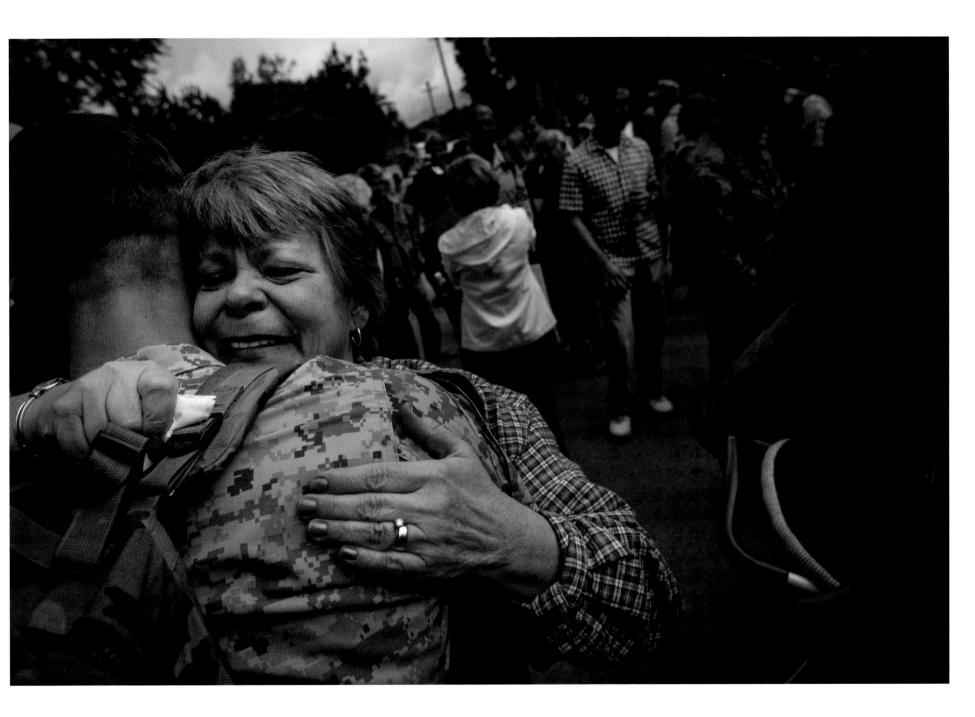

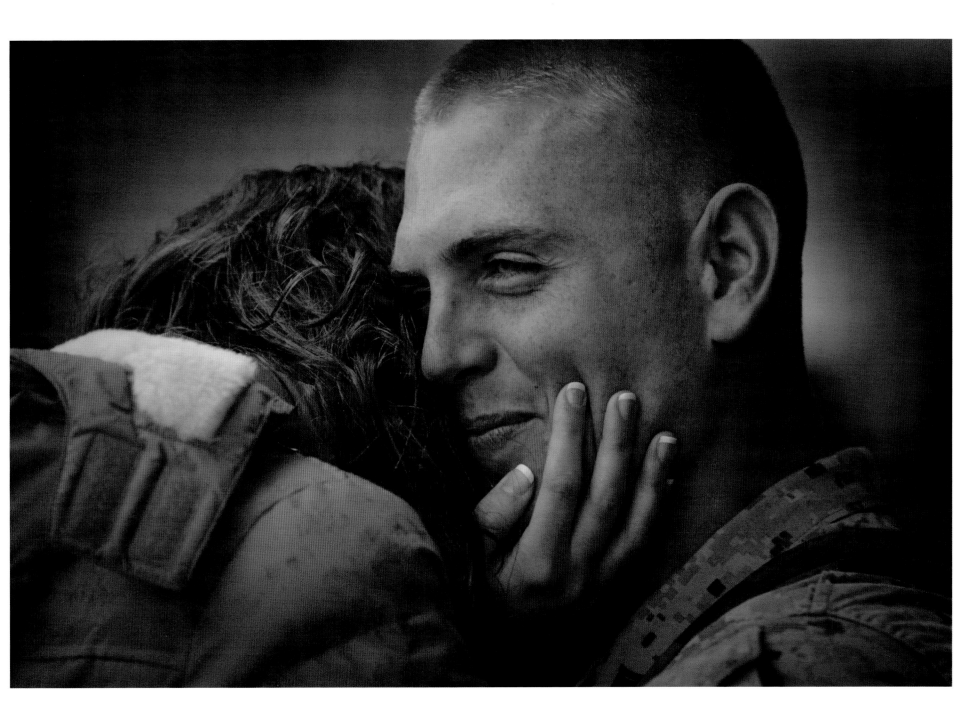

Image Gallery

Name tape from the helmet of Sgt. Christopher Todd Helfin, Kilo Co. 3rd Battalion (BN) 1st Marines. Killed during Operation Phantom Fury in Fallujah, Iraq, on November 16, 2004. Given to the author by members of his platoon.

Spent .50 cal round fired by Marines during Operation Steel Curtain in Al Q'aim, Iraq, on November 6, 2005.

Insurgent battle flag found in a destroyed insurgent position by the author in Fallujah during Operation Phantom Fury. It reads "Saraya al-Tawhid wa al-Jihad" ("The Companies of Unity and Struggle.")

Helmet worn by the author during first embed with the 11th Marine Expeditionary Unit Operation Iraq Freedom II 2004-2005.

Marine K-Bar bayonet captured by insurgents in Haditha, Iraq, on August 1, 2005, and recovered by Marines on November 26, 2005. Given to the author.

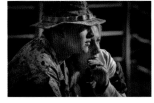

A young Marine embraces his wife as the time draws near for the departure of the 11th Marine Expedition Unit (MEU) from San Diego Naval Station for a seven-month deployment to Iraq on May 27, 2004.

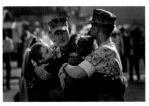

Two Marines embrace sweethearts as the time draws near for the departure of the 11th MEU from San Diego Naval Station for a seven-month deployment to Iraq on May 27, 2004.

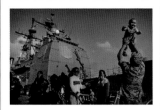

Families gather as the Marines and sailors of the 11th MEU prepare to depart San Diego Naval Station for a seven-month deployment to Iraq on May 27, 2004.

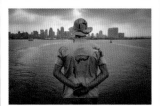

With the San Diego skyline receding into the distance, a Marine "mans the rails" as the amphibious assault ship USS Belleau Wood slips out of San Diego Harbor on its way to Iraq on May 27, 2004.

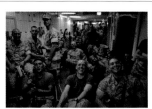

Members of Charlie Company 1st Battalion, 4th Marine Regiment (1/4), infantry battalion for the 11th MEU, enjoy a few minutes of a DVD—the stars of which may or may not be wearing clothing—while passing the ample hours of the Pacific and Indian Ocean crossing.

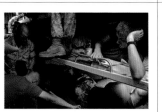

Hemmed in by the feet, heads, arms, and legs of his platoon mates, LCpl Joshua Chenault lies in his rack, going over notes from the day's classes and exercises on June 10, 2014.

A Marine suffering from seasickness covers his eyes in a vain attempt to make the world stop rocking as the USS Denver skirts "super" typhoon Dianmu near the Marianas Island chain on June 18, 2004.

In a steady drizzle, elements of the 11th MEU aboard the USS Belleau Wood take part in an hour-and-a-half conditioning "hump" around the ship's flight deck.

The Marines of Charlie Co. 1/4 exercise on the flight deck of the USS Belleau Wood.

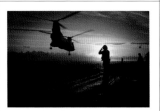

CH-46 helicopters lift off from the deck of the USS Belleau Wood carrying Marines en route to training at Hawaii's Schofield Barracks on June 3, 2004.

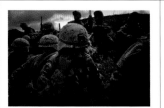

At the Schofield Barracks demolition range, Marines crouch behind an earthen berm, awaiting the practice detonation of a group of bangalore torpedos used to breach defensive fortifications.

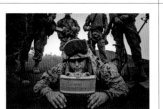

A Marine taking part in demolition training sights a claymore mine on the training range at Schofield Barracks before inserting the electrical trigger that allows it to be detonated on command.

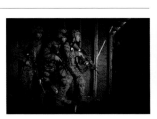

Cpl Joey McBroom (Charlie Co. 1/4) instructs his Marines in room-to-room combat techniques at the Schofield Barracks' urban training facility.

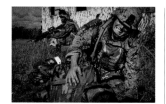

Navy Corpsman Garrison Joslin leans over a "wounded" LCpl Justin Wells (both assigned to Charlie Co. 1/4) during infantry exercises at one of Schofield Barracks' training facilities on June 3, 2004.

At a Waikiki bar, Cpls Robert Bradbury and Morgan Butchee concentrate on the two things that will be virtually nonexistent during their impending tour in Iraq on June 6, 2004.

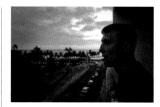

After two days in the field, Cpl Jason Gall stands on the balcony of his Waikiki hotel room, enjoying the first minutes and mai tais of an all-too-brief day-and-a-half Hawaiian liberty.

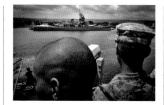

The USS *Belleau Wood* slips past the battleship USS *Missouri*—site of the Japanese surrender in WWII—and out of Pearl Harbor. When the Marines next touch land, it will be to step onto Kuwaiti soil.

LCpl Heidi Kruse slides a sword back into its scabbard in the USS *Belleau Wood*'s hangar bay as she practices the close order drills that are a part of the test she must pass to qualify for promotion to corporal.

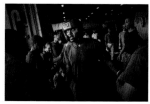

Assistants remove a Marine boxer's gloves following a practice bout in the USS *Belleau Wood*'s hangar bay on June 22, 2004.

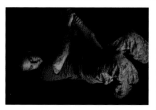

Students taking part in the Marine Corps Martial Arts Program (MCMAP) spar in the USS *Belleau Wood*'s hangar bay as they train for a new belt. MCMAP emphasizes pinning techniques and weapons in hand-to-hand combat.

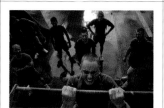

Aboard the transport USS *Denver*, a Marine grimaces through a series of pull-ups. Aboard ship during the long crossing, commanders push their Marines to prepare themselves for the heat, rigors, and dangers of life in Iraq.

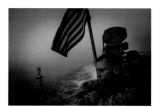

Force Reconnaissance Capt Todd Opalski—a Gulf War veteran—considers the start of his fifth tour in the Middle East as a landing craft from the USS *Belleau Wood* makes its way toward shore.

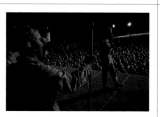

Before finally crossing into Kuwait, Lt Gen Jim Mattis, then commanding general of the 1st Marine Division, addresses the 2,200 Marines of the 11th MEU gathered at Camp Virginia, Kuwait, to warn them of the dangers ahead.

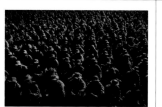

Before finally crossing into Kuwait, the 2,200 Marines of the 11th MEU gather at Camp Virginia, Kuwait, to hear an address of welcome and warning by LGen Jim Mattis—then commanding general of the 1st Marine Division.

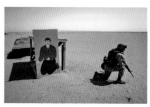

Marines practice patrol techniques in the desert outside Camp Virginia, Kuwait, on July 10, 2004.

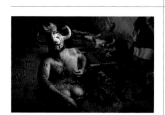

On a dare Cpl Steve Kotecki sits naked in the ice water-filled trash can used to keep drinking water chilled in the 130-degree summer heat at Camp Virginia, Kuwait, on July 9, 2004.

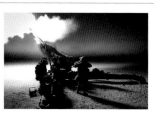

Deep in the Kuwaiti desert, 155 mm howitzers shatter the pre-dawn darkness during live-fire practice, as the 11th MEU carries out final preparations for the crossing into Iraq on July 13, 2004.

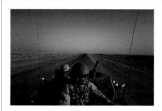

LCpl Moises Ramirez sits atop his Light Armored Vehicle (LAV) as his unit pushes north toward their new homes in Najaf and Diwaniyah to take over operations for units of the departing 1st Armored Division on July 17, 2004.

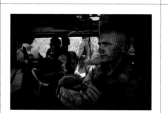

LCpl Jamie Herman keeps a wary eye on the road ahead during a stop by his patrol in the countryside of Najaf. As the day passed into August, both temperatures and tensions rose in the city.

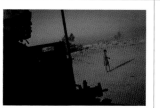

After 43 days at sea and two weeks in Kuwait, the 11th MEU begins operations in Najaf and Diwaniyah on July 24, 2004. The calm of their first weeks would soon be broken by intense fighting.

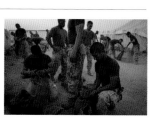

In time-honored tradition, Marines from Charlie Co. 1/4 fill sandbags as they settle into their new home, Forward Operating Base Duke, outside Najaf, Iraq, on July 25, 2004.

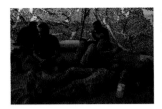

Marines from Charlie Co. 1/4 relax in their company's "smoke pit" at Forward Operating Base Duke—well away from the flammable canvas tents where they are quartered—on July 19, 2004.

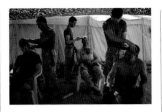

1st Lt Chris Schickling leads the way as he and his Marines submit themselves to their comrade's clippers to keep their hair within regulation at Forward Operating Base Duke on July 30, 2004.

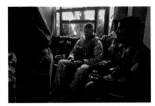

Capt Matt Morrissey, commanding officer of Charlie Co. 1/4, ponders his mission over a cup of tea. Charlie Co. has been tasked with training the Iraqi security forces in Najaf—a city home to Moqtada al-Sadr's Medhi Army militia.

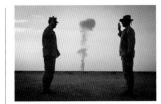

Sgt Jonathan Ross reenlists for another four years of service in the Marine Corps outside FOB Duke, near Najaf, on Monday, October 4, 2004. Ross chose this scheduled detonation for the moment for his reenlistment.

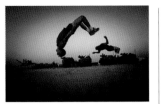

With a little time on their hands, LCpls Jason Barrett and James Johnston practice their self-taught back flips at Forward Operating Base Hotel in Najaf on July 29, 2004. The time of recreation and relaxation would be short lived.

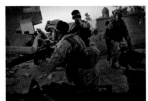

Charlie Co. 1/4 pursues fighters of the Mehdi Army militia through the Wadi-us-Salaam "Valley of Peace" cemetery on the first day of the Battle of Najaf on August 5, 2004.

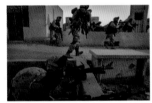

Charlie Co. 1/4 pursues fighters of the Mehdi Army militia through the Wadi-us-Salaam "Valley of Peace" cemetery on August 5, 2004. The cemetery is believed to be the largest on Earth.

Marines wounded by an RPG are treated and prepped for evacuation by their comrades on the opening day of the Battle of Najaf in August 2004.

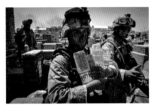

Marines holding positions in the Valley of Peace cemetery receive resupply on the second day of the Battle of Najaf on August 6, 2004. Temperatures regularly soared well above 100 degrees.

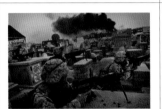

With smoke rising from a building set alight by tank fire, Marines with Bravo, Charlie, and Weapons Companies 1st Battalion 4th Marines continue a second day of fighting in the Najaf cemetery on Friday, August 6, 2004.

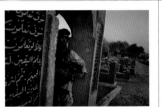

With smoke rising from a building set alight by tank fire, Marines with Companies Bravo, Charlie, and Weapons 1st Battalion 4th Marines continue a second day of fighting in the Najaf cemetery on Friday, August 6, 2004.

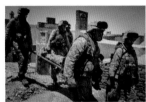

The body of a Marine—killed by a sniper's bullet—is carried by his comrades on the second day of the battle between the Mehdi Army militia and the 11th Marine Expeditionary Unit in Najaf on August 6, 2004.

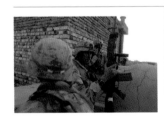

After receiving orders, 1st Lt Seth Moulton prepares to redeploy his platoon as evening falls on the second day of fighting between elements of the 11th Marine Expeditionary Unit and the Medhi Army.

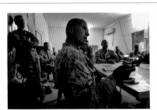

Lt Col John L. Mayer, commanding officer for 1st Battalion 4th Marines, briefs his commander, Col. Anthony Haslam, and fellow battalion commanders as the Battle of Najaf continues on August 11, 2004.

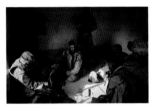

Taking shelter in a crypt, Capt Matt Morrissey passes orders to the officers and senior NCOs of Charlie Co. 1/4 during a lull in fighting between Marines and Mehdi Army gunmen in Najaf's Valley of Peace Cemetery on August 6, 2004.

Navy chaplain Lt Cmdr Paul Shaughnessy blesses LCpl Michael Daniels in the early morning hours before his infantry company's withdrawal from the Valley of Peace cemetery on the third day of the Battle of Najaf, Sunday, August 7, 2004.

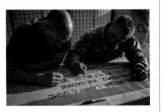

1st Lt Jeremy Sellars and 1st Sgt Justin Lehew prepare a wooden box to return the personal effects of LCpl Larry Wells—killed by a sniper's bullet—home to his family in Louisiana.

Marines with Charlie Co. 1/4 approach a medical clinic wreathed in smoke from burning tires during a raid on the Najaf home of Mahdi militia leader Moqtada al-Sadr.

Under covering fire from machine gunners, Marines from Charlie Co. 1/4 enter a school occupied by Medhi Army militiamen during a raid on the Najaf residence of Moqtada al-Sadr on August 12, 2004.

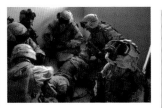

LCpl Ryan Borgstrom, struck by shrapnel from a hand grenade, is treated by his fellow Marines inside a school occupied by Medhi Army militiamen on August 12, 2004.

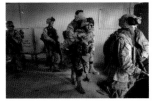

LCpl James Hassel carries his wounded comrade, LCpl Ryan Borgstrom, from a school occupied by Mehdi Army militiamen during a raid on the Najaf residence of Moqtada al-Sadr on August 12, 2004.

Marines search a school recently cleared of Mehdi Army militiamen during a raid on the Najaf residence of Moqtada al-Sadr on August 12, 2004.

Cpl James Jenkins shines his flashlight on a poster of Moqtada al-Sadr inside Sadr's Najaf residence during a raid on the home on August 12, 2004.

LCpl Joshua Bryant waits for his platoon to return to their base after Charlie Co. 1/4 and attached units carried out a raid on the Najaf residence of Moqtada al-Sadr on August 12, 2004.

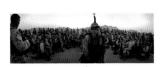

1st Sgt Justin Lehew addresses Charlie Company 1st BN Marines before an assault to dislodge Medhi Army militiamen occupying Najaf's Imam Ali Shrine. The assault and its aftermath would help bring the Battle of Najaf to an end.

The Marines of Bravo Company 1/4 carry out a raid on a technical college in Kufa on August 19, 2004. The school was believed to be held by fighters from the Mehdi Army.

During a raid, Marines with Alpha Co. 1/4 run through a burning building inside Mehdi Army-occupied Kufa, Iraq, on August 21, 2004. The raid netted two dozen suspected militia members.

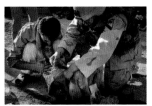

Army medics with the 1st Cavalry Division operating in support of Marines of Scout-Sniper platoon assist Iraqi civilians severely wounded by mortars fired by fighters from the Mehdi Army on August 19, 2004. The child did not survive.

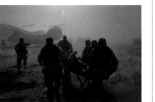

Marines rush a casualty to a waiting cas-evac helicopter for transport to a hospital as the 11th MEU and supporting Army units begin their final assault on the Imam Ali Shrine and its environs on August 25, 2004.

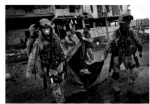

Marines carry the bodies of enemy dead from their positions in Najaf's Old City as they prepare for the final push on the Imam Ali Shrine during the last days of the Battle of Najaf on August 26, 2004.

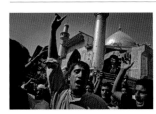

As a truce brings a conclusion to the Battle of Najaf, supporters of Moqtada al-Sadr and his Mehdi Army celebrate within the walls of Imam Ali Shrine on August 27, 2004.

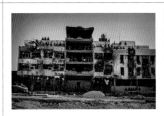

At the end of the Battle of Najaf, the 156 Marines and sailors of Charlie Co., 1st Battalion, 4th Marine Regiment crowd the windows and doors of ravaged hotels they took and held through three days of fighting.

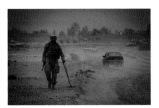

LCpl Jon Maxey sweeps a roadside, searching for buried improvised explosive devices (IEDs) outside Fallujah on October 30, 2004.

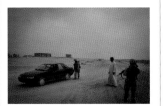

Marines with Kilo Co. 3rd Battalion 1st Marines (3/1) search a car and driver at a checkpoint on the outskirts of Fallujah on October 30, 2004.

LCpl Taylor Volz, Kilo Co. 3/1, walks through the desert by moonlight during a night patrol on the outskirts of Fallujah in the last days before the November 2004 assault on the city.

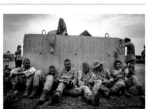

Marines with Kilo Co. 3/1 joke and relax at their base outside Fallujah as they rest and refit before the massive assault on the city that would follow a week later.

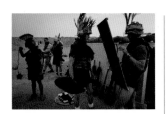

Gladiators and charioteers prepare for glory during the "Ist Annual Thundering Third Chariot Race" at Camp Abu Ghraib, Iraq, on Friday, November 5, 2004.

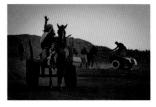

Winners and losers in the 3rd Battalion Ist Marines' "Ist Annual Thundering Third Chariot Race," a company-versus-company chariot race complete with costumes, at Camp Abu Ghraib, Iraq, on Friday, November 5, 2004.

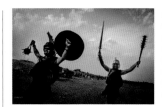

Kilo Co. 3/I charioteers Sgt Aristotel Barbosa (*left*) and Pfc Alex Nicol (*right*) raise their arms in triumph during the "Ist Annual Thundering Third Chariot Race" at Camp Abu Ghraib, Iraq, on Friday, November 5, 2004.

Marines with Kilo Co. 3rd Battalion Ist Marines sit in a foxhole on the outskirts of Fallujah in the final hours before the November 2004 assault on the city. The battle would cost the battalion 28 dead and 275 wounded.

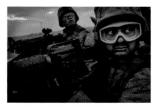

Tension fills the eyes of Navy Corpsman Alejandro Barrosa as he and the members of his squad cross into Fallujah in the opening moments of the attack on November 9, 2004.

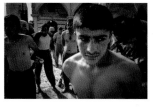

After storming a mosque that was the source of sniper fire, Kilo Co. 3/I Marines detained a dozen men possessing weapons, ammunition, cell phones, and medical supplies hiding inside on November II, 2004.

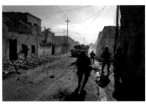

The Marines of Kilo Company 3rd Battalion Ist Marines fight through Fallujah's Jolan District on November II, 2004. 3/I faced fierce opposition the minute it entered the city.

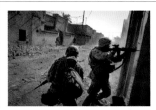

Ist Lt John Jacobs provides covering fire as his platoon—part of Kilo Company 3rd Battalion Ist Marines—fights through Fallujah's Jolan District on November II, 2004.

LCpl Andrew Wright and another Marine examine the bodies of two insurgents killed by a Marine grenade on November 10, 2004.

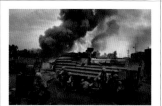

After the detonation of an insurgent weapons cache, Marines and Iraqi civilians take shelter from falling debris on November 9, 2004, the first day of the push into Fallujah.

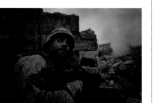

Cpl Tyler Johnson peers around a corner before firing on insurgents taking cover inside a home in Fallujah on November 17, 2004. An armored bulldozer was ultimately called in to demolish the home with the insurgents still trapped within.

Cpl Tyler Johnson peers around a corner before firing on insurgents taking cover inside a home in Fallujah on November 17, 2004. An armored bulldozer was ultimately called in to demolish the home with the insurgents still trapped within.

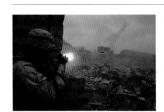

Cpl Tyler Johnson fires on insurgents taking cover inside a home in Fallujah on November 17, 2004. An armored bulldozer was ultimately called in to demolish the home with the insurgents still trapped within.

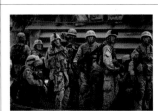

Cpl Anthony Cucchiara demands to know the situation of platoon mates across the street as Kilo Co. 3/I pushes southward through Fallujah on November 12, 2004, and encounters the heaviest resistance they have faced since the assault began.

A family of refugees—the father shirtless to show he is not concealing weapons—approaches a Marine patrol in Fallujah on November 18, 2004.

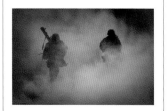

A team runs through the cloud of smoke and dust thrown into the air by the launching of their shoulder-fired rocket at an insurgent position in Fallujah on November II, 2004.

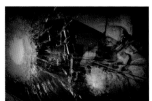

On Route Henry, the scene of bloody fighting, LCpl Don Choi prepares to drive a Humvee whose windshield has been spiderwebbed by shrapnel from insurgent mortars on November 12, 2004.

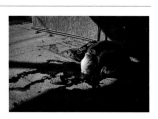

An elderly man mistaken for an insurgent in the first hours of the assault on Fallujah lies dead outside his home after being killed by Marines on November 9, 2004.

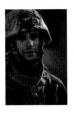

Above left: Sgt Morgan W. Strader in Fallujah on November 10, 2004. Strader would be killed two days later.

Above right: LCpl Sam Severtsgaard in Fallujah on November 10, 2004.

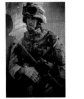

Above left: LCpl Charles Monroe in Fallujah on November 10, 2004.

Above right: LCpl Martin Ochsner in Fallujah on November 10, 2004.

LCpl Ben Dickinson gives the thumbs up as corpsmen work to treat his shrapnel wounds received in an RPG attack on November 13, 2004.

Marines from Kilo Co. 3/1 guard suspected insurgents captured as US Marine and Army units consolidate their control of Fallujah on November 18, 2004—nine days after fighting began.

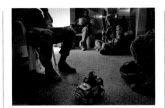

After months of wondering whether the next car is carrying a suicide bomber, Marines fashion their own car bomb as they wait in a commandeered home on the second day of their advance through Fallujah on November 10, 2004.

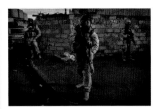

Sgt Byron Norwood and other members of 3rd Battalion 1st Marines halt briefly on the first morning of the Fallujah assault on November 9, 2004. Norwood was killed in action four days later.

An insurgent lies dead on the floor of a home in Fallujah after Marines with Kilo Co. 3/1, clearing blocks house by house, entered the residence and discovered and killed the fighter and at least four other insurgents on November 13, 2004.

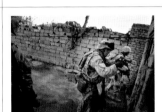

Cpl Ryan Weemer clears houses with his 9 mm pistol as part of a squad from Kilo Co. 3/1, November 13, 2004. Minutes after this photo was taken, the fight known as the "Hell House" would begin. Weemer would kill two insurgents with the weapon before being wounded himself.

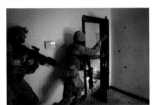

LCpl Samuel Severtsgaard, backed by LCpl Cory Carlisle, throws a grenade into the center room of the "Hell House" on November 13, 2004.

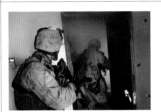

Cpl Ryan Weemer, LCpl Cory Carlisle, and Staff Sgt. John Chandler rush the center of the "Hell House" after the detonation of a Marine grenade on November 13, 2004.

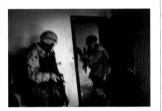

A wounded Cpl Ryan Weemer flees the "Hell House" after being shot twice by insurgents in the upper level of the house on November 13, 2004. LCpl Cory Carlisle was also wounded and was unable to flee the center room.

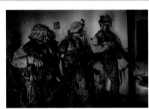

LCpl Michael Van Hove, Cpl R. J. Mitchell, and 1st Sgt Bradley Kasal prepare to rush the center room of the "Hell House" to rescue wounded Marines trapped inside on November 13, 2004.

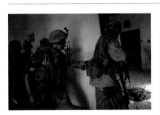

LCpl Michael Van Hove, Cpl R. J. Mitchell, and 1st Sgt Bradley Kasal, along with Pfc Alex Nicoll and LCpl Morgan McCowan, rush the center room of the "Hell House" to rescue wounded Marines trapped inside on November 13, 2004.

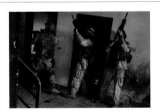

First Sgt Bradley Kasal, Pfc Alex Nicoll, and LCpl Morgan McCowan (*from left*) search for insurgents as they attempt to rescue comrades trapped in the "Hell House" on November 13, 2004. Seconds later insurgent grenade and rifle fire would critically injure Kasal and Nicoll.

LCpl Morgan McCowan surveys the center room of the "Hell House" in a momentary lull in the fire fight on November 13, 2004.

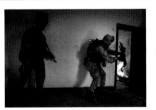

LCpl John Winnick fires his M-16 toward the ceiling of the "Hell House" as the Marines attempt to pin down the insurgent fighters inside while they evacuate their wounded on November 13, 2004.

A dead insurgent lies in the front room of the "Hell House" as two Marines take cover from the rifle fire of their comrades on November 13, 2004.

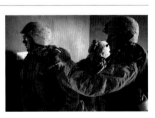

1st Lt John Jacobs gives orders to LCpls Dane Shaffer (*right*) and Chris Marquez (*center*) as Kilo Co. 3/1 works to extract its wounded from the "Hell House."

LCpl Dane Shaffer rushes into the center of the "Hell House" as he and LCpl Chris Marquez brave the house's "kill zone" to pull their wounded comrades to safety on November 13, 2004.

LCpl Justin Boswood and 1st Lt Jesse Grapes expose themselves to insurgent fire to point rifles at the insurgents' position as they lie and kneel in an interior doorway across from where wounded Marines are being evacuated.

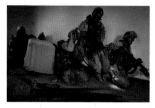

A Marine lies dead where he has been shot in the doorway of the house's interior room. An insurgent also lies dead across the room.

His fellow Marines prepare to carry a gravely wounded Pfc Alex Nicoll from the "Hell House." Nicoll would lose his left leg below the knee.

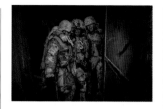

First Sgt Brad Kasal is carried from the "Hell House" by LCpls Chris Marquez (left) and Dane Shaffer (right) on November 13, 2004. Kasal would be awarded the Navy Cross for shielding another Marine from insurgent fire with his own body.

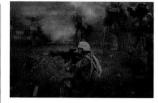

After the leveling of "Hell House," LCpl Chris Marquez (foreground) and his platoon mates unleash their rage on an insurgent who, though trapped in the rubble of the house, still managed to throw a hand grenade at the withdrawing Marines.

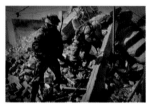

Soaked in insurgent blood, 1st Lt Jesse Grapes walks away from the rubble of the now-leveled house. In the background, LCpl John Winnick sinks his bayonet into the corpse of the last insurgent. The "Hell House" is over.

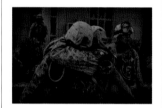

Two Marines embrace in sympathy after the death of a comrade during a patrol near Kilo Co 3/1's temporary base in Fallujah on November 14, 2004.

The outskirts of Haditha, Iraq, on Tuesday, October 11, 2005.

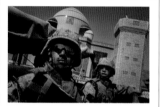

LCpl Rodolfo Ruiz Jr. (left) and Navy Corpsman Nathan Brindley (right) ride through the streets of the al-Anbar Province city of Hit, Iraq, on Sunday, September 18, 2005.

An Iraqi family in Haditha watches a passing patrol of Marines of Kilo Co. 3/1 from behind a screened window two days ahead of an election on October 13, 2005.

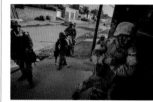

Staff Sgt John Saul shoulders his way through a locked gate as a squad from Kilo Co. 3/1 secures a pair of homes near the company's base in the al-Anbar Province city of Hit on Sunday, September 18, 2005.

Marines with Kilo Co. 3/1 work to rebuild and improve an outpost in the desert outside the al-Anbar Province city of Hit, Iraq, on Sunday, September 18, 2005.

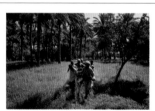

During a sweep by Kilo Co. 3/1 through palm groves along the Euphrates River in Hit, Iraq, on September 25, 2005, four men are taken into detention on suspicion of being insurgents tasked with guarding a large weapons cache.

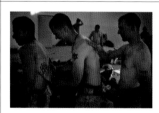

The Marines of Kilo Co. 3/1 eat, relax, and treat themselves for heat rash and aching muscles after a long day of searching for insurgents and weapons in Haditha on October 6, 2005.

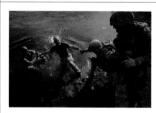

Marines search for artillery shells, mortars, small arms, and ammunition hidden by insurgents in the waters and along the banks of the Euphrates River in Haditha on November 12, 2005.

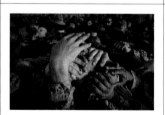

The Marines of Kilo Co. 3/1 join hands in a show of unity before leaving their base for the commencement of Operation River Gate—a search for insurgents in Haditha on October 3, 2005.

A Marine flashlight illuminates a man found wandering into a newly established outpost in Haditha on October 9, 2005. He was later released on the belief that he attempted to enter the base because he is mentally ill.

An **IED** detonates ahead of a convoy from 3rd Battalion 1st Marines in southern Haditha on October 10, 2010.

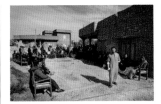

Relatives and neighbors gather outside the house where the bodies of Iraqi civilians killed by Marines from Kilo Co. 3/1 have been brought before their burial in Haditha on November 20, 2005. The deaths triggered a war crimes investigation that lasted 6 years.

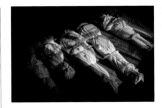

The shrouded bodies of Iraqi civilians lie on the floor of an Iraqi home. In total, 24 civilians were killed by Marines in Haditha on November 19, 2005. One Marine was also killed by an **IED** at the start of the violence.

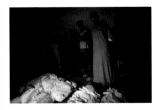

Relatives and neighbors gather around the shrouded bodies of civilians killed by Marines from Kilo Co. 3/1 in Haditha on November 12, 2005.

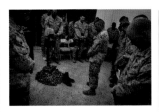

A memorial service for LCpl Miguel Terrazas, who was killed by an IED in Haditha on November 19, 2005. The service was held at the company's firm base. His death sparked the killings that left 24 civilians dead.

A Marine with Kilo Co. 3rd Battalion 1st Marines walks along the banks of the Euphrates River as the sun begins to rise during a pre-dawn patrol in Haditha on November 28, 2005.

Marines from Golf Co. 2/1 and Iraqi soldiers move from their attack positions in a predawn sweep into the Iraqi-Syrian border town of Ubaydi as part of Operation Steel Curtain on November 14, 2005.

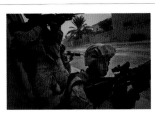

Members of Lima Co. 3rd Battalion 6th Marines (3/6) take part in Operation Steel Curtain, an operation to clear Husaybah, on the Iraq-Syrian border, of insurgents on November 2, 2005.

A team of Marine assault men from Lima Co. 3/6 fire a rocket at an insurgent position in Husaybah during Operation Steel Curtain on Saturday, November 5, 2005.

Marines from Golf Co. 2/1 move into their attack positions before a predawn sweep into the Iraqi-Syrian border town of Ubaydi as part of Operation Steel Curtain on November 13, 2005.

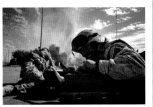

Marine engineers, exposed to insurgent gunfire, employ a mine- and IED-clearing device to make a breach for Lima Co. 3/6 to push forward during the second day of Operation Steel Curtain on November 6, 2005.

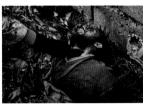

Marines from Golf Co. 2nd Battalion 1st Marines check the pulse of an insurgent killed in a brief exchange of fire during Operation Steel Curtain in Ubaydi on November 14, 2005.

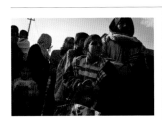

Iraqi civilians make their way to the outskirts of Husaybah during the morning hours of the third day of Operation Steel Curtain, an operation to clear the city of insurgents on November 7, 2005.

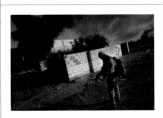

Smoke rises from a burning car destroyed by a Marine rocket team in Ubaydi after they discovered a wire leading away from it, triggering suspicions it might be a car bomb, on November 15, 2005.

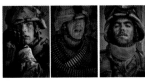

Left: A Marine from Lima Co. 3rd Battalion 6th Marines during Operation Steel Curtain. *Center:* A Marine from Lima Co. 3rd Battalion 6th Marines during Operation Steel Curtain. *Right:* LCpl Cody Blaylock, Golf Co. 2nd Battalion 1st Marines, in Husaybah on November 6, 2005.

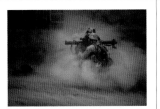

A team of Marine assault men from Lima Co. 3/6 fire a rocket at an insurgent position in Husaybah during Operation Steel Curtain on Saturday, November 5, 2005.

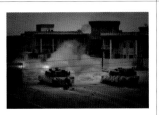

Two tanks attached to Fox Co. 2/1 open fire on a suspected insurgent position in Husaybah on November 8, 2005.

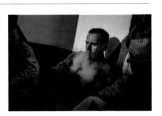

Marines from Lima Co. 3/6 smoke a water pipe to shake off a cold, achy morning in the early hours of November 11, 2005—the sixth day of an operation to clear Husaybah and Karabilah of insurgents.

Marines with Golf Co. 2/1 make their way through a breach in a wall made by combat engineers to help avoid sniper fire and IEDs during the third day of Operation Steel Curtain on November 8, 2005.

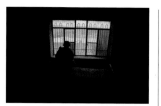

A Marine from Lima Co. 3/6 takes a halt during operations to clear Husaybah of insurgents on November 5, 2005. The operation was the largest since Fallujah and involved 2,500 US personnel and 1,000 Iraqis.

LCpl John Baldonado from Echo Company 2nd Battalion 5th Marines (2/5) holds the citation detailing his actions meriting the Navy Achievement Medal during a ceremony at the company's base—the "Snake Pit"—on January 9, 2005, in Ramadi, Iraq.

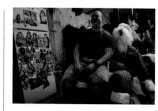

Santa Claus visits the Marines of Golf Company 2/5 at their base—Hurricane Point—in Ramadi, Iraq, on Christmas Eve, 2004.

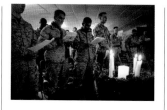

The Marines of 2/5 celebrate midnight services at their base (Hurricane Point) in Ramadi, Iraq, on December 24, 2004.

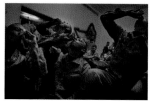

After a delay caused by the Battle of Fallujah, Marines from Golf Co. 2/5 received the traditional beer and rum served to honor the Marine Corps' November birthday on Christmas Day 2004.

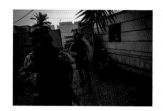

Marines with Golf Co. 2/5 search for insurgents who attacked their platoon with RPGs and small-arms fire—an attack that cost LCpl Isaiah Ramirez his right foot—during a daytime patrol on January 11, 2005, in Ramadi.

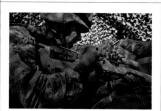

Marine scout-sniper Sgt Ian Jennings puts a round through the chest of an insurgent during an attack on the Al-Anbar provincial Government Center on Saturday, January 15, 2005, in Ramadi, Iraq.

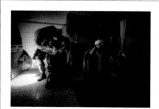

Marines with Echo Co. 2/5 Marines detain several men on suspicion they are connected to the construction of car bombs on January 20, 2005, in Ramadi during a cordon and search patrol.

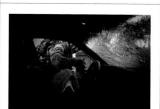

A Marine with Golf Co., 2/5 inspects a car driven by a man who was shot to death when he failed to stop his vehicle as he sped toward a Marine patrol in Ramadi on January 20, 2005.

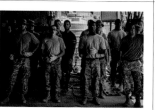

Stretcher bearers drawn from nearby support units stand ready to carry newly arrived patients into Ramadi Surgical's triage bays on Thursday, August 10, 2006. The patients are Iraqi civilians and Iraqi policemen wounded—many fatally—by a car bomb.

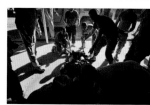

After an IED strike, Army medics and a Navy nurse prepare to lift the stretcher of a badly injured soldier and carry him into an ER for treatment by Navy surgeons at a forward surgical unit, Charlie Medical, at Camp Ramadi, Iraq, on October 22, 2006.

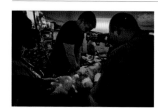

Lt Cmdr David Junker performs CPR on a Marine wounded in an IED strike at Charlie Medical in Camp Ramadi on October 8, 2006.

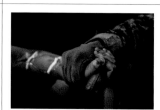

A Marine 1st sergeant holds the hands of one of his Marines wounded in an IED strike in the ER at Charlie Medical in Camp Ramadi on October 21, 2006.

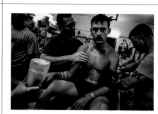

A Navy nurse attends a Marine survivor of an IED strike on October 6, 2006.

Navy chaplain Lt Cmdr Father Denis Rocheford says a prayer over a Marine who suffered catastrophic injuries in an IED strike in the ER at Charlie Medical in Camp Ramadi on October 21, 2006.

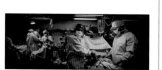

With two badly wounded patients and more on the way, surgeons and assistants operate on two beds simultaneously in the OR at Charlie Medical in Camp Ramadi on Friday, September 29, 2006.

A medical form details the double amputation of a Marine wounded in an IED strike in downtown Ramadi on Sunday, October 22, 2006.

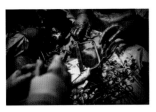

Navy surgeons at Charlie Medical amputate the left leg of a gravely wounded Marine after the Marine's Humvee was demolished in an IED strike in Ramadi on Friday, October 6, 2006.

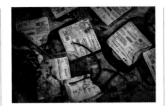

Empty blood bags carpet the floor of the operating room at Charlie Medical on Friday, October 6, 2006. The blood is drawn from volunteers who line up out the door of the facility, eager to aid their wounded comrades.

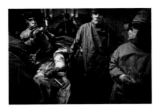

A Marine undergoes a double amputation in the operating room at Charlie Medical after his legs were shattered by an IED strike in Ramadi on Sunday, October 22, 2006.

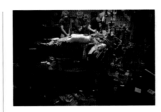

The aftermath of a double-amputation operation on a Marine whose legs were destroyed by an IED strike in Ramadi on Sunday, October 22, 2006.

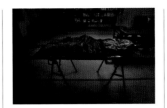

Out of site of his grieving comrades, a Marine killed in an IED strike waits alone before he can be carried to the morgue at Charlie Medical in Ramadi on October 21, 2006. The IED also killed two other Marines.

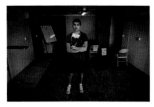

A Navy nurse watches as the body of a fallen Marine is taken to the morgue at Camp Ramadi on October 8, 2006—the first step in the long journey home to the United States.

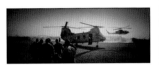

Medics and a Marine helicopter crewman load a soldier onto the CH-46 helicopter that will carry him to Baghdad for further surgery on September 28, 2006. The transport helicopter's gun ship escort waits to lift off in the background.

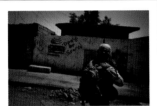

A Marine with 2nd Battalion 5th Marines walks past encouraging words in central Ramadi on May 10, 2007. In recent months, Ramadi had become an island of stability as tribal leaders split from the insurgency after years of intimidation.

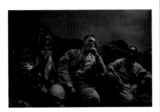

Lt Col Craig Kozeniesky meets with Sheik Shahoud Asi for dinner and cigars on May 22, 2007. In recent months, Ramadi had become an island of stability as tribal leaders split from the insurgency, a process dubbed the Sunni Awakening.

A Marine with 2nd Battalion 5th Marines walks past a newly painted Iraqi flag in Ramadi on May 10, 2007. In recent months, Ramadi had become an island of stability as tribal leaders split from the insurgency after years of intimidation.

Even a sandstorm cannot dim LCpl David Stone's delight at the prospect of heading home as Kilo Co. 3rd Battalion 1st Marines passes the few remaining hours of its long deployment in Iraq on January 24, 2005.

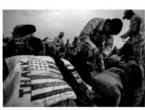

A few days before they begin the journey back to the United States after eight months in Najaf, Iraq, Marines with Charlie Co. 1st Battalion 4th Marines pack their gear for the trip to Kuwait on January 31, 2005.

From the last vehicle of a Kuwaiti-bound convoy, LCpl David Mitchum waves to a passing Iraqi girl as the first wave of elements from the 11th MEU begins the journey home from Najaf to California on February 1, 2005.

LCpl John Thoennes and Navy Corpsman David Whittington sleep during the 22-hour flight home from Kuwait to Frankfurt, Germany, then to March Air Force Base outside Los Angeles on February 5, 2005.

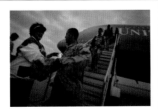

Marines with the 11th MEU and 1st Battalion 4th Marines are greeted by a supporter at March Air Force Base as the units return to California from Najaf, Iraq, after an eight-month-long deployment on February 6, 2005.

A bus window gives a Marine from 1st Battalion 4th Marines a first look out on the California landscape he left eight months before as his unit returns from Najaf to Camp Pendleton, California, on February 6, 2005.

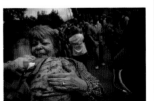

Finally home after nearly nine months, a mother hugs her Marine son on February 23, 2005. For many their time at home will be short, with some units scheduled to redeploy by fall; a third combat deployment in as many years.

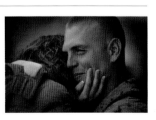

A Marine and his girl embrace as the eight-month deployment of the 11th Marine Expeditionary Unit and 1st Battalion 4th Marines comes to an end on February 6, 2005, at Camp Pendleton, California.

ACKNOWLEDGMENTS

I acknowledge and dedicate this book to Roberto Abad, Chris Heflin, Megan McClung, Byron Norwood, Brian Olivera, Yadir Reynoso, Juan Segura, Abraham Simpson, Morgan Strader, Miguel Terrazas, Larry Wells, and too many other Marines and sailors who gave their lives for country and comrade. I also dedicate this book to their families for their unending sacrifice.

Thank you to every Marine and sailor—in this book or out—who let me in on the plan, found me a seat, put up with my disregard for my own safety, and made this book possible in a thousand other ways large and small. Top of the list are Carlos Brown, John Chandler, Jesse Grapes, John Jacobs, David Junker, Justin Lehew, Chris Marquez, Alex Martin, Adam Mathes, John Mayer, Dan McSweeney, Matt Morrissey, Seth Moulton, Bradley Kasal, Steve Kotecki, John Saul, Chris Schickling, Jeremy Sellars, Dane Shaffer, all the officers and men of Charlie Co. 1st Battalion 4th Marines and Kilo Co. 3rd Battalion 1st Marines, and hundreds more—but not less in any way. An especially huge thanks to Carrie Batson, who made sure the 11th MEU didn't leave or come home without me, and was a friend and advocate at every turn in between and after.

Thanks to Tara Farell, Seamus Conlan, and everyone at the photo agency, World Picture News, for giving me a home at the start. Thanks to Jamie Wellford, Scot Jahn, and everyone at *Newsweek* and *US News*—and all the editors—who did their best to make sure the world saw the war through my work. Thank you to Grayson and Cynthia Dantzic for their unending faith and encouragement. I wouldn't be writing these words now without it. Thank you to Dan Rather and Seth Moulton (once more), and all the contributors for sharing your reflections and support for the book. Thank you to Debra Pearson for the same. Thank you to Francesca Richer for your elegant designs. And thank you to Pete Schiffer, Ian Robertson, and everyone at Schiffer Publishing who made this book a reality.

Thank you to my father, Barry, who when I told him I was starting this adventure said, "I was wondering what was taking you so long," and to my wonderful mother, Marilyn, who loved me in stoic silence as I returned to the wars time and time again. I couldn't have been blessed with more understanding or loving parents. It was probably that love, as much as any body armor or sandbag, that helped me come through the wars intact.

And best for last . . . Thank you to my wife, Deirdre, who year on year waited on her own private Ithaca, with strength, determination, and love. All the credit goes to the wives.

LUCIAN READ is an Emmy award-winning documentary director, cinematographer, and photojournalist. Between 2004 and 2010, he spent more than three years embedded with US forces in Iraq and Afghanistan and witnessed many of the pivotal events of both wars. These embeds included a complete deployment with the 11th Marine Expeditionary Unit in Iraq and multiple long-term embeds with brigades from the 4th Infantry and 101st Airborne Divisions in Afghanistan. His photojournalism work during the wars for publications such as *Vanity Fair*, *The New Yorker*, *Newsweek*, *Time*, and *Rolling Stone* garnered a World Press Photo Award in 2006. A collection of his work is in the permanent collection of the National Museum of the Marine Corps in Quantico, Virginia. In addition to the Iraq and Afghan Wars, Read has covered conflicts and current events across the globe. Read is a creator of the Norman Lear executive-produced documentary series *America Divided*. He was awarded Emmys in 2015 and 2017 for investigations of deaths on the US-Mexico border and child labor in Mexico. He directed the Occupy Wall Street feature documentary *99%* — an official 2013 Sundance selection. His work as a producer for the news magazine program *Dan Rather Reports* from the Afghan War was nominated for an Emmy in 2010. He currently lives in Brooklyn, New York, with his wife Deirdre and son Bering.

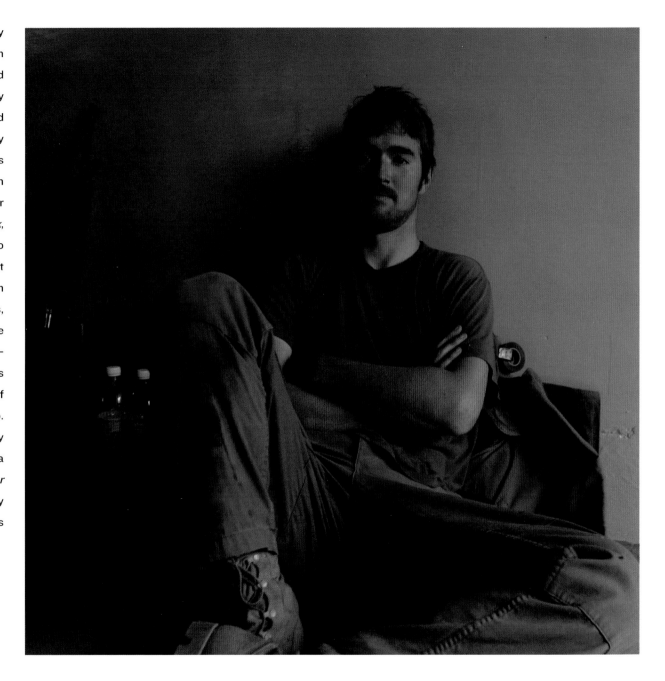

Edited by Ian Robertson
Designed by KASTL, NYC
Type set in Knockout/Alternate Gothic Compressed ATF

ISBN: 978-0-7643-5799-2
Printed in China

Published by Schiffer Publishing, Ltd.
4880 Lower Valley Road
Atglen, PA 19310
Phone: (610) 593-1777; Fax: (610) 593-2002
E-mail: Info@schifferbooks.com
Web: www.schifferbooks.com

For our complete selection of fine books on this and related subjects, please visit our website at www.schifferbooks. com. You may also write for a free catalog.

Schiffer Publishing's titles are available at special discounts for bulk purchases for sales promotions or premiums. Special editions, including personalized covers, corporate imprints, and excerpts, can be created in large quantities for special needs. For more information, contact the publisher.

We are always looking for people to write books on new and related subjects. If you have an idea for a book, please contact us at proposals@schifferbooks.com.